Paul Miloscur

Elizabeth Sasser

Out of the Ordinary

Out of the Ordinary

Foreword by Frank Waters

Texas Tech University Press

The Art of

Paul Milosevich

Text by Elizabeth Sasser

Lubbock, Texas

To the Creative Spirit within each one of us; to the memory of my parents; and to my children, Jena, Tanya, Karla, and Vincent

Special thanks to my family, friends, teachers, and patrons over the years, without whom this book would not be possible. Also to Texas Tech University Press for their help and support, and to Betsy Sasser for her insightful work on the biographical text.

<div align="right">P.M.</div>

The narrative portion of this book was done within a deadline of about two months. Without the cooperation of the artist, this would have been impossible. There were hours of taped interviews, which were joined by a conversation taped during the summer of 1988, and an interview from a decade earlier. It is from these exchanges with the artist that all unfootnoted quotations within the text derive.

Appreciation must also be expressed to the staff of the Texas Tech University Press, especially to Judith Keeling, for making the writing a happy experience.

My husband, Tom Sasser, who was patient and helpful in reading and commenting on the manuscript, deserves special thanks for the support necessary to bring the writing to completion.

<div align="right">E.S.S.</div>

Printed in Hong Kong

This book was set in 10 on 13 Trump and printed on acid-free paper that meets the guidelines for permanence and durability of the Committee on Production Guidelines for Book Longevity of the Council on Library Resources.

Jacket and book design by Joanna Hill
Jacket art *Levi Jacket* and *Antonio Fernandez* by Paul Milosevich

Manufactured in Hong Kong by Everbest Printing

Library of Congress Cataloging-in-Publication Data

Sasser, Elizabeth Skidmore, 1919-
 Out of the ordinary: the art of Paul Milosevich / Elizabeth Sasser.
 p. cm.
 Includes index.
 ISBN 0-89672-235-X (cloth). —ISBN 0-89672-236-8 (pbk.)
 1. Milosevich, Paul, 1936- —Criticism and interpretation.
 I. Title
 ND237.M525S27 1991
 759.13—dc20 90-39478
 CIP

92 93 94 95 96 97 98 99 9 8 7 6 5 4 3 2

Texas Tech University Press
Lubbock, Texas 79409-1037 USA

Contents

Foreword

This book of paintings by Paul Milosevich is not only a thirty-year retrospective of a highly original artist, but a visual history of his life and hometown of Trinidad, Colorado.

Here are paintings of his family members, dog and calf, farm, town, and countryside. We see still lifes of old Model-T autos, his father's hammer, scythe, cap and gloves, and other such period "stuff" as the artist calls it. These are glimpses back into a boyhood of a half-century ago. They are followed by paintings of a bigger and later world seen with the same engrossing interest.

Paul Milosevich is a grass-roots representational painter. He is also a talented portrait artist. Personally, I think the compassionate portraits of his father and mother; of Pat Barela, the Spanish primitive wood-carver of Taos, New Mexico; and of Nicolai Fechin, the world-famous Russian portrait artist who lived for a time in Taos; and others are among the best work he has accomplished.

I met Milosevich twenty years ago when he was painting in Taos and visited me at my home. He was already widely known, and I have followed his accomplishments ever since.

As with most artists, his road to recognition has been a rough uphill climb. His parents, Zora Padjen and Matt Milosevich, were Yugoslav immigrants. The youngest of their eight children, Paul was born in 1936 in Trinidad, Colorado, where his father was a coal miner and farmer. I knew Trinidad well as a boy myself; it was then a rough-and-tumble town. In its public schools, young Milosevich developed a love for drawing, but no art classes were available. His other chief interest was golf, which continued throughout his life, as attested by his one-man show of golf art in 1988 at The Sporting Scene in Dallas, Texas.

Graduating from high school, he studied for a time in Los Angeles, California, then returned to Trinidad Junior College. Here he met the Western artist Arthur Roy Mitchell who greatly aided his development. Twenty years later, Milosevich, in turn, helped to establish the present Mitchell Museum in Trinidad.

There came now many years of work and living during which he matured as a man and as a professional painter. Only a comprehensive biography could record his outer and inner experiences. He was

married and divorced twice, and had four children: three daughters, Jena, Tanya, and Karla; and a son, Vincent. The struggle to provide for his growing family is attested by his work on the wheat harvest in Texas, as a clerk and stenographer, and as a full-time janitor for five years in Long Beach, California.

Meanwhile, Milosevich persisted in his study and practice of art. By 1965, he completed work for his bachelor's and master of arts degrees in painting and drawing at Long Beach State University. Odessa College (Texas) appointed him instructor of art, then chairman of its art department. Awards and commissions began to come in.

In 1970, he toured art museums and galleries in New York and other large Eastern cities. Finally, in 1971, he visited his parents' homeland of Yugoslavia, and exhibited in Holland a collection of his watercolors and drawings. What a long way he had come from his boyhood in rowdy Trinidad!

But Milosevich was still a down-to-earth Southwesterner committed to his own native land. And here, upon his return, he has continued to live in Colorado, New Mexico, Texas, and California, his work expanding steadily his reputation as a devoted grass-roots painter.

Frank Waters

Introduction

What goes around, comes around. Or as Paul Milosevich phrases it, "One of the nice things about being an adult is realizing the dreams of your childhood." Despite a diversity of subjects painted and changes of geographic scene—from Trinidad, Colorado; to California; to West Texas; on to New Mexico; and back to Texas again—Milosevich's career as an artist has had a unifying balance of memories and relationships that always seem to be waiting for the right moment to surface. There is the love of the land fostered by his Yugoslav parents' pride in their Colorado farm where the painter grew up. Those early years brought an awareness of the light that affects every aspect of nature and the changes of the seasons. Light and shadow patterns have had a strong fascination for the artist since childhood. He says that light is an essential element in any painting whether it is done out-of-doors or in the studio.

A childhood in Trinidad was an introduction to a melting pot of Italians, Spanish, Yugoslavs, Anglos, and others who came west to find work in the mines or the lumber industry, or to acquire land. In such an atmosphere, a high-spirited youngster found mimicking local characters he saw on the streets amusing, but, in doing this, he was developing a keen observation for detail and nuance of expression that refined his talent for capturing a portrait likeness. Moreover, an ethnic awareness may have influenced the artist's later respect for and interest in the American Indians, their ceremonialism, and the tribal dances held in the pueblos of New Mexico.

It would have been difficult to predict that a boy listening to radio broadcasts of country and western music would, as a grown-up, receive commissions to do portraits of the annual inductees into the Nashville Songwriters' Hall of Fame and would have, among many musician friends, Tom T. Hall, Joe Ely, and Terry Allen.

Another serendipitous turn had its beginning in that the Milosevich farm stretched beside a golf course. In this case, the green was actually greener on the other side of the fence. The Milosevich boys earned pocket money caddying during the summer months. Golf has remained one of the artist's favorite recreations, and in the last few years, he has received many commissions to paint portraits of famous golfers. In

1988, he was asked to do a painting of Patty Berg for the Far Hills, New Jersey, USGA Golf House Museum.

The artist's simple pleasure in everyday objects has grown, rather than diminished, over the years. There is an affection for polished kettles with reflected images, brooms and mops that have absorbed an attachment for work-roughened hands, hats whose shapes have adapted to their owners' demands, guitars, old boots, and Levi jackets. A journalist remarked recently that the painting of a Levi jacket, treated so realistically that it offered a map of every fold and wrinkle, caught her eyes when she was halfway across a crowded room. She was drawn to the painting and took delight in every thread and stitch. Before this chance encounter, she had never heard of Paul Milosevich, but from that time on, whenever she saw one of his paintings, it seemed like a visit with an old friend. She concluded with the comment that to be attracted to a painting across a gallery filled with people wasn't such a bad way to be introduced to a painter and his work.

Milosevich's paintings are difficult to ignore, even though they possess no deliberate flash or shock appeal. Their strength issues from the artist's sincere effort to communicate his feelings about what he has chosen to paint. The paintings are not frivolous nor are they inflated to a pseudo-importance by tricks of surface virtuosity. An admonition Milosevich makes to his students is "paint *simply* and paint the *obvious*, not the impossible."

Beginning his career in the 1960s, the artist was thrust into the mainstream of abstract expressionism, which gained, in many cases, such general acceptance that it influenced the removal of courses in portraiture and life painting from the curricula of many colleges and universities. But Milosevich's heroes belonged to an earlier generation of artists. He looked to Édouard Manet, Robert Henri, Edward Hopper, N. C. Wyeth, Nicolai Fechin, and painters of similar talents as role models. His mentors included painters of the American West Arthur Mitchell and Ramon Froman, while Frank Waters, the writer, was another source of inspiration. In the 1970s, op art, pop art, and minimalism succeeded each other in rapid succession. Milosevich was neither disturbed nor deterred. He followed his own path, which led to what has been called West Texas realism. His work remained in touch with the grass roots of the country and his own background. He maintained the work ethic that had been a part of his boyhood training and his family's belief that work was the only honest way to make a living.

Nevertheless, having attained a successful style, Milosevich has never been satisfied with repeating himself year after year. Since his college days, he has taken workshops and has taught classes; he has become acquainted with painters whom he admires and from whom he has received the inspiration and encouragement to continue to stretch his goals. His art has always been in a process of emergence, of progression, and of change, not for the sake of change, but for the sake of growth.

When he was just beginning his career, Philip Rhys Adams, for many years the director of the Cincinnati Museum of Art, gave a lecture to a group of art students at the Columbus Gallery of Fine Arts (Ohio). He was asked how one could assess—without the advantage of historical perspective—the importance of a contemporary artist. Without hesitation, he answered that he, personally, looked for evidence of growth and a willingness on the part of the artist to experiment, instead of allowing contentment over early successes to cause an unending repetition of the same techniques and the same subjects in his paintings.

By this standard, Paul Milosevich's career as an artist is maturing in the soundest way possible. He is avoiding Ramon Froman's grave warning, "The only sin is the refusal to grow."

Out of the Ordinary

The Early Years
Trinidad, Colorado

D escribing the landscape where he grew up, Paul Milosevich says, "Trinidad [was] dominated by a famous landmark, Fisher's Peak. No matter where I have lived since my childhood, my psychological . . . frame of reference [and my experiences have always been oriented to] our field leading up to the foothills and on up to that . . . blue-gray mesa."

The rugged contours of the mountain found a match in the crusty, unyielding character of the artist's father, Matt Milosevich, a Yugoslav who arrived in the new world in the early twentieth century. Young men born in the Balkans in the days before the First World War were faced with a term of service in the army of Austria-Hungary. This was a motivating force for the journey across the Atlantic, but young Milosevich's departure from the village of Ledenice could also be described by the Yugoslav proverb *trbuhom za kruhom*, "the stomach follows the bread." Matt Milosevich's first destination was Canada, where he earned a living as a lumberjack. A move to Minnesota followed; then the urge to go farther west led to mining copper in Utah. The need for coal miners in Trinidad, Colorado,

had brought European immigrants to the foothills of the Rockies. Among the miners, there were relatives of Milosevich. After long working hours, friends would gather in the Dalmatian Bar to drink wine and sing Yugoslav folk songs. The familiar language and the traditions of his homeland provided the catalyst that influenced Milosevich to buy a farm and settle down. At the age of forty, he decided it was time to find a bride and raise a family. He heard from Ledenice that a girl who had been ten when he left the village was still unmarried. The preliminary courtship was conducted by mail. Zora Padjen, who arrived in New York with a tag printed Trinidad, Colorado, pinned to her coat and who, without even a rudimentary knowledge of English, traveled halfway over the United States, demonstrated the strength of character that would help her endure hardships and loneliness with uncomplaining optimism. Paul, the youngest of eight children, remembers his mother "as a sensitive, hardworking woman and very supportive" to all of her sons and daughters.

On growing up in the 1930s, the artist comments that money was always scarce:

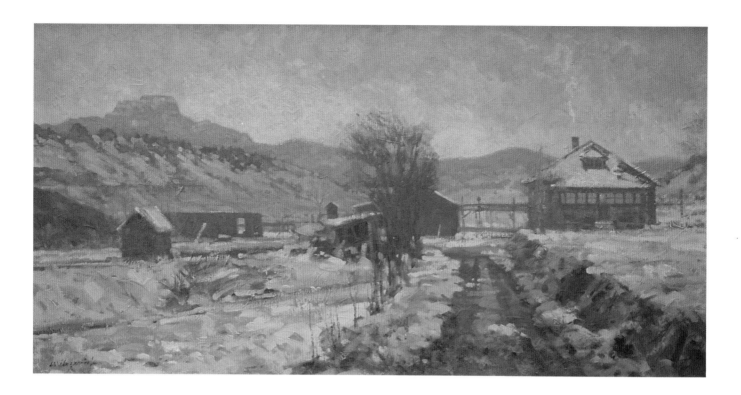

Homecoming

[It was necessary to practice] different ways to ask my Dad for a nickle to buy a pencil. At Christmas, we had no tree, and [we] wrapped [our] school books and exchanged them as make-believe presents. There was no electricity, no indoor bathroom, and the main source of heat was the kitchen stove. We did our homework by kerosene lamp light. . . . [Without TV,] our senses were bombarded by the sight of piled-up snow, the high mountain light coming in at the kitchen window and catching my mother rolling out pasta on the long table. The sounds we heard were magpies, meadowlarks, and nighthawks. The smells were pine trees, lilac bushes in the spring, and fresh-cut hay. . .When Dad's Model-T disappeared in the dust toward town, we had our play time.

Time for play was short. The Milosevich farm was a model of the farmsteads around Ledenice. Work during the summer began at sunrise and ended at sunset. The village women worked in the fields side by side with the men; therefore, Mrs. Milosevich was expected to help with the crops and with the harvest. Idle hands, hands stuck into pockets, or even hands engaged in what might be too trivial to be called work were regarded with suspicion. Paul recalls his mother's love of crocheting, but when her husband's Model-T came into sight, the crocheting was quickly put away in a drawer.

Matt Milosevich's Model-T was a familiar sight in Trinidad. One day the farmer was stopped by a rich Texan who offered to buy the antique auto. Milosevich shook his head and asked, "What would I do with the money?" Refusing to take no for an answer, the Texan pressed a blank check into the owner's hands and told him to fill it out for any amount he would accept. The check, still blank, was returned promptly to the Texan, and Milosevich drove away in his famous Ford.

When extra money was needed, a few dollars could always be expected from wine made after an old Yugoslav recipe. Juice was stomped from the grapes with feet encased in rubber boots. Even the barrels were homemade; Milosevich had spent some time as a cooper at Walter's Brewery in Trinidad. After the seasonal work among the grapevines and in the corn and alfalfa fields ended, there were sauerkraut and sausage to make. A daily task was caring for the pigs and cows. At milking time, there were always cats waiting in the barn for their supper.

Fortunately for the Milosevich boys, at the golf course located over the hill from the farm, fifty cents a day could be earned caddying. Paul observed, "The golf course and the farm, lying almost side by side, seemed centuries apart. My brother Vince and I spent as much time as possible on the golf course in the summers. That was our idea of 'the good life.' "

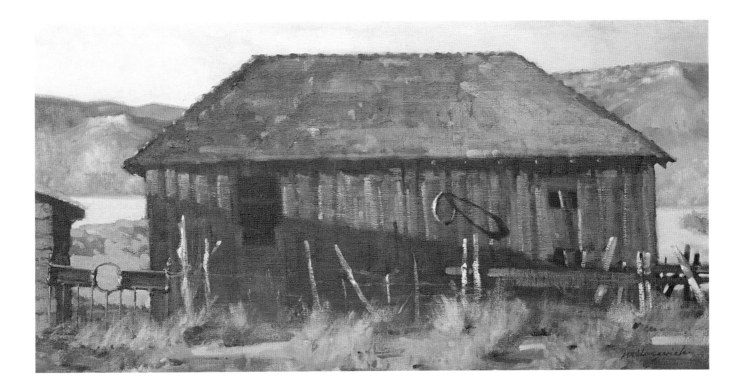

The Barn

In those early years, the good life did not include art instruction or even examples of "real art" to see. There were photographs of family members on the walls of the farm house. In elementary school and junior high, art was not taught, but Paul says, "I got to draw Christmas scenes on the blackboard, and I was generally known as the class artist. In high school, I did sketches of sports heroes, golfers, and popular singers." There was a radio station in Trinidad that employed a blind disk jockey; he gave equal time to country, western, Italian, and Spanish records. Mrs. Milosevich was especially fond of Hank Snow's songs. Popular magazines were another source of pleasure —*Collier's, American Magazine, Saturday Evening Post, Popular Science,* and *Popular Mechanics.* Among the illustrations, Giorgi's pretty girls and Norman Rockwell's Americana stimulated Paul's interest in drawing people and trying

his hand at portraiture. Evidences of this are preserved in a notebook with sketches of admired golfers.

In retrospect, there were other enduring influences at work. The painter has written:

Dramatic lighting, the four distinctive seasons, and a small-town way of life . . . have influenced my work. Walking around Trinidad [was] like taking a course in art appreciation. There [was] variety in line, shape, texture, color, value, and space; [in] trees, rocks, creeks, hills, mountains, [and] clouds. In the town itself there [was] an interesting mix of Hispanic, Anglo, and European types, all bathed in Colorado sunlight, and each one aware that looming above the town was Fisher's Peak.

The return to the mountain and to the landscapes of memory did not take shape on canvas until after Matt Milosevich died, in 1980, at the age of 96. Zora Milosevich's death followed a year later. Shortly afterwards, their son painted the snow-covered farm on which he had grown up: the house and barns bathed in a wintry blue light; the end of the cold months heralded by the brown spongy ground where the snow line stopped and by the puddles left as the ice thawed; and unchanged by the rotating year, the hazy blue of Fisher's Peak immobile against the sky.

Other Trinidad paintings from the early 1980s included a deserted barn caught in the glow of the late afternoon sun. During this period, the painter chose to limit his palette to cadmium orange, ultramarine blue, burnt sienna, and white. Instead of

inhibiting freedom, the limitation resulted in rich variations of warm browns laced with sunlit gold, tangerine, rose, and tawny ochres, which contrasted with the cooler blues that shifted from dark hues to icy white. A mood of twilight reverie is present also in an oil study of a cow shed. Every board and post seem to have been revisualized and the textures saturated with the sunrays of a winter afternoon. There is no evidence of reworking the painted surface, no laborious backpedaling to manipulate wash on wash; instead, brush loads of pigment have been stroked on, each adding to the construction as a whole. A watercolor of an old manger is equally frugal in its means. The negative and positive patterns formed by the wood are a reminder of the gingerbread carpentry outlining the eaves of frame houses in Colorado mining towns.

The cows that found shelter in the sheds and stable furnished another

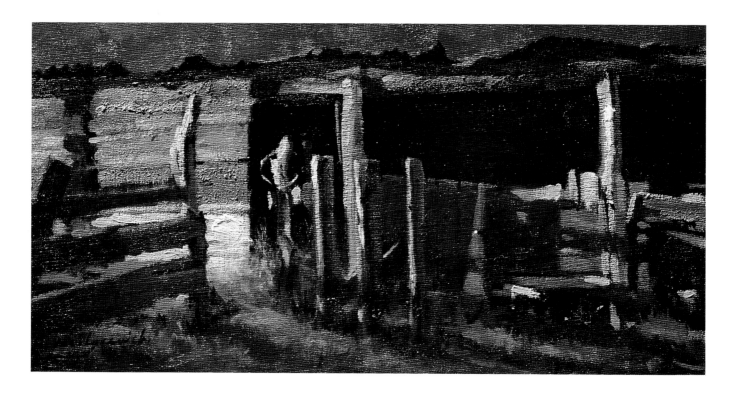

Cow Shed

Manger

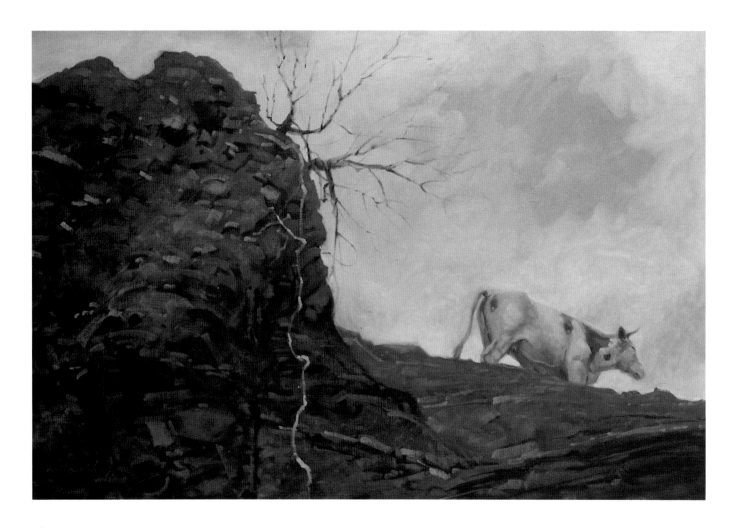

The Slate Bank

subject for painting. *The Slate Bank* reveals a dark mass on one side of the canvas with a gentler descent on the left along which a cow moves. The curving contour that divides the charcoal-colored cliff and the gray hillside from the light sky suggests the oriental yin and yang. The slate embankment on the Milosevich land was the place where the boys went to slide down the steep slope on fenders taken from cars that had been discarded at the dump. Paul says of his bovine subject, "The cow's name was Bessie. There was always a cow called Bessie in our dad's barn." Contrasting with the stark mono-chromatic values in *The Slate Bank*, there is another painting, in which a white-faced calf stands knee-deep in a tapestry of grasses covered with a dusting of yellow flowers.

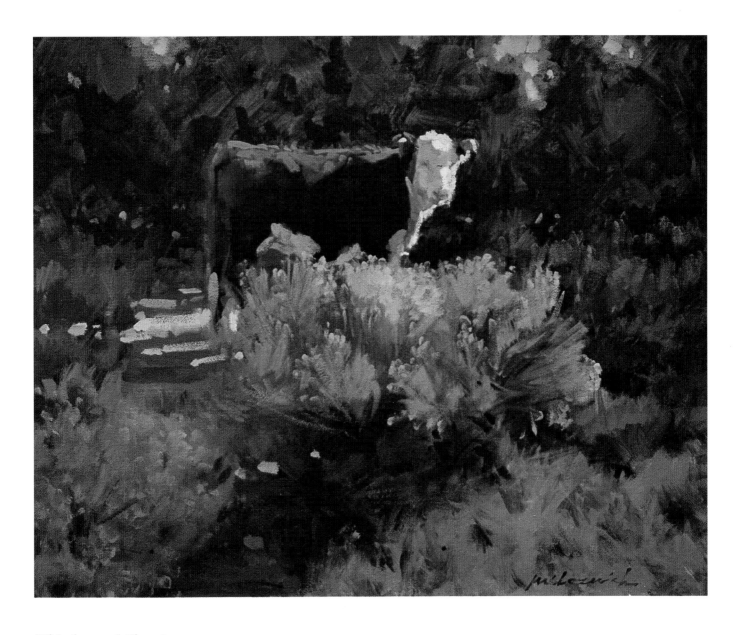

Whiteface and Chamisa

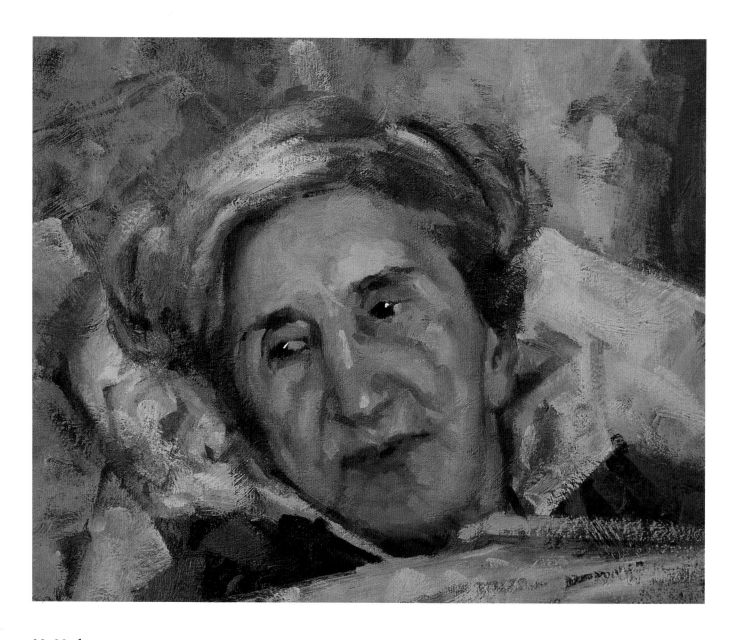

My Mother

The same limited palette of colors and the vigorous definition of brush strokes were used by the artist in portraits of his mother and father. The likenesses depended upon snapshots and Paul Milosevich's ability to give life and vitality to remembered images. Bedridden (as she was for several years), Zora Milosevich lies among pillows whose blue shadows activate the warmth of her face. Her eyes look away, but they gleam with sparks of life. The portrait of Matt Milosevich is a masterly canvas not only from the standpoint of a painterly tour de force, but because of the portrayal of a remarkable and implacable human being. The fea-

tures seem to have been carved from the impasto of paint. The patriarchal figure is as enduring as Fisher's Peak. He belongs to the earth and in the landscape. The following translation from the Spanish lines written by Frank Waters and quoted by Paul Milosevich are an epitaph for such men and women as Matt and Zora:

From the earth I was formed
The earth gives me food;
The earth has sustained me,
And finally the earth I will become.[1]

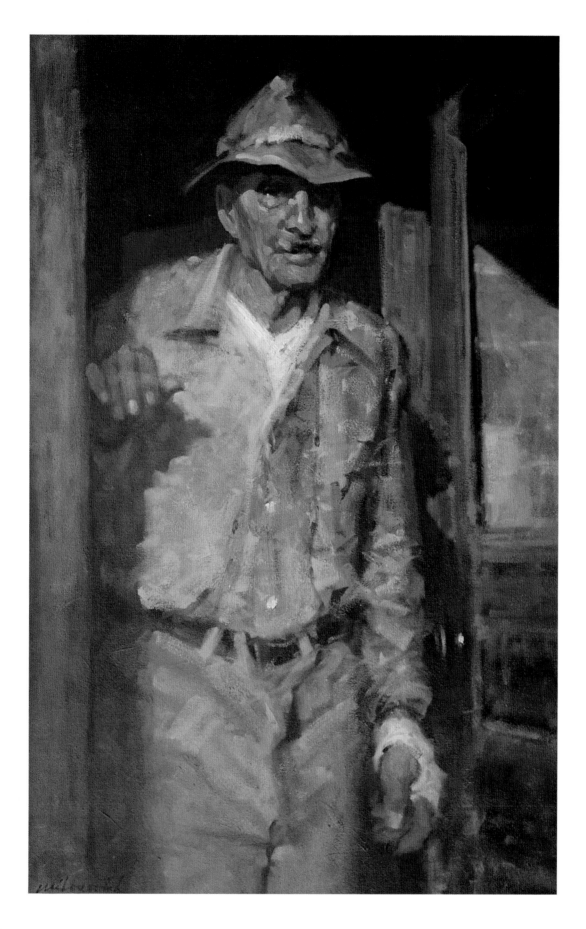

My Father

*Look there at the old house set
beneath the field steppes,
I was born there, and I knew I'd
never die.*

Vince Milosevich
"I Wonder As I'm Passing
Through My Homeland"

The Artist as a Young Man

I n summary of his post-high-school years, Paul Milosevich explains, "All of my older brothers and sisters moved to California after finishing high school, so I did, too, leaving our parents alone on the farm." This was a time for working at a variety of jobs and for taking classes at El Camino Junior College. Recently, the painter counted some of the jobs he has had at various times in his career. The list sounds like that counting rhyme familiar to children, "Rich man, poor man, beggar man, thief; doctor, lawyer, Indian chief." It begins: goat-milker, caddy, driving-range shagger, stock boy for Western Auto, file clerk, clerk-typist, stenographer, sewage plant attendant, fertilizer sacker, switchboard operator, prison-camp clerk, Montgomery Ward salesman, gas station attendant, shipping clerk, plumbing-supply clerk, truck driver, freight forwarder, wheat-harvest hand, United States Steel printing operator, janitor. The work ethic learned on the farm from Matt Milosevich must have helped to give value to each undertaking. At least "working one's way through college" was not an idle phrase in the artist's vocabulary.

At El Camino Junior College, one major followed another: liberal arts, dentistry, architecture, business. Golf was the culprit. As a player on the golf team, Paul was advised by the coach to take "easy courses, like business" that would not cut into practice and time off for tournament play. Trying to follow this advice, Paul chose an art class. "I took my first drawing class and I was 'hooked'," Milosevich admits.

In 1957, he made the move back to Trinidad, and his credits were transferred to Trinidad Junior College. This turned out to be a landmark decision. Arthur Roy Mitchell was teaching art classes at the college; a native of Trinidad, Mitchell had become a successful Western illustrator in New York before deciding to return to Colorado to teach and paint in his hometown. According to Milosevich, "Mitchell was the artistic catalyst I needed at that critical time, and I will be forever grateful that I was fortunate enough to work with him." At freshman orientation, Mitchell seemed to his potential student "the most interesting looking man on the Trinidad Junior College faculty. [He] was about seventy at the time, with a thick shock of white hair; [he] dressed in a mixture of khaki, plaid tie, and Stetson hat." Later, after enrollment, Milosevich

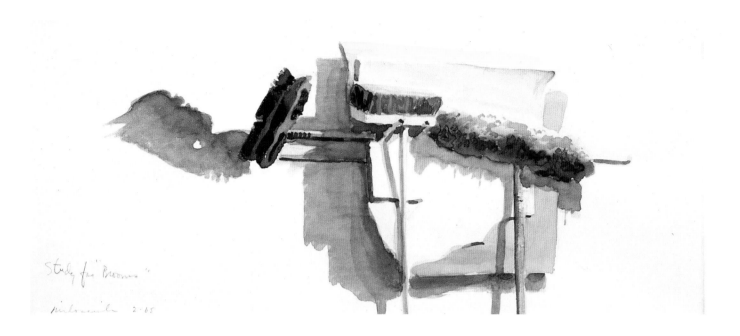

The Brooms

was introduced in Mitchell's class to some "original, professional paintings"; the art student said to himself, "This is for me." Mitchell had also a fine collection of the original paintings done for book illustrations by Harold Von Schmidt, Harvey Dunn, and Nick Eggenhofer, men he had known on the East Coast. The impact of these on young Milosevich was profound. "Von Schmidt's work just knocked me out," he recalls. Mitchell became for Paul a father figure. Both Matt Milosevich and Arthur Mitchell were rugged characters; each was determined, resolute, iron willed, taciturn. The elder Milosevich could not verbalize his pride in his son's accomplishments. When shown sketches, he responded grudgingly, "Well, you've got to do something to pass the time." Mitchell was the approving mentor who could give the pat on the back. High grades were awarded sparingly by the art teacher. On one occasion, however, Milosevich earned an A. He was told that this was only the second A that Mitchell had ever placed on a student's drawing. If it had been the Nobel Prize, it could not have seemed a higher honor. A remark of Mitchell's that the artist has never forgotten is the admonition, "Paint not only what you see, but what you know and think and feel about what you see."

In 1958, art classes were temporarily interrupted by a trip to Torrance, California, to marry Wanda Myers. The couple returned to Trinidad, and Paul resumed classes. Work at a gas station supported the continued education and the family. A daughter, Jena, was born in 1959. In the same year, Milosevich received an associate of art degree from Trinidad Junior College.

The next year marked the return to the West Coast. The painter decided to work for a bachelor's degree, with a major in art education, at Long Beach State College. Three years later, this was accomplished and a new goal was set—two years of further study that would result in a master's degree in drawing and painting. In retrospect, the five-year stint has a surrealistic quality. To support a growing family, which by 1963 included daughter Tanya, and to afford the continued education, Milosevich took a full-time job as a janitor. Working hours were from 10:00 p.m. to 6:00 a.m. Classes were scheduled throughout the mornings until two in the afternoons. On a good day, five hours of sleep were snatched between 4:00 p.m. and 9:00 p.m., then back to a hard night's labor. "I was twenty-nine years old when I finished college," Milosevich says, "and I felt like an old man."

Despite the difficulties, the janitorial years are characterized by two sparkling paintings that commemorate brushes and brooms with a sunny magic. The watercolor and oil were unmistakable signs of subjects that would attract the artist again and again. Simple, shopworn, overlooked and discarded objects that are humble and bypassed for the more obvious glitz of the advertising mystique are lifted from oblivion by the artist's pencil and brush. They are given the warmth and affection

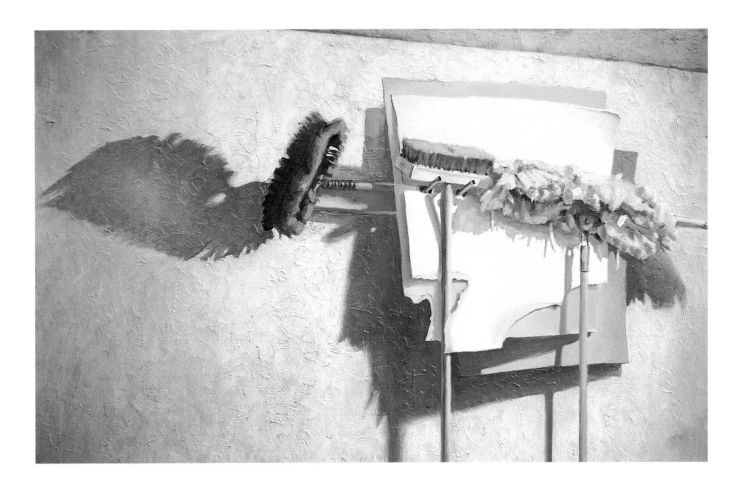

The Brooms

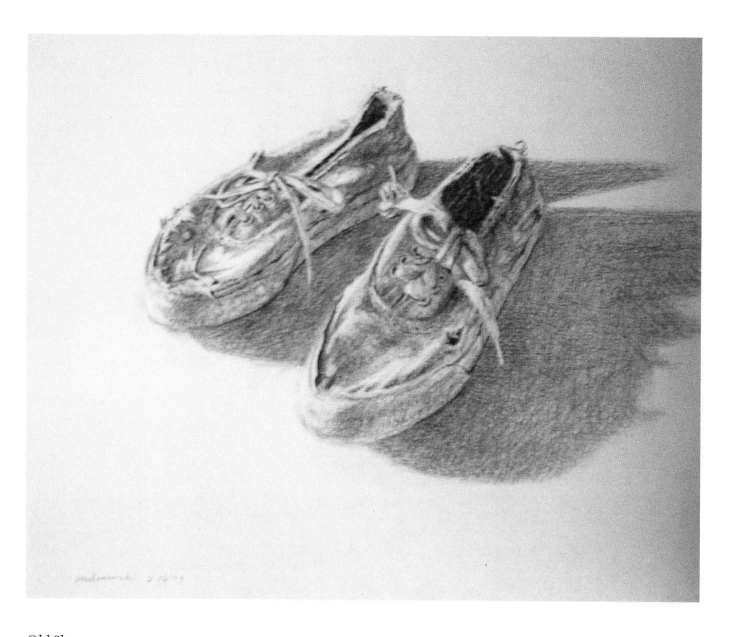

Old Shoes

reserved for old shoes and old friends.

Hard work and responsibilities did not destroy the pleasures of graduate study. A master's project that focused on realistic portrait painting was approved. This was remarkable in a decade consumed by enthusiasm for abstract expressionism. In most schools throughout the country, portrait and figure painting had been replaced by homage to Jackson Pollack's labyrinth of dribbles coiling in a calligraphic frenzy, to James Brook's upheaval of visceral forms, and to Willem de Kooning's ferocious assault launched in his studies entitled *Women*. Mark Rothko

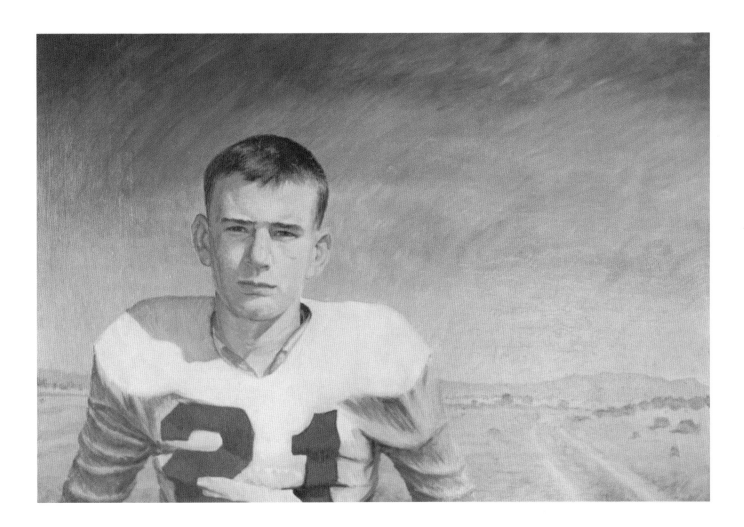

George

wrote, "The familiar identity of things has to be pulverized in order to destroy the finite associations with which our society increasingly enshrouds every aspect of our environment."[2]

Flying in the face of the avant-garde tastes, Milosevich was inspired by Rembrandt and the impressionist painters Manet and Degas, as well as by the twentieth-century artists Nicolai Fechin and Andrew Wyeth. Ten portraits were done as a part of his thesis. One of these is entitled *George*; an adolescent youngster in a football jersey stands before an empty landscape. Squinting slightly in the sun, the ballplayer conveys the ability to control not only the pigskin but also his place in the vast spaces with which he is surrounded. The limpid air overhung with gathering storm clouds is delicately textured by brushwork suggesting an affinity with Peter Hurd's style.

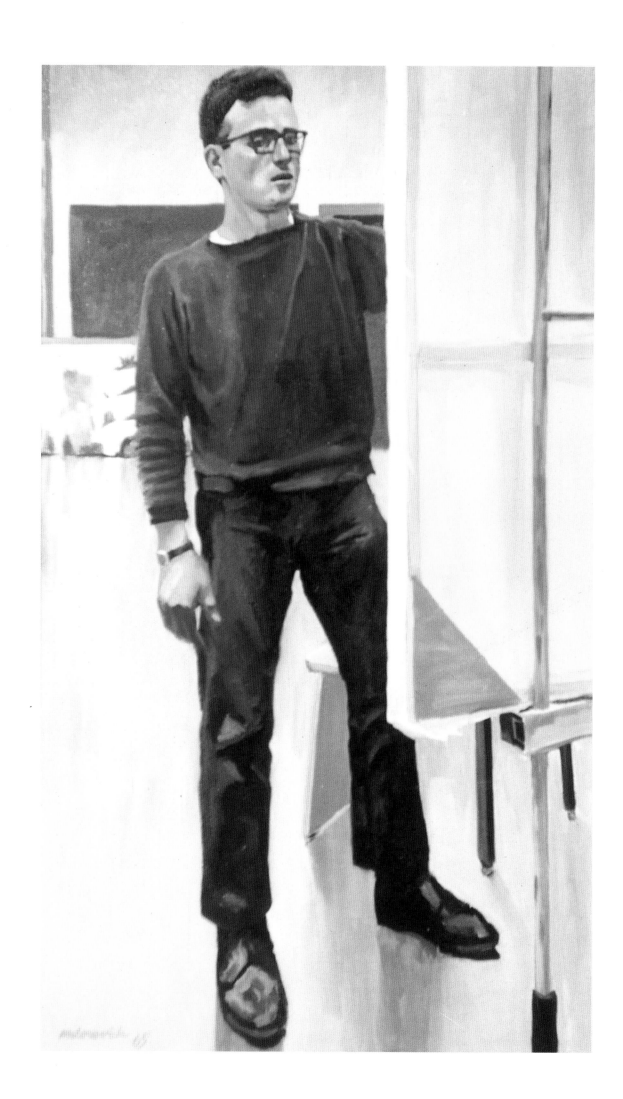

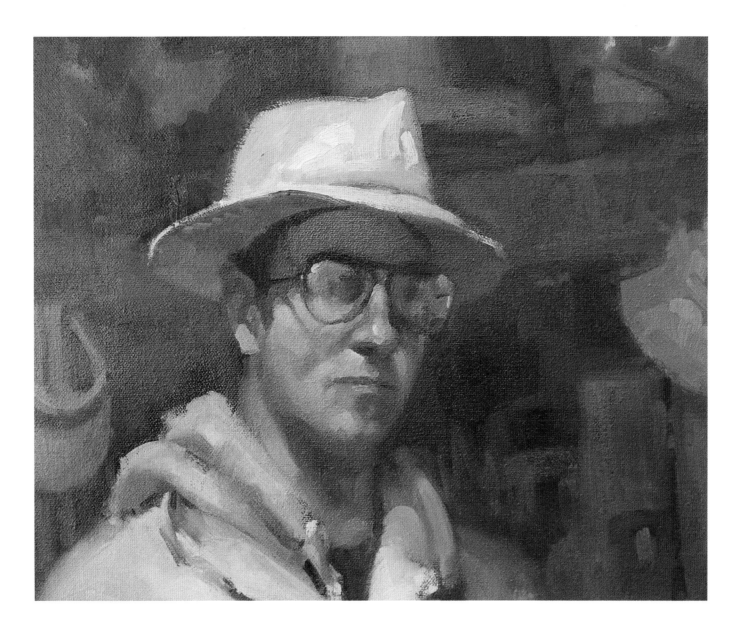

Self-Portrait

From the same period, there is a self-portrait in which the artist stands in front of an easel. The back of the canvas faces the viewer. The painter stands out solidly against a light background, a device that the artist explores fully in the years ahead.

The boyishness and self-confidence of the full-figure study create an interesting counterpoint to the sober mood dominating a self-portrait from the early 1980s. It belongs in the same general time frame as the likenesses of Matt and Zora Milosevich. The limited palette of three colors and white was chosen once again. The artist's forehead is shielded in the shadow cast by a

white hat; the eyes are further concealed by the blurred highlights reflected on the surface of a pair of glasses. The face is meditative; thoughts and feelings are hidden like a room behind drawn shades. The same hat that the elder Milosevich wore in his portrait hangs on the wall on the right. On the left, a golfing cap occupies a hook. The golf cap is part of the past, but it is also linked to the future.

The future was not to be anchored on the West Coast. Once more, opportunity drew the Milosevich family east, this time to Odessa on the High Plains of Texas and to a new venture—teaching art in college classes.

Self-Portrait (left)

Way out in Western Texas, where
the Clear Fork's waters flow
 Larry Chittendon
"The Cowboys' Christmas Ball"

Odessa, Texas

I n retrospect, "August of 1965 was memorable," Milosevich reminisces. "One week I was a janitor making $300 a month, working 10:00 p.m. to 6:00 a.m. The next week I was an art instructor at Odessa College, earning $600 a month, working roughly [from] 9:00 a.m. to 4:00 p.m. The free time and extra money were amazing."

It seems likely that the discovery of West Texas was equally amazing. The artist's migration left behind the ocean, the California haze hanging over the hills. The foothills of the Rockies and the blue mass of Fisher's Peak had no counterpart in the Texas flatlands stretching as far as the eye can see. West Texas is a land of harsh light and heat. In the words of "Hell in Texas," a cowboy complaint, "The heat in the summer is a hundred and ten, / Too hot for the Devil and too hot for men."[3] The sun bakes the fields, occasionally drawing from the ground a shimmering mirage. Irrigation pumps send streams of water between the plowed furrows; in the late summer, the fields are quilted with a white cotton patchwork. There are no boundaries, just infinite space. At the rim of the earth, ground and sky merge, leaving no trace of where one ends and the other begins. Crisscrossing at right angles, the flatness is divided symmetrically by straight roads. In one of his ballads, Butch Hancock sings, "You can drive all day and never leave Texas." This is the landscape of David Byrne's *True Stories* and the myth told in the movie script about the origin of Texas and Texans:

God had been working on the Earth [in Texas]. . .when it got dark He had to quit. "In the morning," He said, "I'll come back and make it pretty like the rest of the world, with lakes and streams and mountains and trees." But when God came back the next morning, He discovered that the land had hardened like concrete overnight! Not wanting to have to start all over again, in His infinite wisdom He had an idea, "I'll make some people who like it this way."[4]

And He did, and those folks learned to endure wind and dust storms and a country where there are no trees or houses for miles until, suddenly, the sky is pierced by the circling blades of a windmill or a piece of farm machinery towers like some forgotten dinosaur. Down near Odessa, an oil rig may appear darkly silhouetted in the daylight and lighted like a Christmas tree at

night. Oil pumps, bobbing up and down like giant crows in a cornfield, fill acres with their creaking.

The perception of the South Plains depends not only upon sound and sight, but on particular smells that identify the region. The smell of oil saturates the air in the Permian Basin. In the fall, farther north close to Hale Center and New Deal, there is the acrid odor of burning cotton burrs. From the pits close to the gins, lazy plumes of smoke drift horizontally across the roads. A cotton farmer may look at a complaining newcomer with pity and explain that the offense to the nostrils is nothing but the smell of "greenbacks."

In West Texas, the sky is the landscape, filled with shifting cloud patterns and red and gold sunsets slipping into violet and deep purple. The weather is the news. Eyes scan the sky for the predicted blue norther rolling across the prairies from Canada; dark clouds are scanned for the rain that may be falling in a curtain of gray ten miles down the highway, stubbornly refusing to move or spread. Dark, leaden cloud banks are watched for the sign of a funnel dropping toward the earth

with the ability to carry in its path blocks of a city or to throw barns and farmhouses around like a shake of the dice.

The pioneers migrating to the South Plains were survivors; their characters were formed by standing firm against undependable nature, rains that never came, the dust bowl, tornadoes. The people that Paul Milosevich found in Odessa were not so different from the self-reliant immigrant farmers and coal miners he had known in Trinidad. From the Odessa years, the double portrait of the parents of Paul's sister-in-law, *Los Samoras* reveals the same no-frills, true-grit reality that is etched on the faces of West Texas farmers and their wives, cowhands, and oil field workers. Done in acrylic from a black-and-white snapshot, the artist eliminated the idea of color and maintained the stark realism of light and dark passages enhanced by the boldly contrasting textures in the woman's blouse and the curtain behind the figure of the man. Milosevich associates the flat black of the skirt worn by Mrs. Samora with his observations of Manet's paintings—for example, the black gown of the woman tending the bar at the Folies-Bergère. The black skirt in *Los Samoras* becomes a foil for the study of the work-roughened hands of the wife. The white border suggests that of the photograph from which the painter was working and underscores the faithfulness to the camera study.

The camera has been a tool of artists since the second half of the nineteenth century. In the last fifty years of the twentieth century, Polaroid prints have become the modern

equivalent of the sketch pads carried for out-of-doors notations and to record impressions of exotic lands to which artists traveled. Notes made on the spot with ink, pencil, or watercolor were employed as useful details to jog the memory when a major oil painting was initiated back in the studio. Today, Polaroid shots examining a subject from many angles have been substituted for the earlier practice of sketching at the site. Milosevich, in pursuing landscape paintings or portraits, may work from nature or from live models; on the other hand, it may be necessary to rely upon snapshots or Polaroid photos.

Milosevich has no illusions, however, concerning the role of the photographic portrait versus a portrait painting. On this subject, he is quoted at length by Michael Ventura in the catalogue for the 1985 exhibition The Santa Fe Change, at The Museum, Texas Tech University:

I like to do portraits. I'll always do them. Of course there are fantastic cameras and photographers, but a painted portrait is a different kind of activity. For one thing, a photographic portrait is a split-second recording. A painted portrait takes hours to do. And if it's done from the person actually sitting there, it's like a three-hour to ten-hour recording of this person—and ten hours of the artist's life that was spent doing this. And the physical properties of paint, plus everything that the artist brings into it, plus what kind of responses the subject triggered in the artist. And sometimes you can look at a painted portrait and sense the hours that went by. You don't get that in a photograph. . . . Even when you're doing a portrait from a photograph, the hours you spend concentrating on that person will show.[5]

It was in Odessa that Milosevich introduced a new subject for

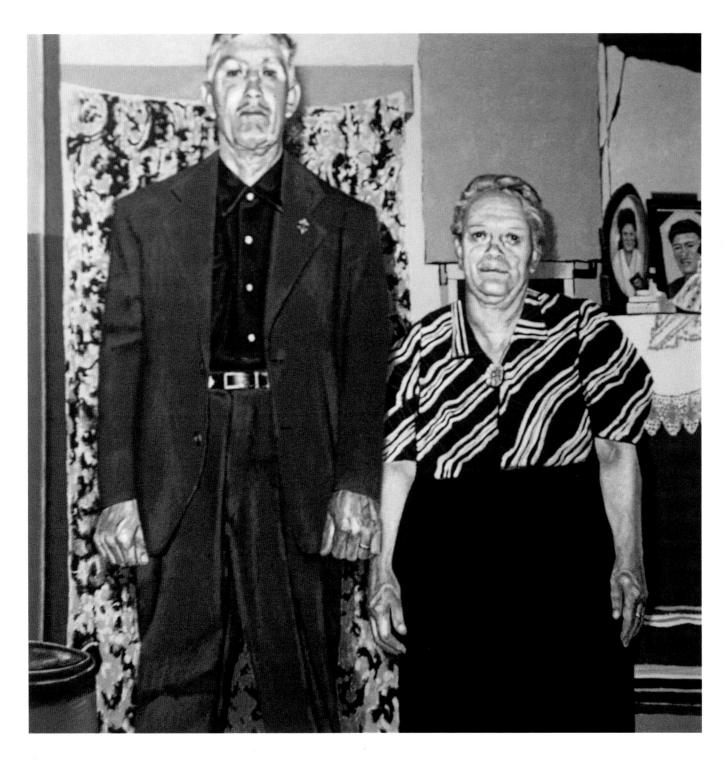

Los Samoras

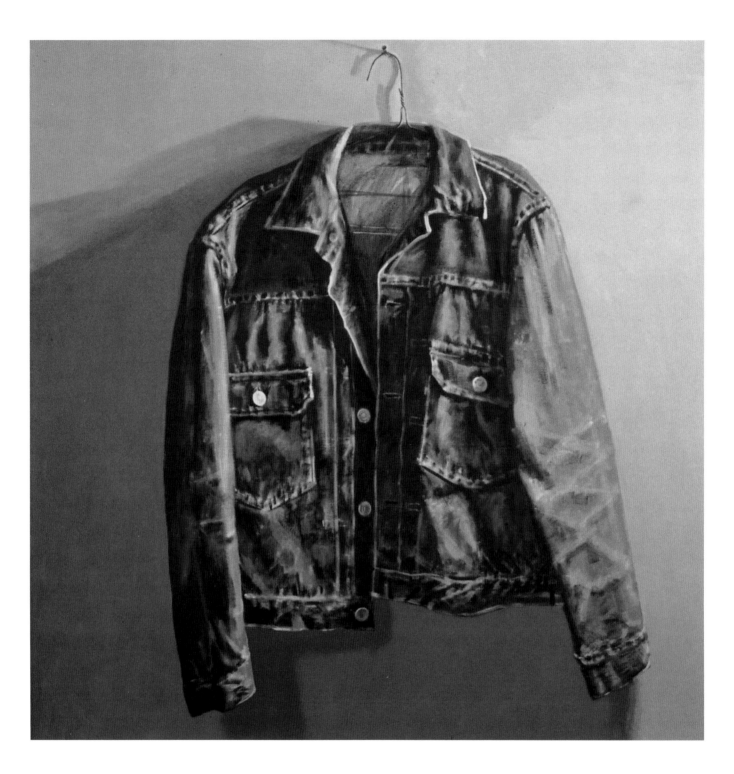

Levi Jacket

Ramon Barela (right)

portraiture—a Levi jacket. The denim that has been molded to its owner's contours by long wear waits on a hanger to be fleshed out again. It occupies space, casts shadows, and has an identity that dominates the canvas. It is an example of trompe l'oeil, West Texas style. In the 1960s, the Levi trademark was synonymous with roughnecks, cowboys, farmers, and country and western singers. Levis were the chosen hippy uni-

form. Calvin Klein, Ralph Lauren, rhinestone cowboys, and designer jeans were still in the future.

Denim jeans, boots, and a slouched jacket, topped by a high-crowned black felt hat were a proper costume for a young Hispanic art student at Odessa College painted by Milosevich. The standing figure of Ramon Barela is placed against a flat white ground. It presents the fully

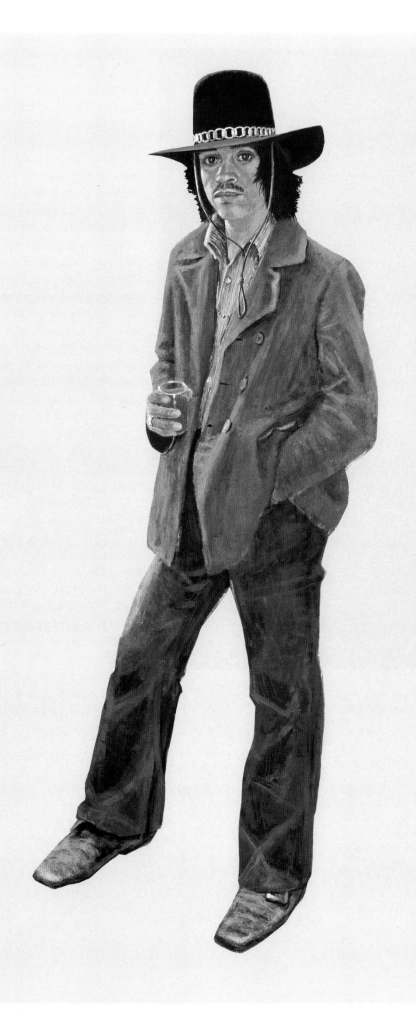

Highway

developed concept experimented with in *Self-Portrait of the Artist* (see p. 18) in which the painter placed himself behind his easel, emphasizing the solid figure by the light tones of the background. The interest in the use of a flat white or off-white ground was suggested to Milosevich by paintings he had seen in a New York gallery and by Manet's dramatic study of a youthful *Fifer*.

Barela's large, dark eyes look out candidly at the observer. His face is thoughtful and unflinching, possibly curious, but the expression is neither judgmental nor arrogant. The pose is easy; one hand is slipped in a pocket, the other holds a wine glass. Every detail of clothing, every wrinkle and shadow is delineated with care and a keen interest in representing contrasts in fabrics. The contour lines are varied, avoiding any hint of dullness. The smooth lines of the crown and brim of the hat are contrasted with the "staccato" accents of the wisps of Barela's black hair. In the underpainting, the artist drew the figure with fluid brushstrokes of green pigment and then flowing red lines. These colors were not entirely covered when the blue-gray tones of the jeans were added. The linear accents of red and other colors contribute a lively animation to the finished work.

At Odessa, drawing and painting were of necessity combined with teaching duties. In this new pursuit, Milosevich discovered unexpected

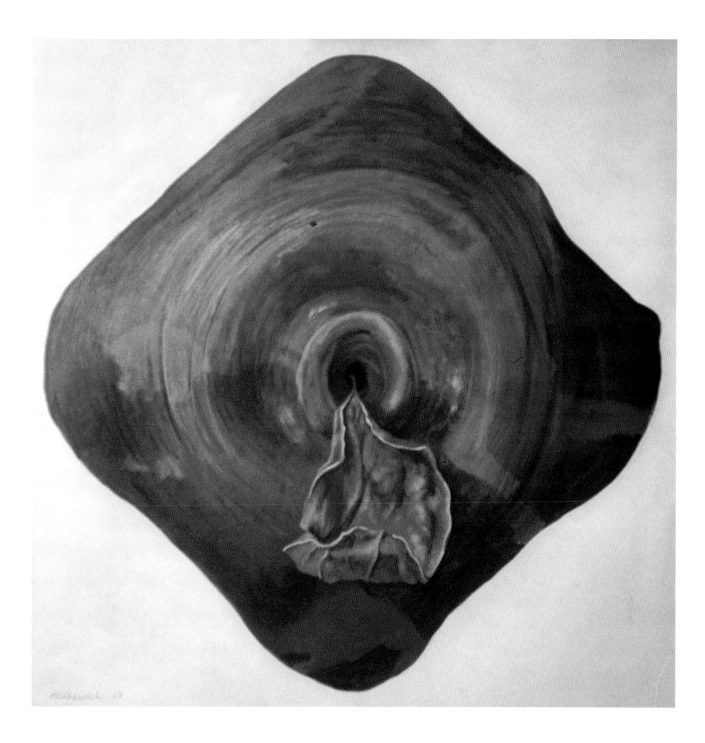

Pot and Leaf

values. He explains, "Teaching unfamiliar classes brought the opportunity to appreciate art movements and characteristics from cave paintings to modern times. Some of the ideas [which were a part of art appreciation courses] I was able to digest and weave into my work. I began to combine abstraction and realism into some kind of traditional/contemporary unity. Sometimes the results were very self-conscious and 'staged' but on rare occasions, the pieces seemed to come together naturally."

The intersecting highways and fields suggest the abstract quality of the landscape—the orthogonal sections broken by the curvilinear playas when seen from an airplane flying high above the ground. Another handsome semi-abstraction is a painting of a piece of pottery and a dried leaf painted on a white square canvas. It is painted as if viewed from an aerial vantage point.

Adopting a mandala-like design, diminishing coils move inward from the outer square of clay to the circular neck of the pot and the dark opening where the leaf uncurls.

During the five years at Odessa College, the artist was promoted from instructor to chairman of the Art Department. Despite the successful experiences of teaching and painting, the years are referred to by Milosevich as "an emotional roller-coaster ride." Personal problems ended in a divorce. Affection for the children—now three daughters with Karla's birth in 1965—and love of art were the steadying influences. There are many sketches in charcoal, ink, and Conté crayon of the little girls. Paul's canvas *Front Door* with its open door looking out into the sunlight seems to be a symbol of new opportunities lying ahead and the closing of one chapter in the developing career of the artist.

Karla (above)

Jena (left)

Tanya (below)

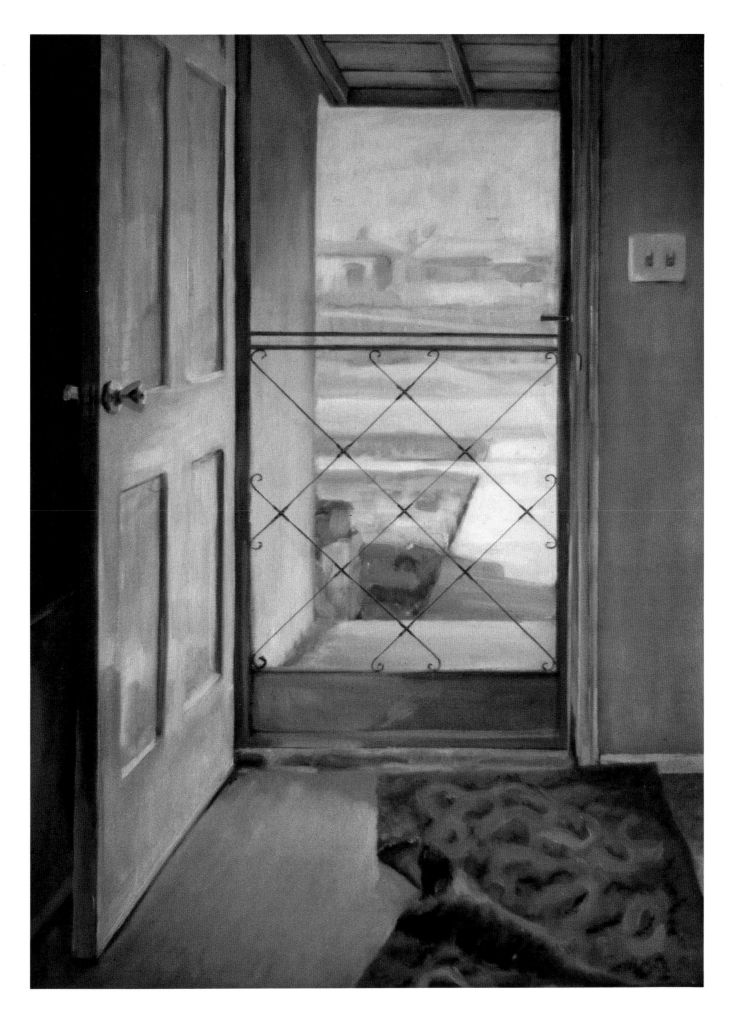

Front Door

Yugoslavia

Koliko ljubav če trajati to samo more zna
(How long a love will last only the sea knows)

from a song popular in Yugoslavia in 1968

During the years of migration and transition from Odessa to Lubbock, Milosevich made two trips to Europe and Yugoslavia. The first trip, in 1968, was also the artist's introduction to air travel. The second trip occurred in 1971. The time spent in his parents' native land was prompted by an attempt to find a fresh perspective, as the painter acknowledges, "on my marriage and on myself." A Yugoslav uncle, Branko, reinforced the wisdom of this action with the folk saying, "It is important to put your mind out to pasture from time to time."

When Paul's mother learned of her son's decision, she was apprehensive about the journey. She had heard that there had been recent violence in Ledenice. A family feud had erupted. One participant, after a round of drinking, decided to throw rocks through a neighbor's window. He was warned by the owner of the house that if this happened again he would be a dead man. It did and he was. Matt Milosevich was less worried. His close relatives were no longer living, but he was pleased, in his taciturn way, by his son's desire to search for roots in Yugoslavia.

At Ledenice, the kinsman from across the Atlantic was greeted with enthusiasm. The little town appeared to have been forgotten by time. There was one cistern in the center of the village to which children would come each morning with their donkeys. The donkeys carried wooden barrels strapped on their sides; these were filled at the well with the water supply for the day. A market supplied fruit and vegetables, together with chickens and eggs. A wry political joke was the observation that politicians were as much alike as eggs in a basket. Only one person in Ledenice owned a car, so traffic proceeded uninterrupted by honking horns.

During the summer, workers were out early in the morning cutting wide swaths of alfalfa with scythes just as it had been done for centuries. The men mowed while women raked the hay. Communal work in the fields provided opportunities for talk and gossip. It did not take long to discover that stories were repeated without regard for the excellent acoustics present in valleys surrounded by hills. Anyone for acres around could hear accounts of the beating Marko gave his wife or the way Ljubo cheated at cards.

To villagers, owning a cow was very fortunate. The youngsters were assigned the chore of watching over the grazing cattle, as well as the

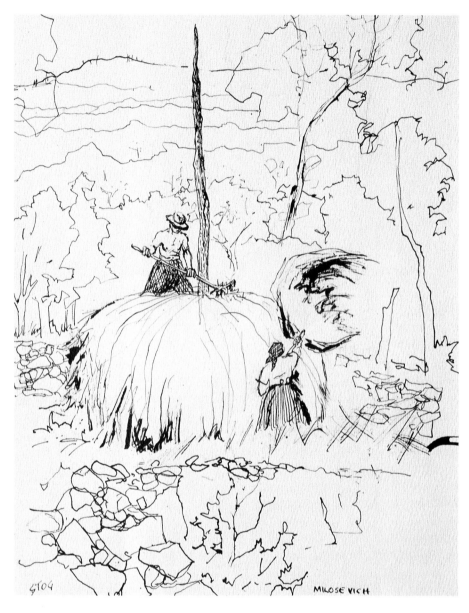

Haystackers

sheep and goats. The family cow was not stabled in a barn away from the house; instead, the barn adjoined the living quarters. Milosevich was given the bedroom next to the space where the cow was kept. Throughout the night, there was the aroma of fresh hay and the soothing sound of the animal breathing.

Most families had small vineyards. The homemade wine was stored in cellars and served in straw-covered bottles. At festivals where food and wine were in abundance, everyone wore traditional clothing. On such occasions, gypsy singers were popular; the painter saw one gypsy wagon with a small brown bear plodding along behind. Following tradition, the Romany people made and sold copperware and woven baskets. Their nomadic existence had changed only to the extent that they were beginning to agitate for land and for a capital city.

On both trips, Milosevich kept diaries illustrated with drawings. Larger sketch pads were filled with quick notations in pen or pencil and with watercolors. The drawings are lively, informative glimpses of everyday life: workers pitchforking hay into a stack, a cowherd taking a break in a roadside bar, the textured

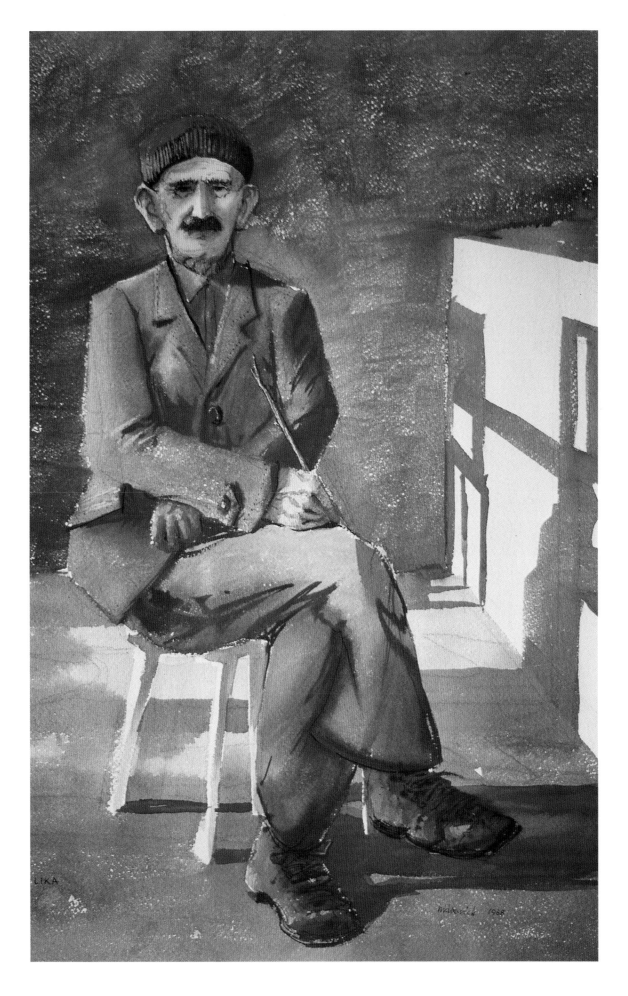

Cowherd

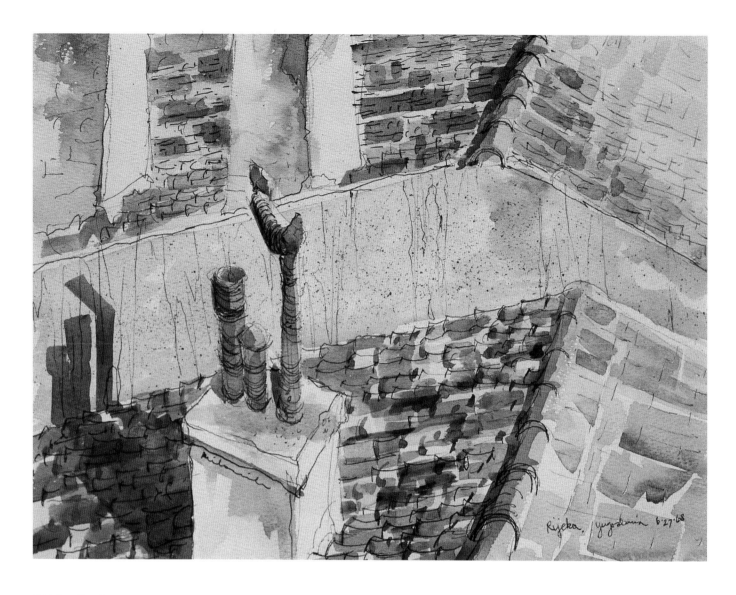

Rijeka Rooftops

details of old houses, the rear end of a small donkey so heavily loaded that his body seems to disappear (p. 36). Relatives are more keenly described by a few strokes of a pencil than with a camera (p. 36). There are sketches of seashells (p. 36) and an oil of the blue Adriatic (p. 37). Another watercolor captures the ancient walls and towers surrounding a city (p. 38). The artist observed, "[Through the sketches] I experienced an emotional tie with the creative traditions of my parents' home."

In the summer of 1971, the year in which the move to Lubbock took place, a second trip to Yugoslavia was brought about by an invitation asking the artist to exhibit his work in a Dutch Gallery at Valkenburg. This provided the chance to see

Clothes Drying in a Window

Water Bearer

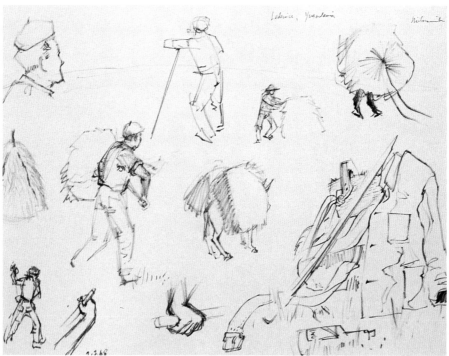

Field Sketches

Rembrandt's paintings in the Rijks-museum and to observe at first hand Frans Hals's slashing brushwork and lushly applied colors.

From Holland, the route stretched south to Greece and a pilgrimage to the top of the Acropolis at Athens. Reaching Yugoslavia, the artist found an international folk-dancing festival in progress in Zagreb. Dancers from all over Yugoslavia participated (p. 39). The dancers from other countries included a group of Canadian Sioux Indians resplendent in feathers and beads. While in the city, Milosevich visited the Academy of Art. He was greeted warmly by the director, who invited him into his office. When both men were seated, the director reached into his desk and pulled out a bottle of plum brandy. Talk about an exchange program for their students was punctuated by refilled glasses.

There were family members living not far from Zagreb. As their guest, the painter was taken by his uncle to see the family vineyard and wine cellar. After sampling a bottle, uncle and nephew tramped off across the

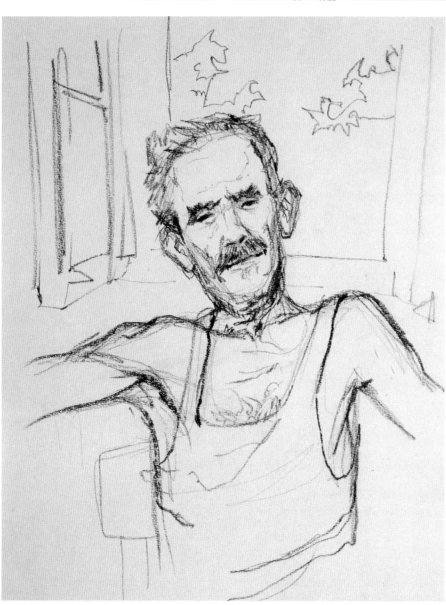

Pere

fields to visit a neighbor's cellar and try another vintage offered with homemade cheese. One of the most vivid encounters along the way was the sight of women dressed in black, riding sidesaddle on little gray donkeys that were referred to affectionately as Yugoslav Volkswagons.

From the standpoint of dependability, donkeys may have had a higher rating than a Yugoslav bus. In retrospect, the American was amused by a bus trip. Tickets were acquired hours before the bus bumbled into view. There was a mad scramble for seats (each place had been sold to several travelers).

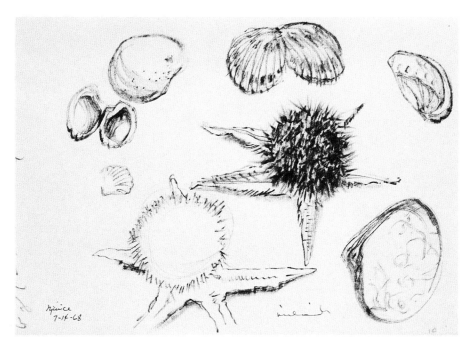

Seashells

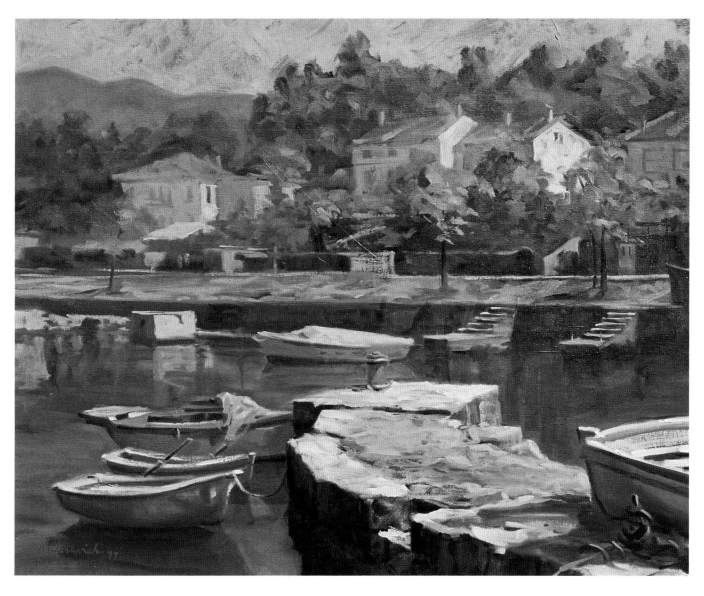

Uncle Branko's Boat

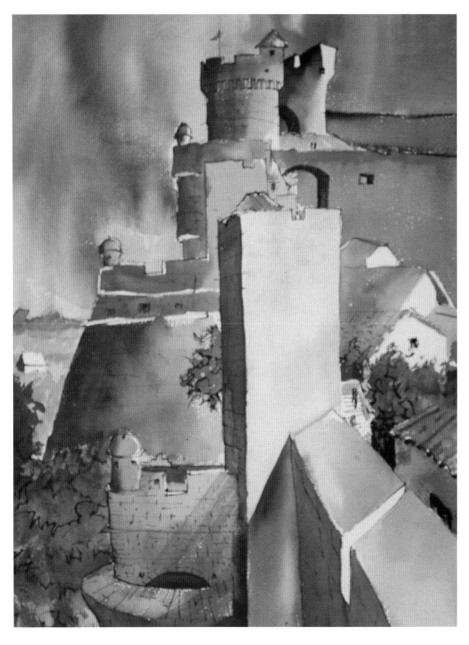

Old Wall, Dubrovnik

Squawking chickens and bleating goats added to the pandemonium. Some people were loaded without their luggage; others watched their bags disappear down the road, while they were left standing in a cloud of dust. Before many miles had crawled by, angry voices were causing a diversion in the back of the bus. The ticket taker crawled over obstacles to investigate. A foul smell was offending the human cargo packed in like beans in a bag. The odor was traced to a man concealing a very ripe cheese in his shirt. Once the cheese was disposed of, out came a can of room freshener (Johnson's Glade, according to Milosevich); this was sprayed over both air and passengers. Good humor having been restored, wine bottles were passed around with equal portions going to the driver. Careening past wrecked cars along the roadside, the bus by some special dispensation was guided to its destination without noticeable loss of life or limb.

Entertained by such happenings and surrounded by family affection and hospitality, the artist found what he calls "mighty good medicine."

In answer to the question, "How did the months in Yugoslavia affect your art?" Milosevich replies that there was the opportunity to become familiar with the work of a twentieth-century Yugoslav sculptor, Ivan Mestrovic, whom he admires, but he explains:

The thing that impressed me most was the art of the primitive naive painters. Subconsciously, their integrity and directness are based not on preconceived ideas of what should be done; it is enough to put down what "is seen" in every detail. The Zagreb Museum is dedicated to these native folk artists. After looking at the rich textures and intricate designs, when I came out of the gallery into the sun, I could see every leaf on every tree. Everything seemed crystal clear. The world looked like it had just been washed.

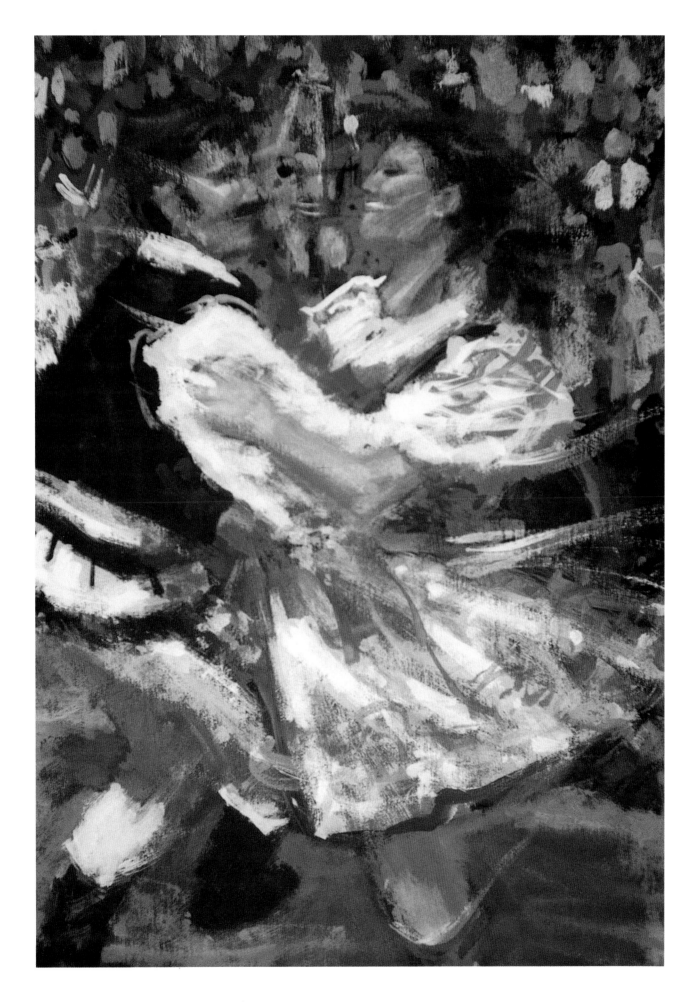

Yugoslav Folk Dancers

Lubbock, Texas

ccording to Paul Milosevich, "The adjustment from Odessa to Lubbock was not difficult. Lubbock [was] like an oversized version of Odessa." He recalls his impressions of the transition:

I thought, in 1970, [when] I was offered a position in the Art Department at Texas Tech University that this was the "big time"—a professorship at a major university. I recalled that eleven years earlier, in 1959, the wheat harvesting crew that I was working with had driven by Texas Tech, and I had gazed longingly at the beautiful campus.

. .

Exposure to the Texas Tech Art Department was another growing experience. Comparing my work to the work of other faculty members and students gave rise to questions like, "How does my work stack up with theirs?. . . Is what I'm doing valid or relevant to what's going on here and at other art centers—[on] the East and West Coasts?" Gradually, I decided to stop comparing my work with others and to use my personal development as a yardstick. Diego Rivera once said, "The more personal the art, the more universal it becomes." An artist's work is rele-

vant to his life and time to the degree that it is a personal vision. I came to believe that an artist is someone who has something to say—and finds a way to say it.

Lubbock breeds artists with unique visions. Picturesque, in a traditional sense, Lubbock is not; nor is it ringed with snow-capped mountains and waves breaking on white beaches. The sand is an accumulation of khaki-colored dust caught by the winds and dropped over the landscape or ruffled into brown dunes across the bare fields. But except for those dusty days in spring, Lubbock is blessed with a rare clarity of light that gives visibility to the land for miles in every direction.

Fortunately, Milosevich possessed the right philosophy for a West Texan. He said in an interview in the mid-seventies, "You don't have to go to the Grand Canyon to find something to paint; all you have to do is step out your own door." Turning to his studio window, which framed a clothesline hung with the family wash, he said that he intended to do a series of paintings using his own backyard or porch as subjects. The sun-streaked afternoon underscored

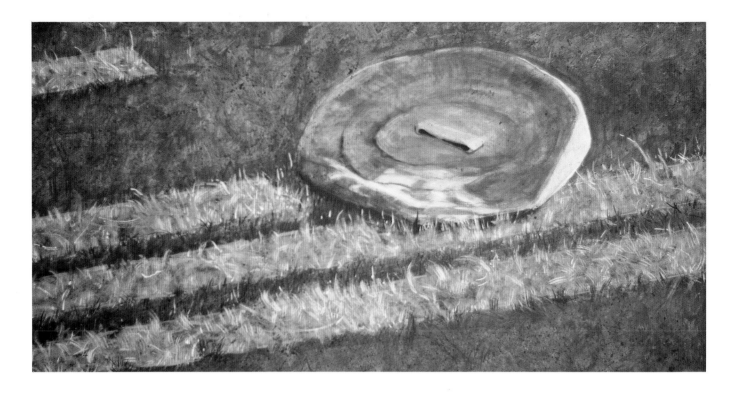

Lid

the power of light to transform ordinary objects with a Midas touch. Milosevich's painting *Lid* pictures the battered top of a trash can pinning down bars of sunlight that slip through missing boards in the fence. The cool colors of the lid are given resonance by the warmth of brown grass and by the yellow bands of sunshine that pick out flecks of red and orange on the dry lawn.

In a painting of a three-colored cat answering to the name of Aunt Sister, gray shadows with warm edges build abstract patterns like those found in Japanese woodcuts. Attention is focused on the circle of the red bowl. The asymmetrical composition depends upon a mop with a red handle and a dustpan hanging in the upper left corner. This is a painting in which all of the elements— texture, color, light, and shade— converge to achieve a simplicity that yet, paradoxically, is disarmingly complex and sophisticated.

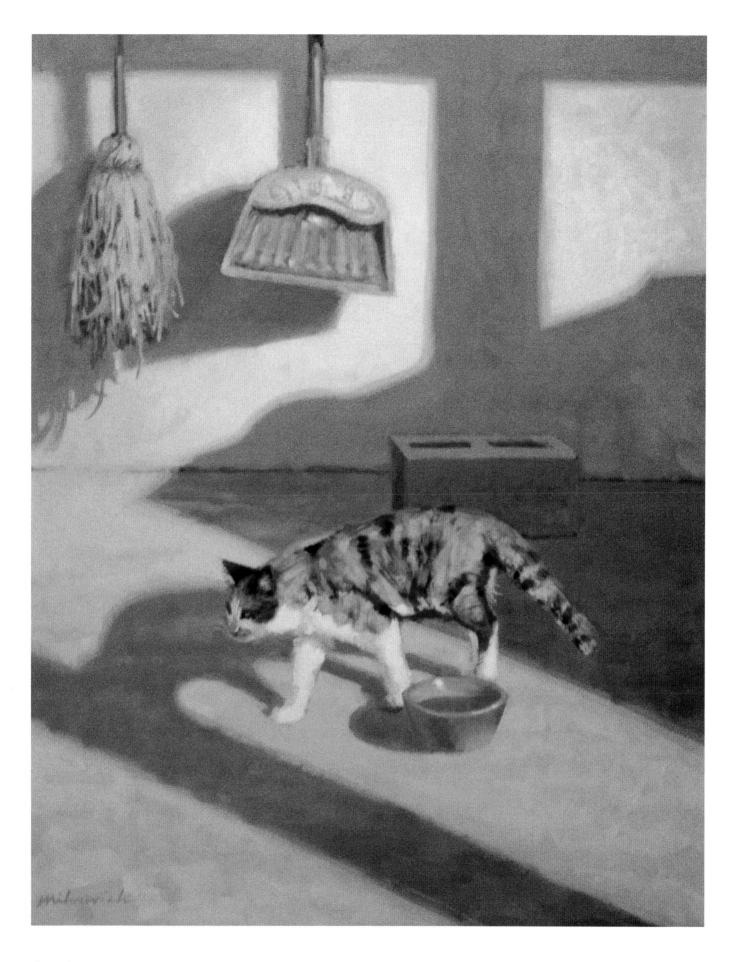

Aunt Sister

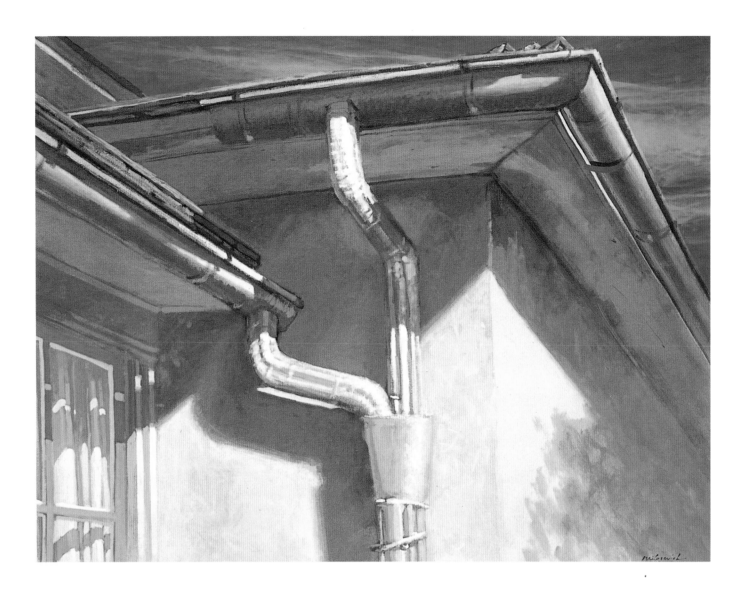

House Corner

Karla in the Snow (right)

The artist maintains, "Light can create mood in a painting, just like it can on the stage. By the way you use light, you can express...emotions which basically tell the way you feel about life." Tranquility and peace radiate from the pale yellow walls and blue shadows of *House Corner*. This is a return to the Milosevich farm. Instead of the snow and chill of a winter evening, late spring spreads over the roof eaves and gutter spouts. There is magic in the blue window enframement and in the shifting shadows of leaves that cast a wavering blue mark on the wall. In contrast to the sun warming the lemon-colored paint of the farmhouse, another Trinidad canvas discloses little Karla wrapped snugly in her sister's coat. She sits like a small Buddha on the ice-blue snow. In the upper part of the long rectangular picture plane, shadows cast by the grape treillage hint at protection for the woolly bundle.

In a painting of Jena in the backyard (p. 46), warm and cool colors are used like builder's blocks to construct masses that are architectonic in their solidity. The device is repeated in the flesh-colored light passages and blue-gray shadows that shape the child's face with the same regard for structural integrity as a sculptor would impose on clay or stone.

Although light is present everywhere, Milosevich believes that West Texas light is different. The High Plains are the right place for artists who feel strongly about the intensity of the sun beating down on flat emptiness. If the light that

Jena

scours the Llano Estacado, as the Spanish called the land, is one of the essential features, there is another characteristic that is just as important. This is the strength and endurance of the people who inhabit the region. It is the sort of character that speaks of a "hard" country and of survivors. George Hancock's book *Go-Devils, Flies, and Blackeyed Peas* is a view of the *real* past by one who was there. The author has a

good many words to say about dust storms: "Some of them [sandstorms] were pretty bad, but if the wind didn't blow at all, the windmills didn't turn and the milk trough didn't perform. So maybe that's the reason West Texans are not bothered by the wind. Do you know how to tell a West Texan by watching him eat? He never completely empties his glass, whether it's milk, water, or hard drink, Maybe the sand in the

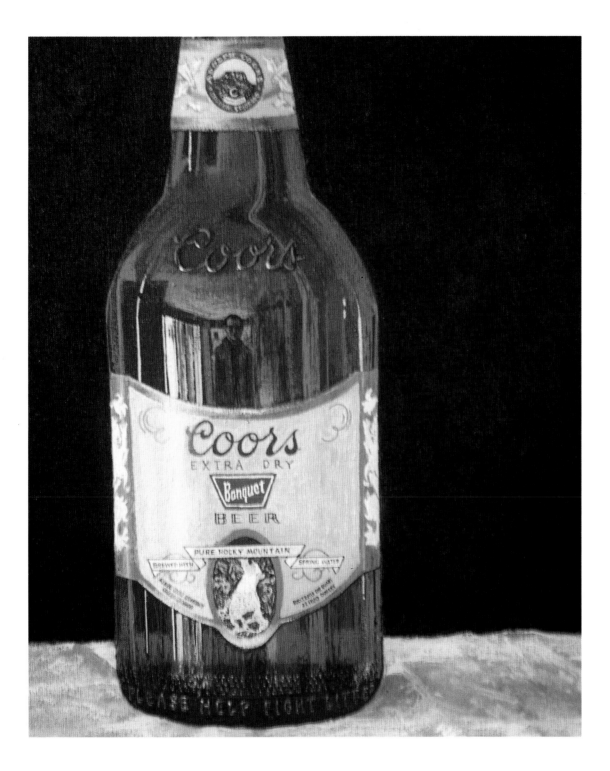

Coors Bottle

bottom?"[6] Maybe that's why Texans prefer "long-neck" beer bottles? Whatever the case, Milosevich painted a self-portrait reflected on the side of a bottle of Coors—an example of "seeing in a glass darkly"? There is no seeing in a black sandstorm. Hancock wrote of one of those trials of nature that he saw blow out of the west at two o'clock one afternoon: "It was black as ink. It looked like it was a mile

Aunt Hatie

high, but it wasn't moving too fast. A flock of crows was flying ahead of it trying to find a shelter, and they were really taking on. We lighted lamps for at least an hour."[7]

These were the days that produced faces filled with true grit like the charcoal drawing of Aunt Hatie, who was said to have had a pet spider. Cheerful adaptability is impressed on the face of the black man painted in three vignettes at the request of Roland Simpson. The subject of the three studies had worked for years in Simpson's lumber yard. There is a profile, a three-quarter view with a toothy grin, and a frontal pose with a meditative smile. In each pose, a yellow hard hat adds a note of bright color. The likenesses seem to have

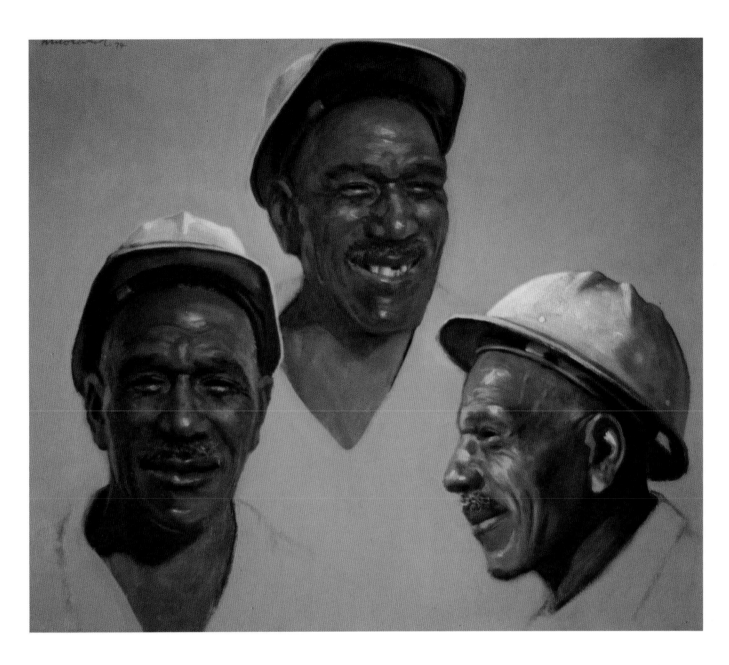

3 Heads

happened almost without effort as the unaffected expressions were set down in paint.

A melancholy mood floats like stale air in a painting of Son House, a blues musician from the Mississippi Delta (p. 50). Done from a photograph, the painting is in monochromatic values stressing burnt umber and white. The subject offered a challenge to the artist to concentrate on the orchestration of values and to study juxtapositions of dark and light. A puff of smoke conceals the hand holding a cigarette. The white cigarette paper against the dark background attracts the attention of the viewer and leads to the highlights on House's forehead and face. The white collar and shirt push the eyes to the fingerboard of the guitar and finally to the light-catching projection of the kneecap. The composition is a handsomely articulated sequence of triangular configurations.

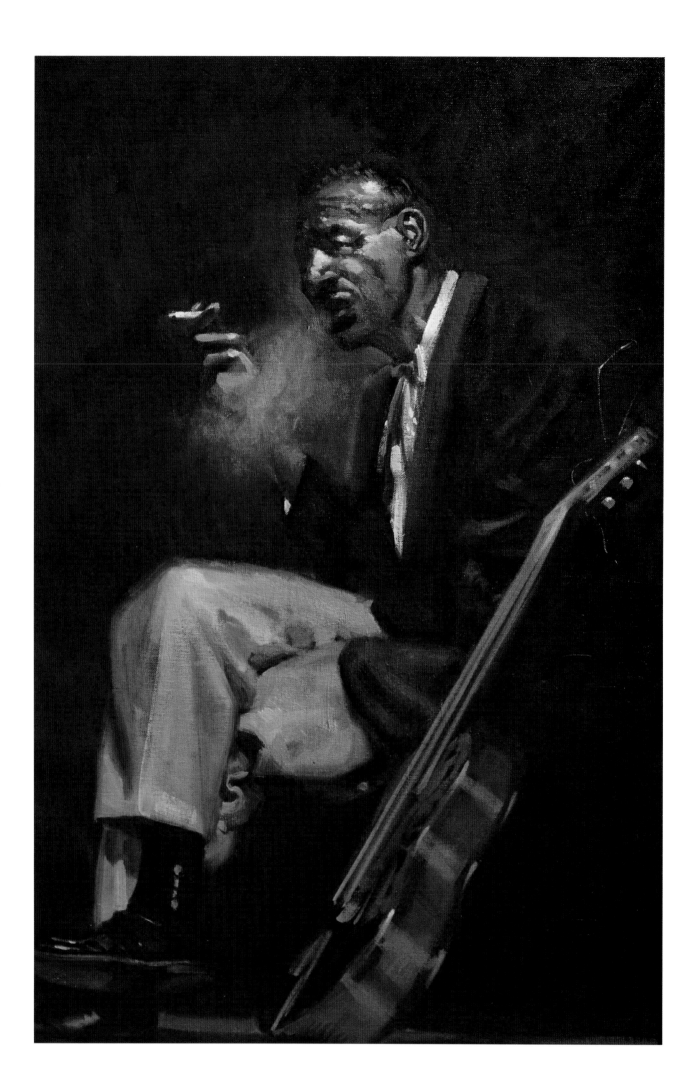

Jim Romberg

There are other portraits from the years spent teaching in the Art Department of Texas Tech University. Jim Romberg, a ceramics professor, was painted against a background displaying one of his ceramic sculptures. The relation between an artist and his art was used as a compositional device also in a portrait of Roger Holmes, an art student (p. 52).

Painted a few years earlier, a canvas entitled *Elfrieda* (p. 53) pictures a young woman austerely dressed in a white jumper, black blouse, and black leather boots. She

sits on a white wicker chair in a glow of golden light. The pose brings about an interaction of two equilateral (or nearly equilateral) triangles. The upper and dominant geometrical shape begins with an apex of copper hair; the descending lines are defined by the black sleeves and end with the hands overhanging the arms of the chair. An implied base line connects the drooping fingers. The smaller triangle is initiated at the crossed knees; its sides are traced by the position of legs and boots. In this instance, the imaginary base, stretching from toe to toe, is slightly

skewed. There is no single axis connecting both triangles, thus avoiding a rigid and formal symmetry. The simple mass of the figure contrasts pleasantly with the lacy wickerwork of the chair back. The curve of the high back fans out like the tail of a white peacock against the flat black background. Elfrieda's simplicity and aloofness are dramatized by the textural brilliance that surrounds her.

The year 1973 was an eventful one for Milosevich; it brought contacts that would extend into the future. An interest in folk music, popular

Son House (left)

Roger Holmes

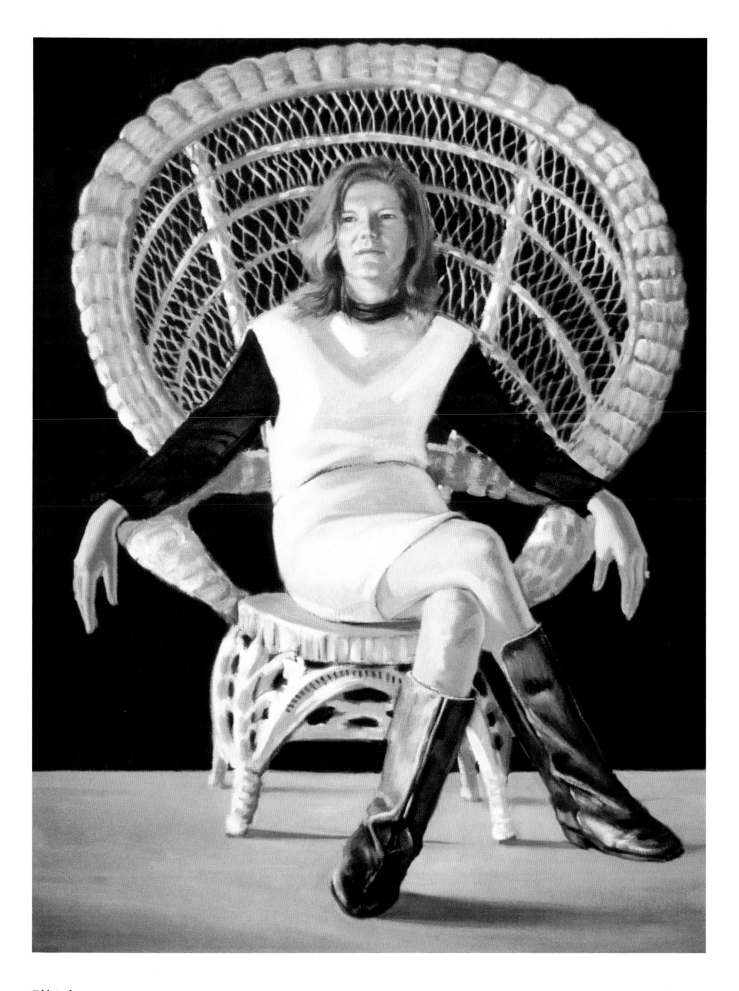

Elfrieda

Spanish songs, and the ballads of country and western singers had been introduced into the Trinidad farmhouse by the local radio station. This music retained its fascination for the artist. In the late 1960s, Milosevich met Jerry Allison, one of Buddy Holly's original Crickets. Allison expressed an interest in looking at some of the painter's work. "Jerry really liked my art," Milosevich says. "I never knew musicians were as interested in art as I was in music."[8] Encouraged by Allison's praise, the artist decided to send some drawings related to Tom T. Hall's songs to the country music star. Six months later, in the fall of 1972, Hall and Roy Clark came to Lubbock to give a concert at the South Plains Fair. After the performance, Milosevich went backstage to meet the performers. The artist relates, "[Hall] remembered the drawings and asked me to go for coffee across the street at the Shamrock, saying he was interested in my doing some drawings for an album jacket."[9] So the two discussed the upcoming album, and Milosevich began to sketch some of the ideas that Hall had suggested.

In January 1973, Hall called unexpectedly. He was doing a show in Fort Worth and invited the painter to drive down for a performance and a chance to talk about the album design. The trip was not an easy one to forget. Milosevich says:

When the day arrived for me to start out for Fort Worth, there was an ice storm. I took my daughter and one of her friends along, and we counted 29 wrecks between Lubbock and Fort Worth. When we finally reached the hotel, it was about midnight. I thought the desk would naturally tell Tom T. that I had arrived. But as it turned out Tom and the band decided to check out [when they got back from the concert appearance]. The desk never gave Hall the message . . . there we were. I had missed the show; the girls had missed meeting Tom T.; I still had the drawings and had to face a long, icy drive back to Lubbock—over six hundred miles round trip. I was really disgusted.[10]

The drawings were delivered to the airport in order to send them on to Nashville, but the airline personnel refused to insure art that was not packed in a crate. The authorities were assured that it didn't matter whether the drawings were insured or not; the artist just wanted them out of his life. There was a happy ending. Hall chose as the jacket design for *The Rhymer and Other Five and Dimers* a drawing of a chair with a Levi jacket draped over it and a pair of well-worn boots on the floor. This theme runs like a raveling from a denim cuff through Milosevich's work, whether the paintings are done in oil, acrylic, or watercolor. On the back of the album, there was a portrait of Tom T. Hall.

This was the beginning of a long friendship. Hall says, "Paul draws songs, which is why we're pals." It also explains why at Hall's Nashville farm, Fox Hollow, there are more than twenty of Milosevich's paintings and why there has been a sequence of album jackets for the country singer's recordings.

By 1975, Milosevich decided to take a major step; he resigned from his position as an associate professor at Texas Tech University in order to devote his time entirely to his personal art.

The transition from the university studios to free-lance art work was made easier by the artist's friendship with professional musicians. He has written, "Tom T. Hall kept me busy for about a year and encouraged me to do something enjoyable and satisfying. Jerry Allison said, 'There's no such thing as security anyway, so you might as well do what you like to do.' I'd always been a folk and country music fan, and it was refreshing to associate with professionals who were doing what they liked for a living."

It was at this time that Milosevich was asked by the president of the Songwriters' Hall of Fame to do portrait drawings of the annual inductees into that distinguished group. The first drawing was of Jimmy Rodgers (p. 56). Other likenesses have included Dolly Parton, Kris Kristofferson, Jerry Jeff Walker, Hank Williams (p. 57), the Sons of the Pioneers, Billy Swan, Billy Joe Shaver (p. 58), Rita Coolidge, Johnny Rodriguez, Marijohn Wilkin, Jessi Coulter, Tex Ritter, Chuck Berry, Johnny Cash, Waylon Jennings (p. 59), and Willie Nelson (p. 59). In the past fifteen years, sixty portraits have been commissioned. Many of the drawings have had to depend upon photographs and glossy prints instead of live models. Capturing character and animation despite such limitations is one of the artist's special gifts. Milosevich is able to look beneath the surface realism of a photograph and come to grips with the uniqueness of his subject.

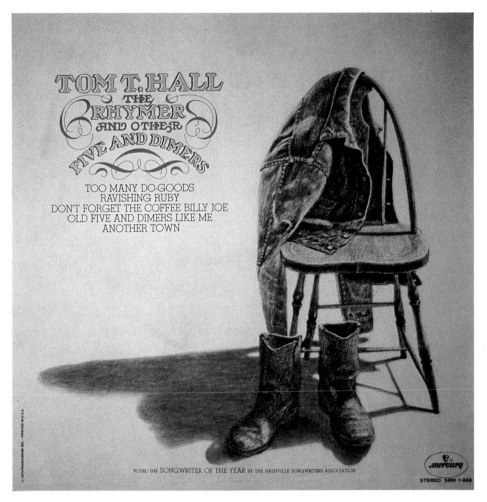

Album cover for Tom T. Halls'
The Rhymer and Other Five and Dimers

Album liner for Tom T. Hall's
The Rhymer and Other Five and Dimers

Jimmy Rodgers

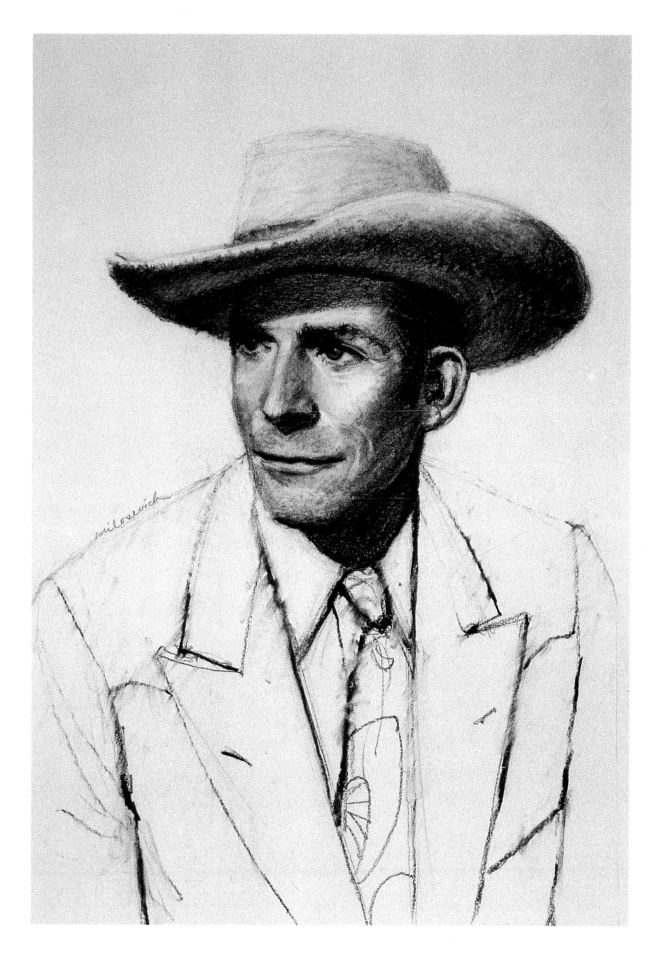

Hank Williams

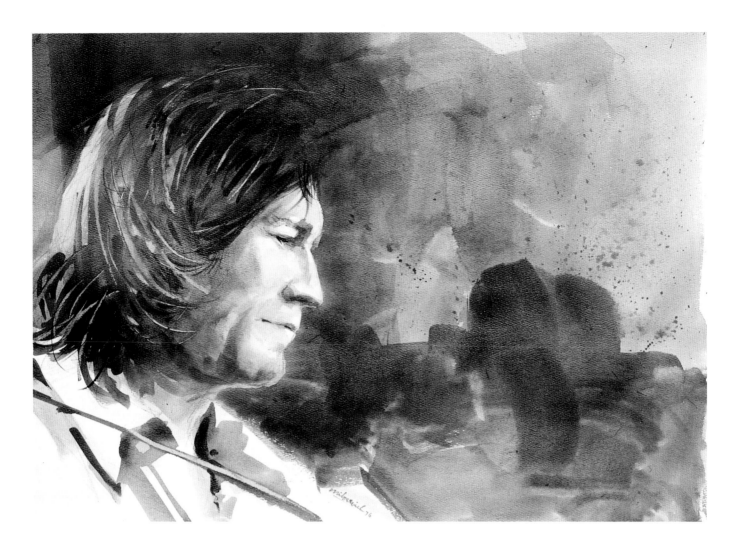

Billie Joe Shaver

Doing album jackets was different from painting commissioned portraits, but the assignments were pleasant. Milosevich says:

I've always been interested in illustration; Mitchell, the artist I studied with in Trinidad, introduced me to the illustrators of the twenties. When I first saw an N.C. Wyeth, it just knocked me out. It has never bothered me to bounce from one type of art to another. When teaching, there is less need to sell one's art; but when one paints for a living, then one needs to think about marketing. Not having a schedule of classes made me more flexible. When I would wake up in the morning, I would think, "What am I going to paint today?" It's a great privilege to be an artist, but you do pay for the privilege.

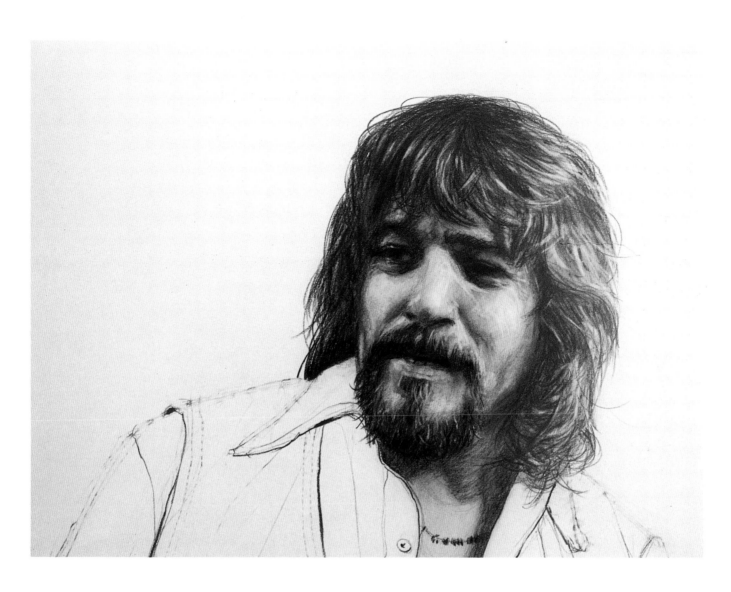

Waylon Jennings

Willie Nelson

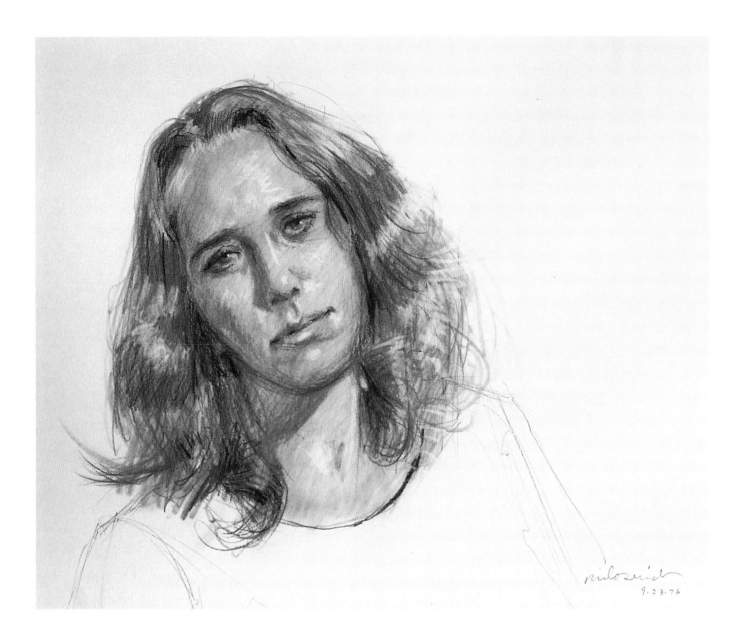

Deborah

In 1976, Milosevich married Deborah Thompson, a sensitive artist known for her assemblages using found objects combined with poetic symbolism and placed in small shrines and box constructions. Deborah Milosevich was one of those who helped launch Lubbock Lights Gallery, a cooperative effort of a group of Lubbock artists and craftspersons. This was one of the forces converging in the mid-seventies to bring about a surge of interest and excitement on the South Plains art scene. Paul Milosevich's paintings were featured in 1979 at the gallery in a one-man show, titled Cowboys and Indians. The paintings were another example of the use of

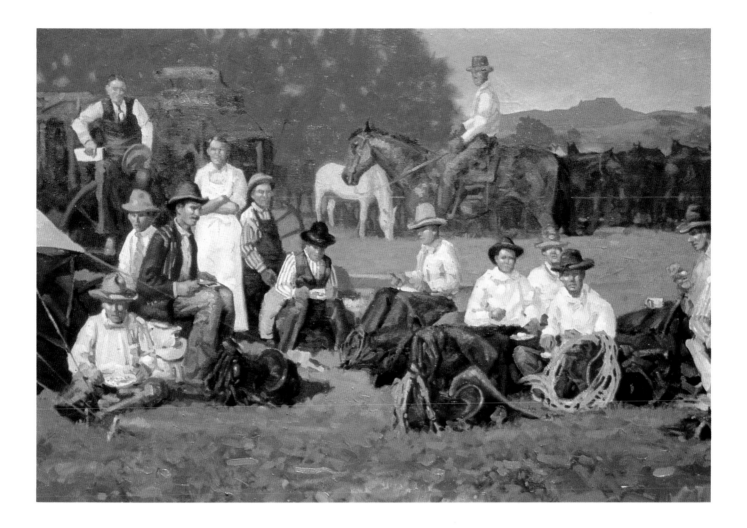

Cowboys at Dinner

photography; this time old postcards contributed western subjects, while the painter added color and panâche and a personal view of events and people. Of the cowboy theme, the artist says,

Arthur Mitchell. . .was a cowboy artist, and somewhere down the road I knew I would take a crack at Western Art. In the late 1970s I found some nostalgic postcards from the 1930s and 1940s about "Cowboy and Indian Life of the Great Southwest." I did eight paintings, each one measuring about three-by-five feet [maintaining the proportions of the cards, but increasing the size dramatically]. Four were about cowboy life, and four were

Indian subjects. . . .The paintings were not copied literally from the postcards which were tinted black and white photos. I used thick paint, a lot of color and a loose impressionistic technique. Great fun.

The paintings are colorful, gutsy, often a tongue-in-cheek exposé of the tourists' dream of the way the west rarely was. Among them were *Cowboys at Dinner, The Trail Drive* (p. 62), *Indian Woman Baking Bread* (p. 63). *Pueblo Dance* (p. 64) takes place in the plaza drenched in the warm pink glow of late afternoon. Long violet shadows complement the lines of dancers in the brilliant colors of their traditional dress. In

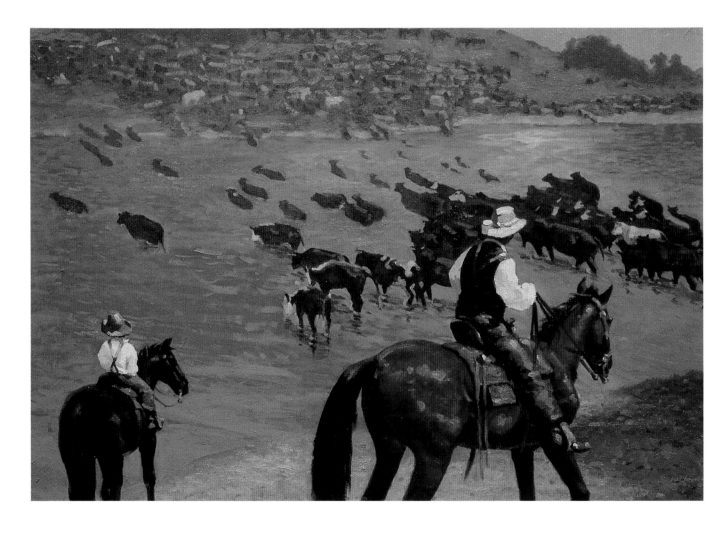

The Trail Drive

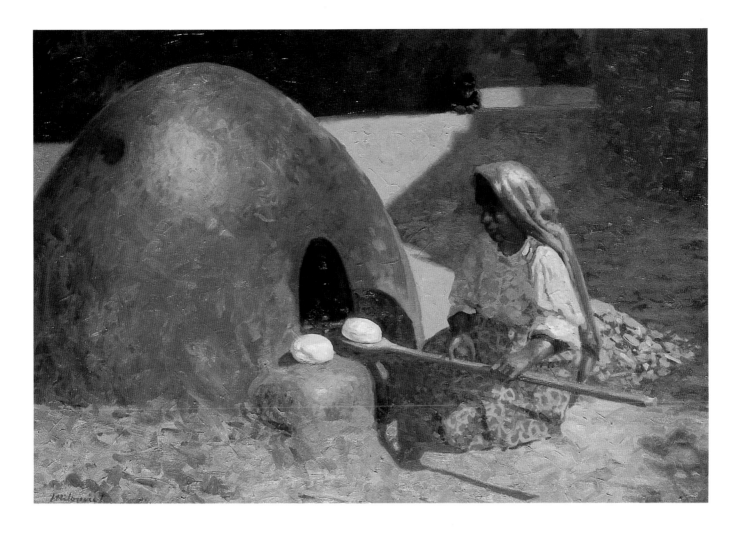

Indian Woman Baking Bread

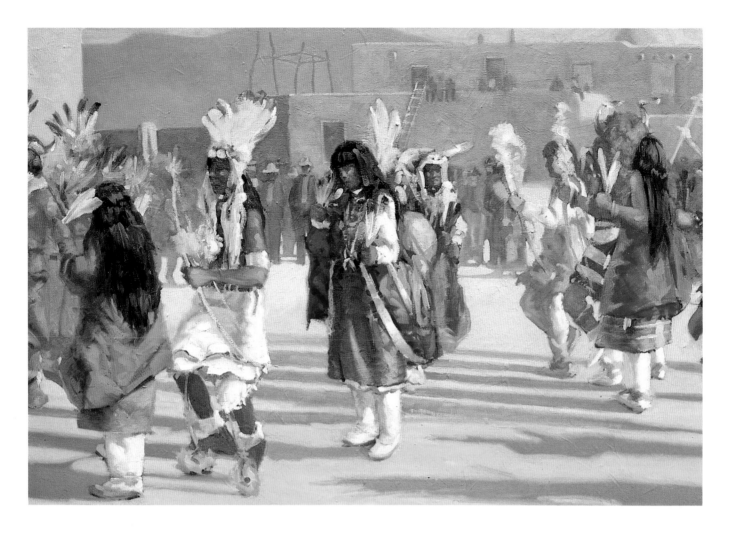

Pueblo Dance

contrast to the slow repetitive cadence suggested by the composition of figures in the plaza at Taos, *Setting Sun* pictures a dancer in a swirl of motion, heightened by the small staccato brush strokes and the palette of high-keyed hues. *Buffalo Medicine Man* (p. 66), on the other hand, is static and somber. One of Milosevich's most striking portraits is *Indian Chief* (p. 67), a head that is commanding in size (the overall dimensions are sixty-six by forty-two inches) as well as arresting in its expression of strength and determi-

nation. Color is the element that matches the power in the bronzed face. Turquoise, blue-green, jade, blue, and lapis lazuli vibrate in the beads and feathered headdress and in the silk scarf that is galvanized by the marigold yellow of the shirt with its veining of orange with green shadows. The chief's demeanor conveys the pride of those people who owned the land long before white men appeared on the horizon. A Taos saying that lodges in the artist's consciousness is, "Let us move evenly together." From Frank Waters,

Milosevich says, "I have gained insight into the philosophy and lifestyle of the American Indians, which makes a lot of sense to me. Ideas like the earth is our mother and should be treated with respect. That nature should be lived with, not conquered, is a key to human survival."

At this period, Milosevich's paintings were moving toward West Texas realism.

Setting Sun (right)

Buffalo Medicine Man (following left page)

Indian Chief (following right page)

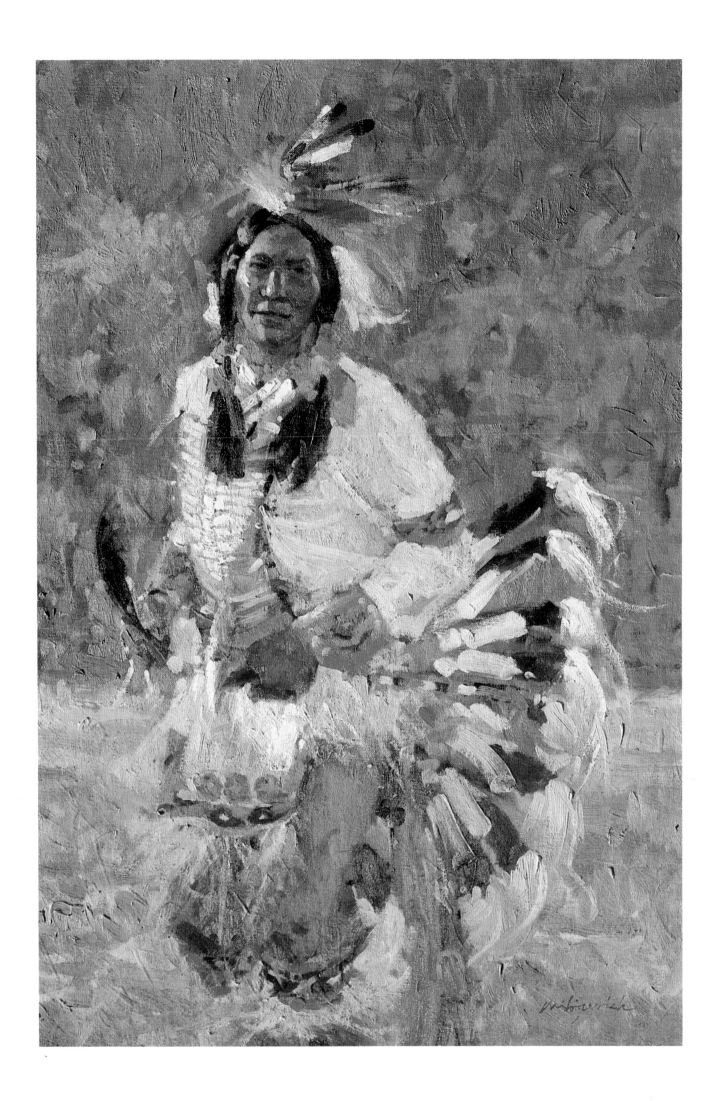

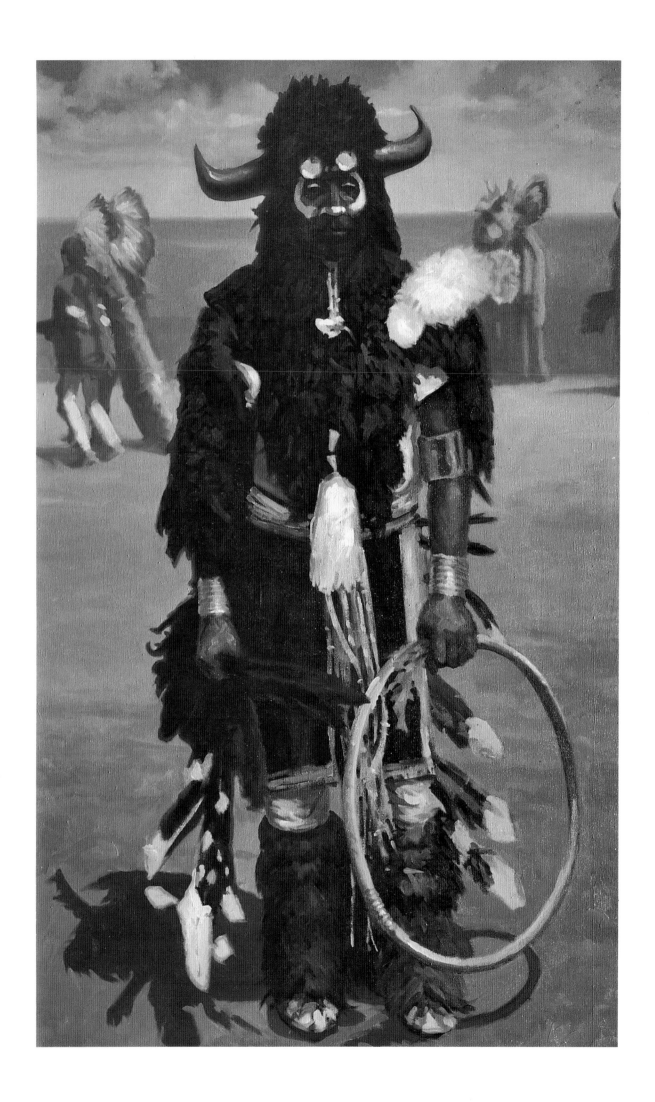

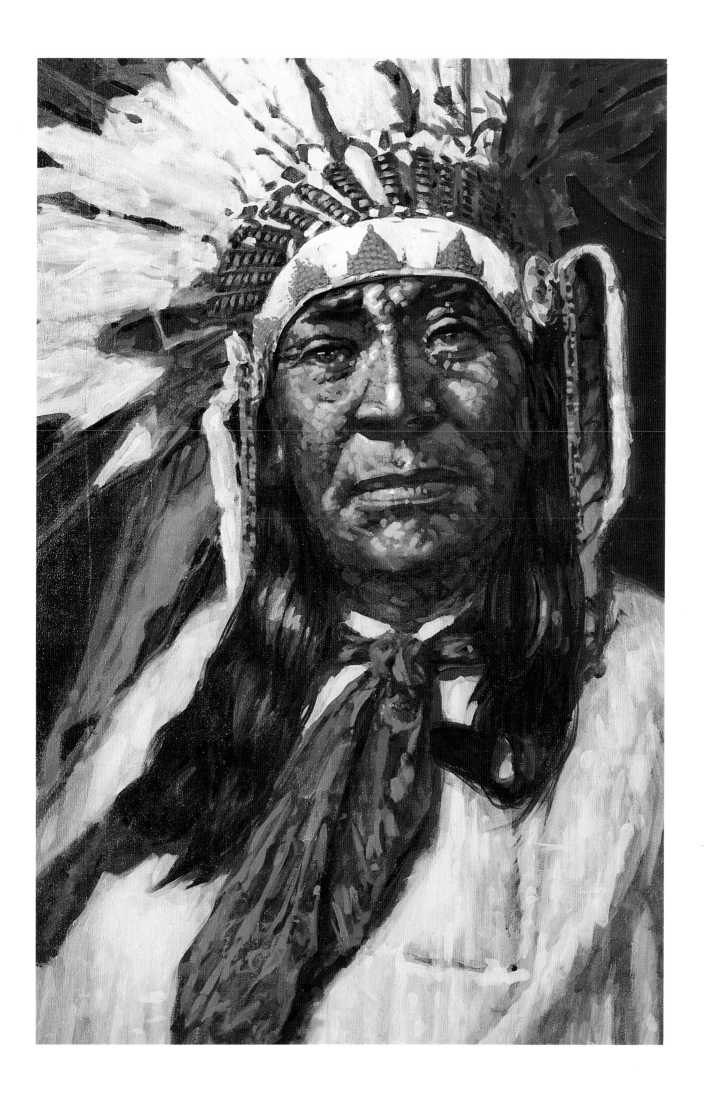

West Texas Realism

A dd *West Texas* to *realism*, include "painting subjects related to the culture and geography of the South Plains," and the meaning of West Texas realism is clear as a day without dust. Milosevich describes it as "painting things flat out the way they are without romanticizing about them." The comment is given a small loophole; one of the artist's favorite sayings by William Merrit Chase is: "Don't hesitate to exaggerate color and light. Don't worry about telling lies. The most tiresome people and pictures are stupidly truthful ones. I really prefer a little deviltry."[11]

Everyone knows that artistic license is allowed. It is self-evident that West Texans are rarely stupid and that they can spin a tall tale with relish; so it is no surprise to discover that Milosevich's painting *Wine, Women, and Song I* (p. 70) hints at "a little deviltry" in the title. It is a still life that brings together objects that provide a recurrent theme in the artist's work. Leather boots, a half-empty wine jug, a blue-jeans jacket, and a guitar are bound into a unity by a white organza petticoat; these have been cast off on a doorstep. A bucolic touch is added by the textured grass contrasting with a woven doormat.

An earlier work, a denser and darker painting, introduced similar elements into the composition. Engineering boots are on the floor, as is a discarded sheepskin vest. A blue shirt is thrown over a chair (p. 71). The dark tones contrast dramatically with the light shirt. The painting seems to turn back to the realism of Chardin's still-life paintings—for example, *La Nappe,* in which a white table cloth plays a role closely related to that of the carelessly draped shirt, offering a counterpoint to the dusky room and still-life objects on the table.[12]

Wine, Women, and Song II (p. 72) fills a square format. A pair of suede moccasins lends an exotic element to the cowboy boots, the jug of wine, and guitar. There are pleasing contrasts between the masculine leather of the boots and the feminine softness of the moccasins. Polished silver buttons catch the light. The ground is a meticulously painted study of matted grass intertwined with dry wisps.

On another canvas, a cowboy hat, denim jacket, and guitar are arranged against a Navajo blanket (p. 73). In this, the microscopic handling of detail has been abandoned for greater speed, broader brushstrokes, and softer edges. It is the repetition of

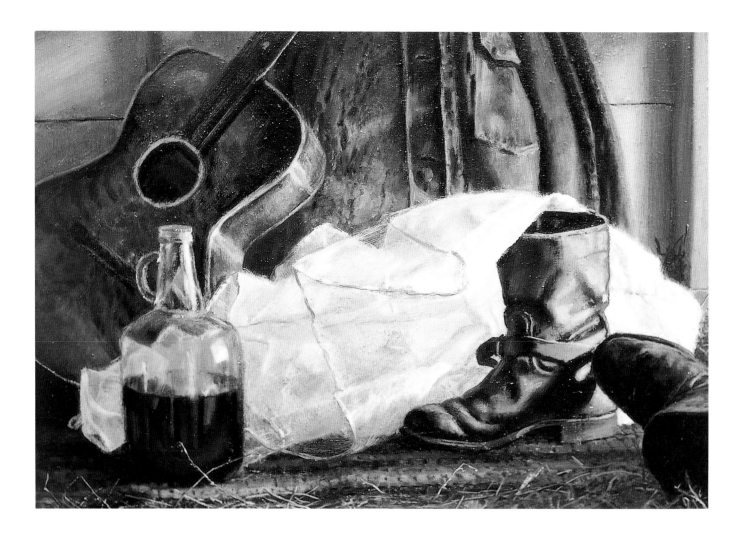

Wine, Women and Song I

subjects that unites certain paintings by Milosevich, rather than a stylistic similarity. During the first two decades of the twentieth century, when Picasso and Braque were inventing Cubism, they, too, were drawn to guitars, wine bottles, and glasses. Although light years away from West Texas of the 1970s and 1980s, the iconography of the Parisian cafés where artists and writers gathered was drawn from commonplace subjects not unlike Milosevich's visual vocabulary of the cafés in small towns of the South Plains where people came to listen to the distinctive music of the region.

When the same subjects are repeated, painted in various lights and from many angles, it is impossible not to ask if there is a personal symbolism or meaning that draws the artist, consciously or sub-consciously, to the particular objects. Why Levis? Why the guitar? Why boots and hats? At one level, it is simple enough; the still-life pieces appeal to the painter because of their shapes, textures, color values, and the dynamics of interelated forms.

But is there a deeper meaning? Levis were first produced in California in the Gold Rush days. Contrary to what might be imagined, jeans are a twentieth-century item of cowboy apparel. They were first worn by workers in mines and by farmers. When an overall manufacturer began to copy the product of Levi-Strauss & Co., the latter's response was to reinforce the heavy blue denims with copper rivets at the pockets. This was practical since miners had a habit of loading their pockets with ore samples.[13] Gradually, Levis moved east, becoming

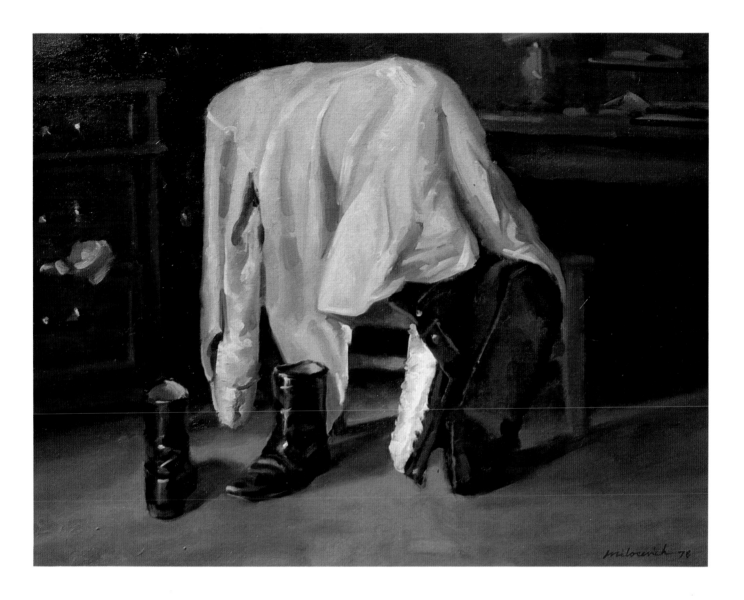

Still Life with Boots and Blue Shirt

ranch and rodeo attire in the 1930s. It was the hippie generation, however, that saw denims and blue jeans as the great equalizers, which removed status in dress and symbolized the rebellion against parental values. Jeans are unisex, contributing equally to the liberation of women and the macho western image. Alison Lurie says, "Men who have never been nearer to a cow than the local steak house [wear] western costume to signify that they are independent, tough, and reliable."[14] In the last few years, the western pose has become high fashion on the streets of large cities; the Electric Cowboy sparkles with sequins and the razzle-dazzle of neon colors that explode and gyrate at concerts of

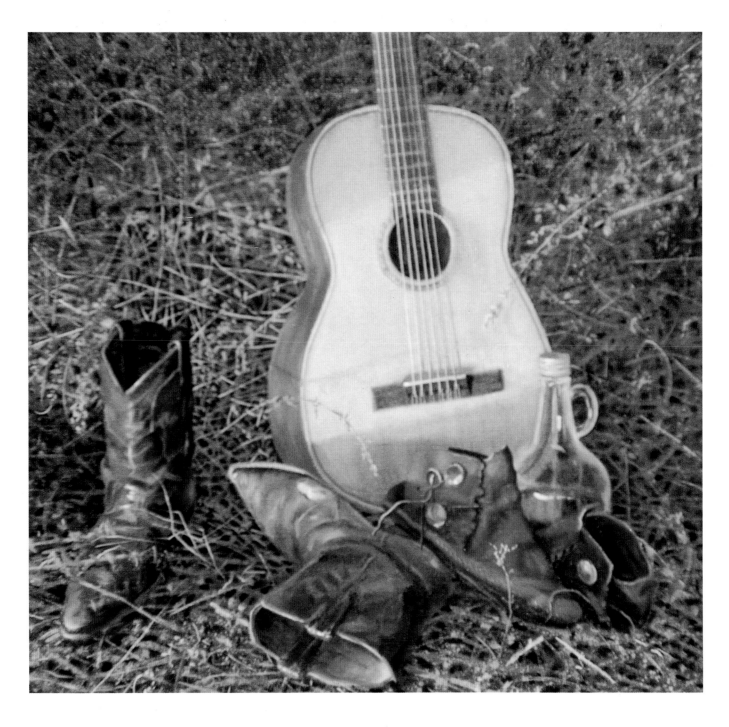

Wine, Women, and Song II

country and rock musicians. In short, jeans are ambivalent. They may suggest honest work, a willingness to get one's hands dirty, the independence and "cool" of the cowboy hero. Jeans and Levis also have an association with the counterculture, with artists and Bohemians. They have become a uniform for both men and women. Woven into the cotton fibers are the concepts of classlessness.

Then there is the hat. A favorite still-life object in Milosevich's painting, it appears also in the artist's

Self-Portrait (see p. 19). The light hat, at least in Hollywood, is associated with Mr. Good Guy. Golf caps and visors present in other Milosevich paintings suggest a favorite occupation.

In *The Language of Clothes*, Alison Lurie writes:

Traditionally whatever is worn on the head . . . is a sign of the mind beneath it. The hat . . . expresses ideas and opinions. Since the head is one of the most vulnerable parts of the body, many hats have a protective function, shielding their wearers from extremes of climate and from human aggression.[15]

Although the era of the hat passed, the western hat has never fallen into obsolescence. It is a part of the practical gear of the working cowboy. It offers protection against the weather, functions as a sun shield, even serves as a pail for water when nothing else is around. The way the western hat is worn becomes a personal symbol and a means of communication. Lurie claims "the higher the crown, the higher the self-esteem of the wearer; the wider the brim, the closer his connection to the realities of outdoor life on the Western Plains."[16] Browns and tans repeat the colors of the landscape and suggest naturalness and a down-to-earth character. The hatband is another personal touch; it may be a simple leather string or band; feathers and Navajo silver conchos call attention to the affluence of the owner. It is amusing to note that in the portrait of Ramon Barela (see p. 25), the tall black hat sports a band made from a chain of aluminum pop-top tabs.

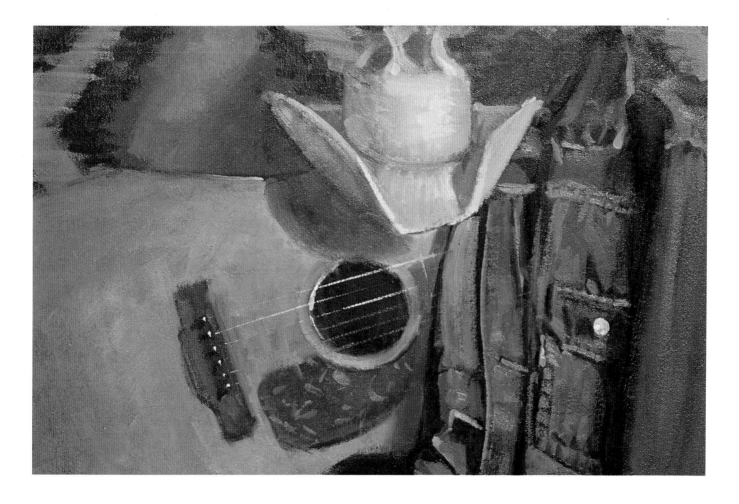

Mitch's Hat, Sonny's Guitar

Levi Pocket

The ever-present boots in the paintings seem to register pride and a down-to-earthness. The guitar is not difficult to assess; it expresses the painter's enthusiasm for music and musicians. The wine jugs, instead of bottles imprinted with the seals of well-known vintners, repeat the notion of simple pleasures rather than flamboyant Bohemianism.

There is one eye-catching sign of the times in *Levi Pocket*. This is a red designer's label surrounded by denim gullies and plateaus. Before designer jeans came into existence, the maker's label was sewn inside, but now that cut, fit, and stitching are difficult to identify, the label is flaunted externally, so that all may read it.

In a watercolor, Levis with a stitched leather belt hang on a wall beside a crumpled hat and sheepskin jacket. The painting has the warmth

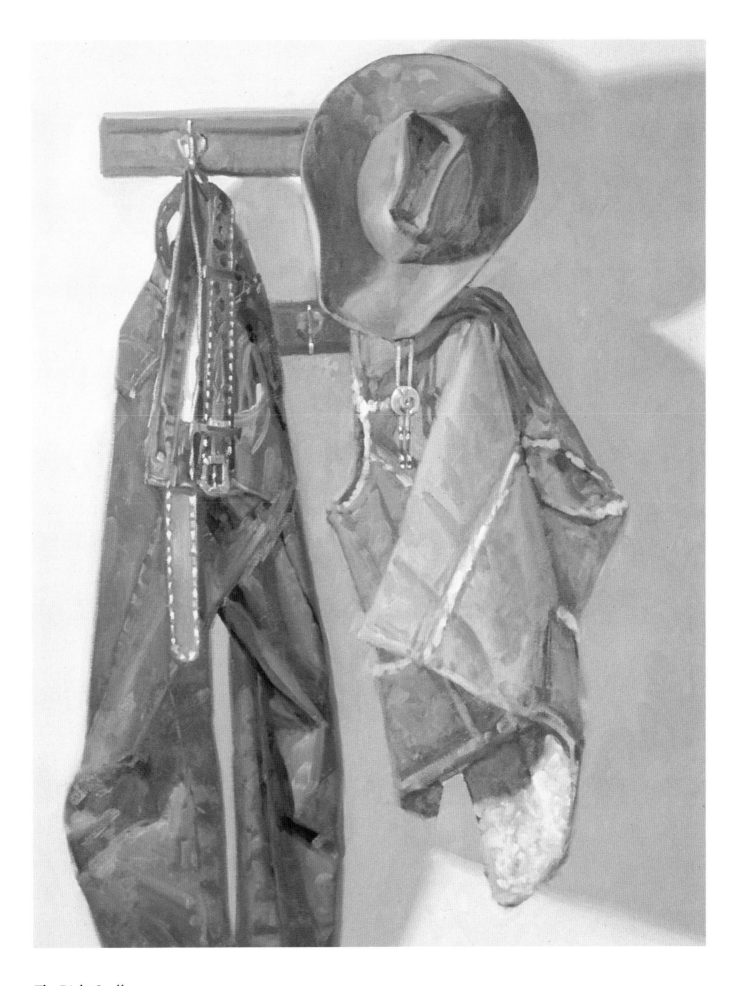

The Right Stuff

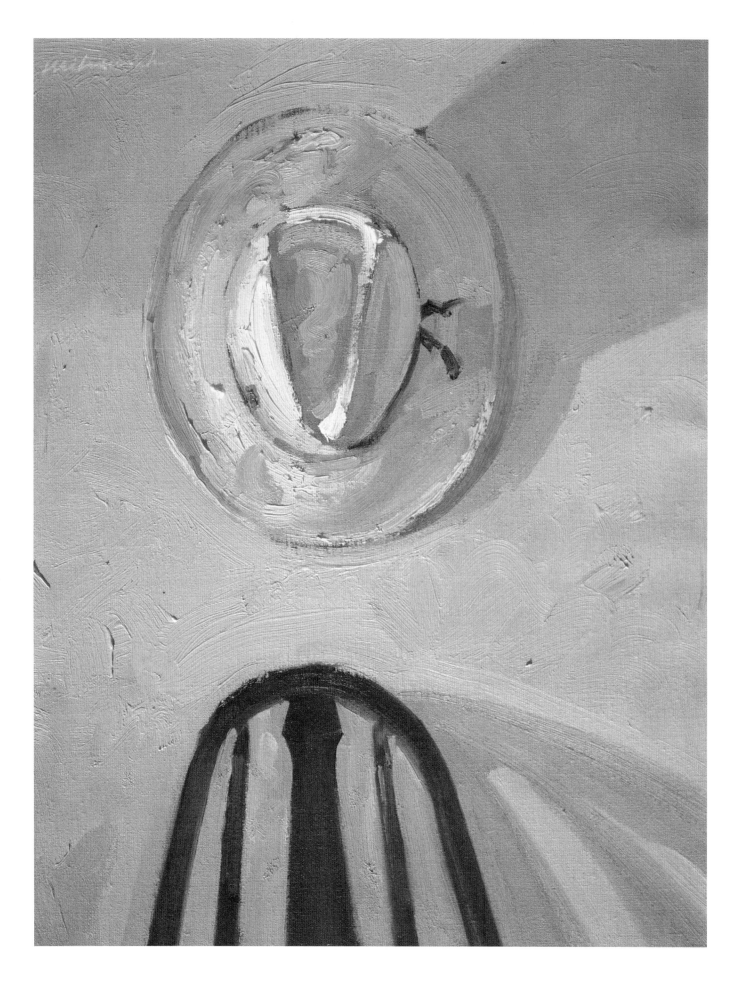

Straw Hat

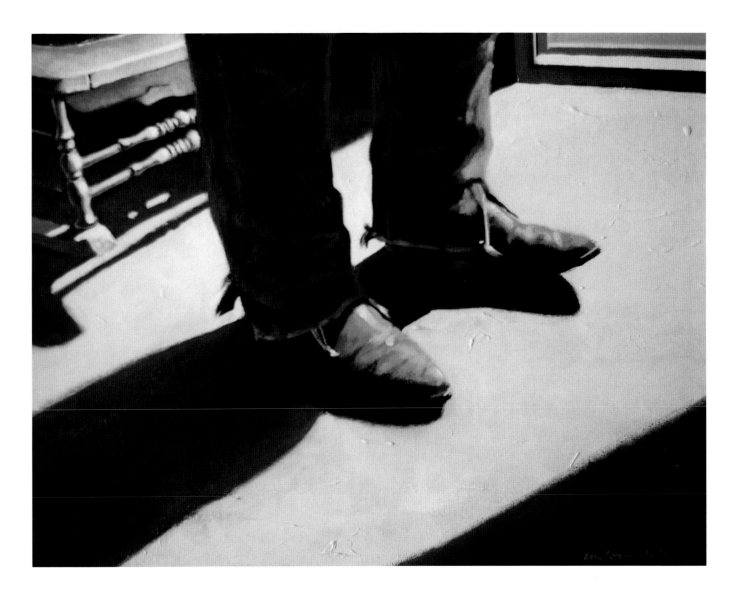

Boots

and luminous quality of light found in the California watercolor of *The Brooms* (see p. 14).

Luminosity also distinguishes an oil painting of a straw hat suspended on the wall like a surrogate sun. The dark oval of an openwork chairback goes out of the picture plane at the bottom of the canvas. In many of Milosevich's paintings, the compositional effect involves a slightly battered circle as a foil for textured space, or, in this case, as a counterweight for the chair.

West Texas realism is not dominated by still-life painting. Levi jackets, jeans, and boots are filled with bodies, legs, and feet. A painting with vigorous light and dark contrasts has as its subject blue-jeans-clad legs and boots standing on a floor swept by light streaming in from a door. The boots and spurs are overhung by the frayed edges of the jeans, which contrast with the smoother wood of an old rocking chair in the background.

In the same vein, there is a charcoal drawing of *Alice's Fiddle* (p. 78). Milosevich was asked to make a drawing of the violin, but he wanted to draw the violin and its owner; a compromise was arranged—the fiddle, and Alice from waist to her bare feet. The deftness in handling the charcoal produced a virtuoso performance that is as whimsical as it is unexpected.

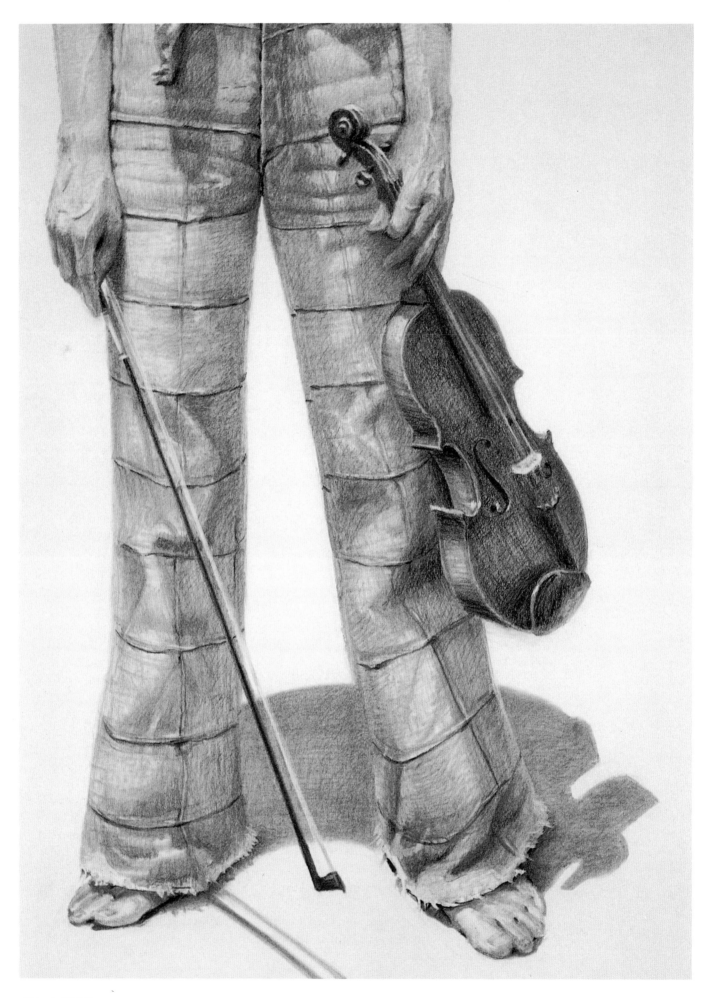

Alice's Fiddle

Another fine portrait is the oil painting of Gene Hemmle, who was for many years chairman of the Texas Tech University Department of Music. The swashbuckling pose and spirited expression preserve in paint the essence of one of the University's legends.

Portrait of Jena, the artist's eldest daughter (p. 80), communicates a different mood. Like her peers, she wears jeans; the composition is built upon a symmetrical triangle with the figure placed against a flat white background. It is a thoughtful and compelling likeness of a girl who is no longer a child and not quite a woman.

West Texas realism is summed up in the drawing *Chris Brock* (p. 85). It has the same tang as a few lines from Larry McMurtry's *Texasville*: "He dressed like an out-of-work cowboy, coughed a lot, and drove a rusty GMC pickup with a couple of pipe wrenches in the front seat."[17]

Gene Hemmle

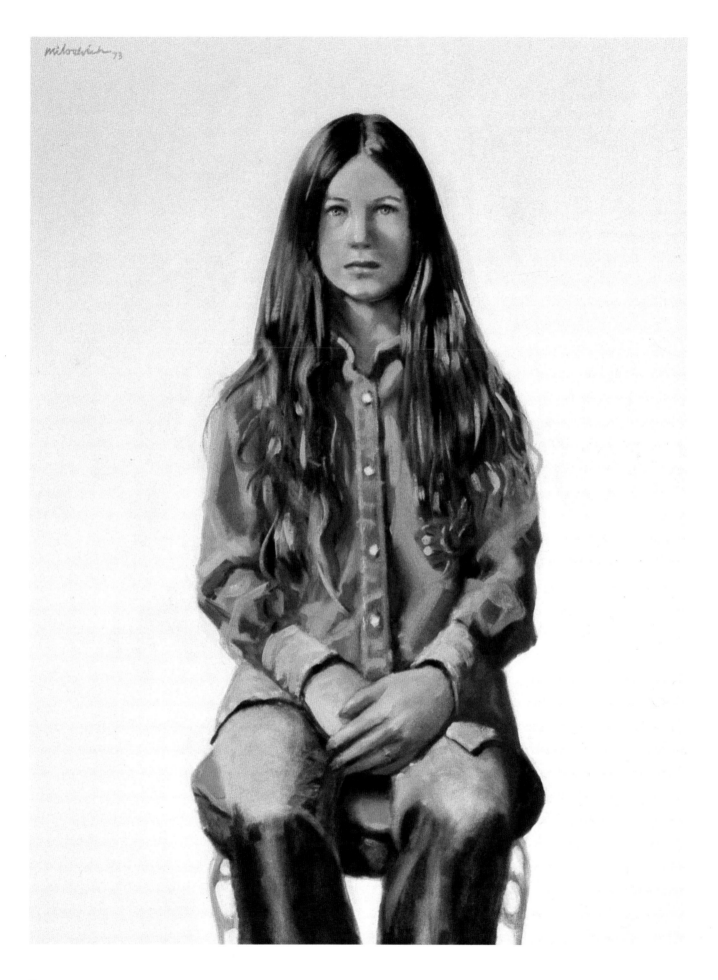

Jena

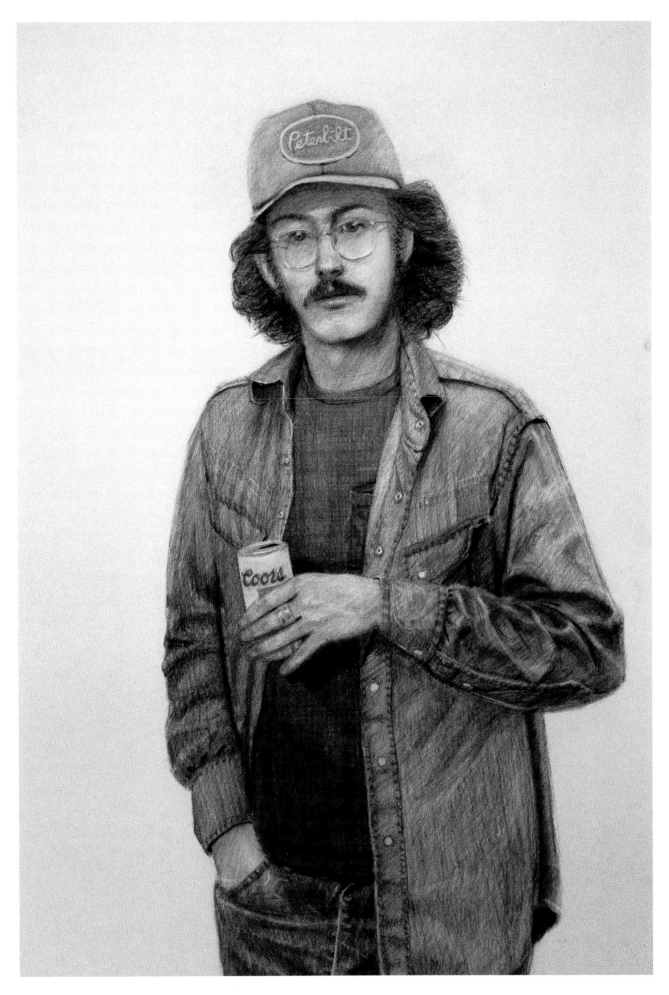

Chris Brock

Honky Tonk Visions

Tell people you live in Lubbock, which I did for several years and people who know about music say, "Ah!" People who don't, say, "What's in Lubbock?"

Russ Parsons

Honky Tonk Visions

Why do music and art flourish on the flat cotton patch of the South Plains? Butch Hancock, described as one of the best songwriters in America in the folk-poet tradition, and who is also a photographer and former architecture student, replies with an answer that is as good as any. He explains that "all of the winds from the North Pole come across Kansas until they hit the Yellow House Canyon and then they spill out in every direction sending all of the ideas for music [and art] swirling around." Paul Milosevich, in the 1970s, was in the right place at the right time to be blown about by the blue northers into a head-on collision with a remarkable group of young musicians, many of whom were also writers and artists.

But to go back to the beginning: for the cowboy riding the line for long hours repairing fences, a harmonica or Jew's harp relieved the monotony. On cattle drives, cowhands on guard during the night sang softly to calm the restless herd. On Sundays, gospel singing was practiced with fervor. Music was in the bones of the pioneers.

Men were willing to ride all day to attend dances and fandangos that promised female companionship and dancing to the tunes wheedled out of one or two fiddles. Cecil Caldwell, a Lubbock fiddler whose memories go back to the thirties, recalls gatherings where, as he put it, "By golly, they'd just make room to dance and that would include moving beds out of a room or furniture out of a room just so they could dance."[18]

A. H. Lester, another early Lubbock musician, played his first gigs at ranch dances. Of these popular social events, he said, "You could get a blond head on your shoulder and just waltz across Texas back in them days. . . . I've seen a lot of people that, when you start the music, they couldn't help but dance. They'd just jump up and down and start dancing. Some of them would lay their crutches down and. . .dance."[19]

One of the few night spots for dancing in Lubbock during the fifties and sixties was the Cotton Club. The club's later days (in the late seventies) were associated with Tommy Hancock, billed (among many titles) as Tommy Hancock and the Supernatural Family Band. Hancock is referred to affectionately as "Lubbock's original hippie."[20] The no-longer-existent dance hall was commemorated by Milosevich with a watercolor of the old sign left

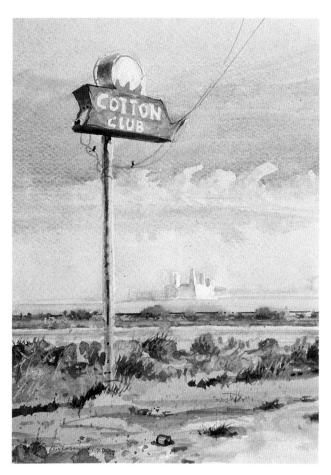

Cotton Club

Jo Harvey Allen

standing to blow in the wind above the bare ground.

In the 1940s, Turkey, Texas's favorite son Bob Wills and his Light Crust Doughboys set toes tappin' to the beat of Western swing. Sidney Keeton, whose first professional jobs were at the Cotton Club, says of Wills, "I think it was the beat to it that made Western swing so popular. I think it was that new rhythm and I guess Bob Wills got it started. Before, it was kind of hillbilly music."[21] Lester agrees, "Bob Wills brought Western music to this country and he helped all musicians. He [was] the King."[22]

For decades, Lubbock, the self-styled "Hub of the Plains," drew musicians to its center; these musicians then fanned out over the country watching the cotton gins disappear in their rearview mirrors. The early generation included such names as Plainview singer Jimmy Dean, the late Roy Orbison from Wink, producer Norman Petty from Clovis, Texas Tech architectural student John Deutchendorf—better known as John Denver, Littlefield's Waylon Jennings, Mac Davis, and many others. The list comes full circle with the mention of that founding father of rock 'n roll, Buddy Holly and the Crickets.

It is with the new generation, however, that this chapter is concerned. This goes back directly to the Flatlanders, a Lubbock band of the early 1970s that brought together Butch Hancock, Jimmie Dale Gilmore, Tony Pearson, and Joe Ely. Other well-knowns include Ponti Bone, Davis McClarty (p. 85), Jesse Taylor, who are, or were, members of Ely's band. The roster continues with the Maines Brothers, the Nelsons, Jim Eppler, who was often painted and sketched by his friend Milosevich (pp. 86-87), Terry Allen (p. 88), as well known as an artist as a musician, and Jo Harvey Allen, actress and writer.

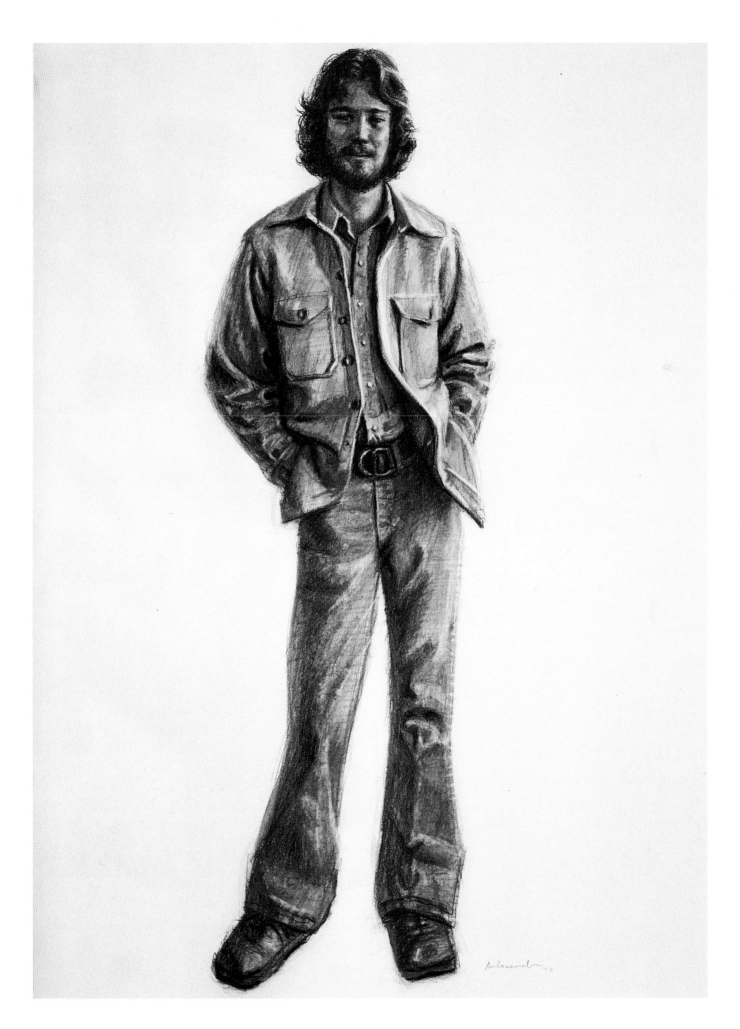

Davis McClarty

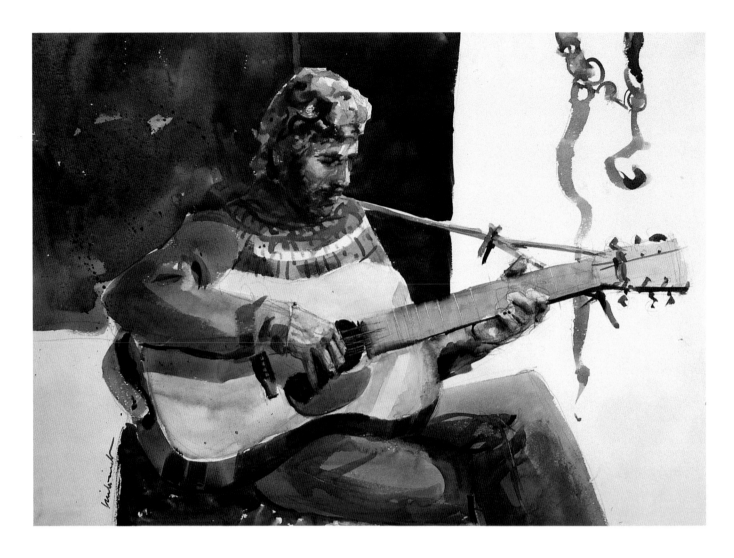

Jim Eppler

The time was ripe not only for new sounds and rhythms but also for Milosevich's West Texas realism and its empathy with the obvious and the overlooked. It carried the right message and created a link between the painter and the music people. Milosevich says he met Joe Ely "officially" at Fat Dawg's and

[I listened] to his music at the Cotton Club, Main Street Saloon; wherever he and his band played I was there with a sketch pad. I did Joe's first album cover, a charcoal portrait (see p. 88). [I] began it about 8 in the morning, and he took it to California that afternoon. The original got lost out there, but we were fortunate to have taken good photos of it and made prints.

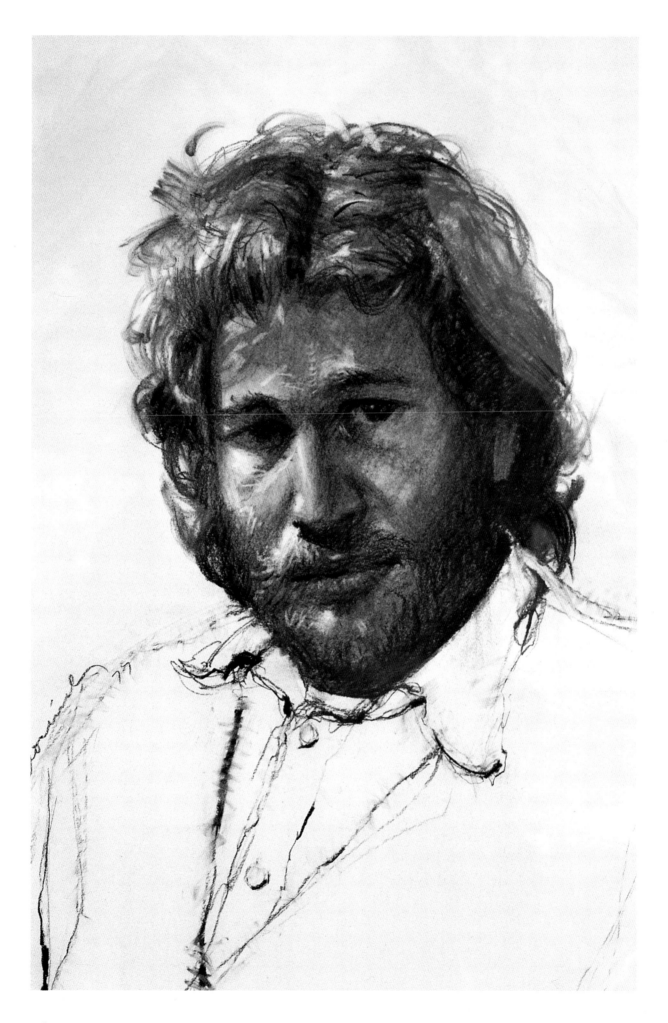

Jim Eppler

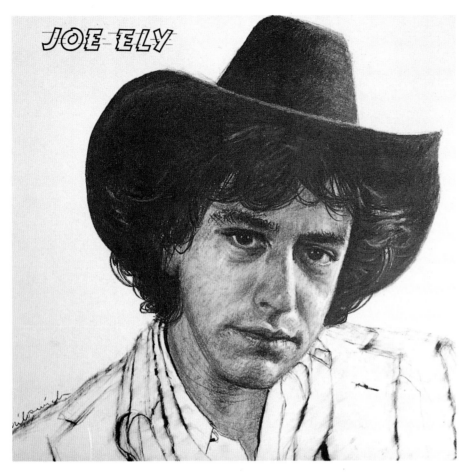

Album cover for Joe Ely's *Joe Ely*

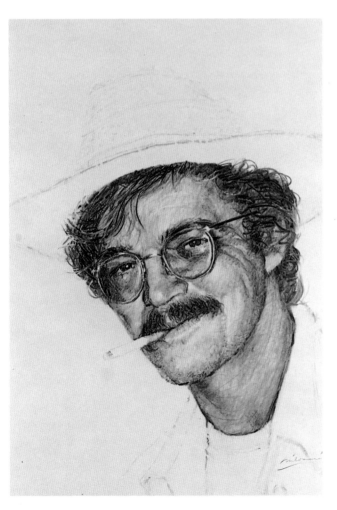

Terry Allen

Other portraits of Ely followed in oil and in charcoal (p. 90). One of the most entertaining is a full-length study. Against a light, flat background (p. 91), Joe, slim as a reed in blue denim, boots, and a cowboy hat, tilts backward, balancing a can of beer, as he rocks with laughter at the happenings at the Bob Wills's Day Parade in Turkey. (Turkey's monument to Wills is a giant metal fiddle from whose cavernous guts tapes of Bob Wills' music are relayed to the town. It may be the campiest memorial in the Lone Star State.)

Recalling another encounter, Milosevich says, "I met Terry Allen over the phone." The story goes like this: Terry Allen and Jo Harvey graduated from Monterey High School in the Hub City and were married. They left the South Plains as quickly as possible, heading for the West Coast. Terry said in an interview, "I convinced myself when I was growing up that I hated Lubbock; I made it a scapegoat for everything that was wrong. . . .You never see your hometown until you go away."

It was during a holiday visit to Lubbock that Allen received the call from Milosevich. The artist had heard that Allen was in the process of recording some new material and suggested to Terry that he might want to get in touch with Joe Ely, Lloyd Maines, and the Caldwell Recording Studio while he was in town. Later, Allen told Milosevich that he drove around the block a hundred times trying to make up his mind what to do. He didn't want anything to do with Lubbock, but he had a hunch that he should follow up on Paul's suggestion. The result was the two-record set *Lubbock on Everything.*

Terry Allen's attitude towards Lubbock has changed in the last few years. He admits,

Joe Ely (Portrait Head)

There is something about West Texas that gets stuck in the bones. That something is never felt stronger than when a native is several thousand miles from home. Maybe a chip was planted long before cowchips were outmoded by the computer. The tendency is for West Texans who develop a case of nostalgia to come loping home by air or pickup. You go back, exasperating as it may seem, because you want to go back and you know damn well there's nothing there except your memories and your friends and the flat land and the wind; that's enough. It makes you know who you are and stiffens your back for going away again.

Roads and cars are important to West Texans. There's the row of Cadillacs planted just outside of Amarillo by Stanley Marsh 3. To own a Cadillac was every young boy's dream in the fifties. Terry Allen's song "Amarillo Highway" leads south to Lubbock. Terry says that as long as it's possible to get out in a car on a starlit night, on a straight road with the radio turned up high, no one should ever need a psychiatrist. Butch Hancock's poetry bites through the dryness and unbroken bowl of the sky to speak up for dirt roads and cattle guards, for trucks and tractors:

This old road is hard as pavement.
Tractors and trailers have sure
* packed it down,*
There's deep ruts and big bumps
* from here to the city.*
This old road's tough but it sure gets
* around.*[23]

Trucks, pickups, cars, and the sun overhead are signs and symbols that set wheels in motion and circles spinning. One of Butch's songs says, "This old world spins like a minor miracle." Woody Guthrie's "Car Car Song" is one of the "modern lullabies" Ely has recently recorded for his daughter. It is no mystery why David Byrne chose to open and end the film *True Stories* with frames of a red convertible parked on a road that stretched from nowhere to nowhere. Both beginning and ending are left open ended to reach out to infinity: "Enlightenment doesn't care how you get there."[24]

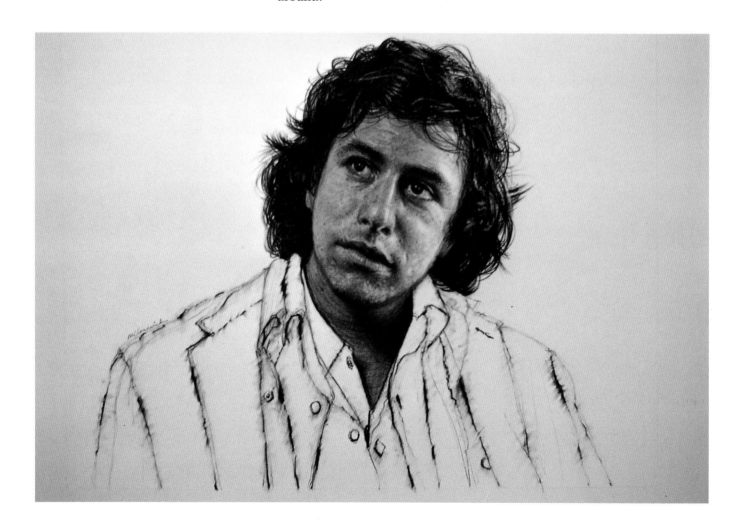

Joe Ely

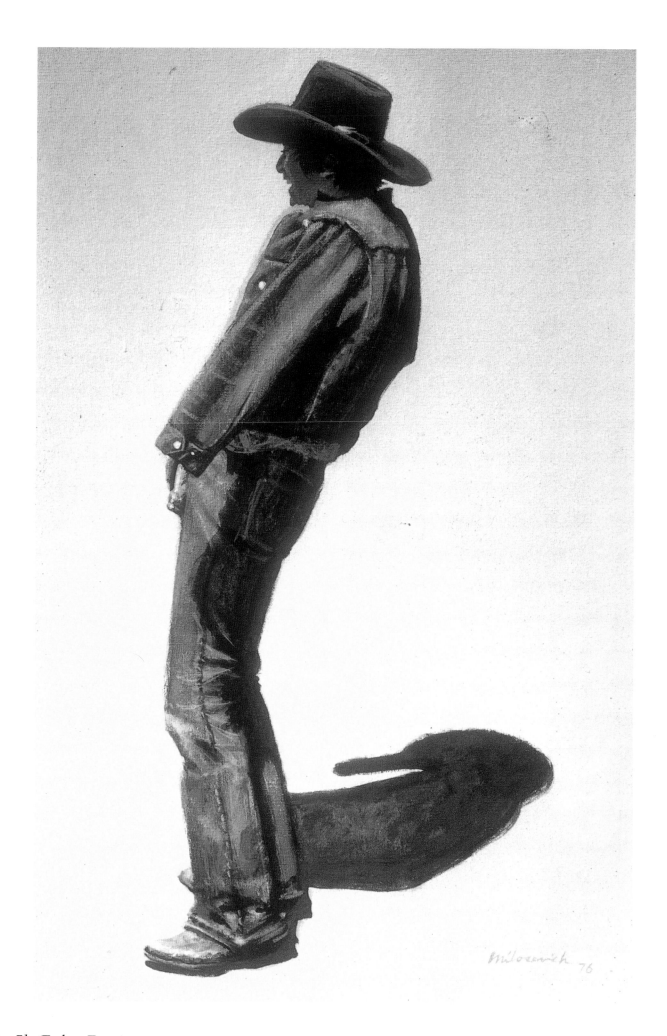

Joe Ely (Turkey, Texas)

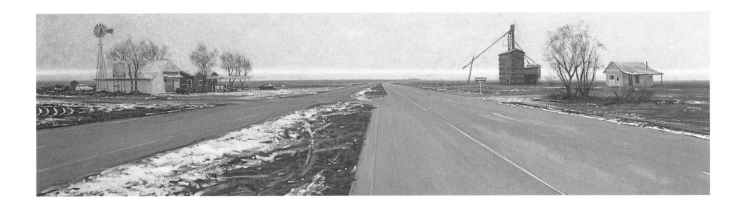

Crossover

Red Camper

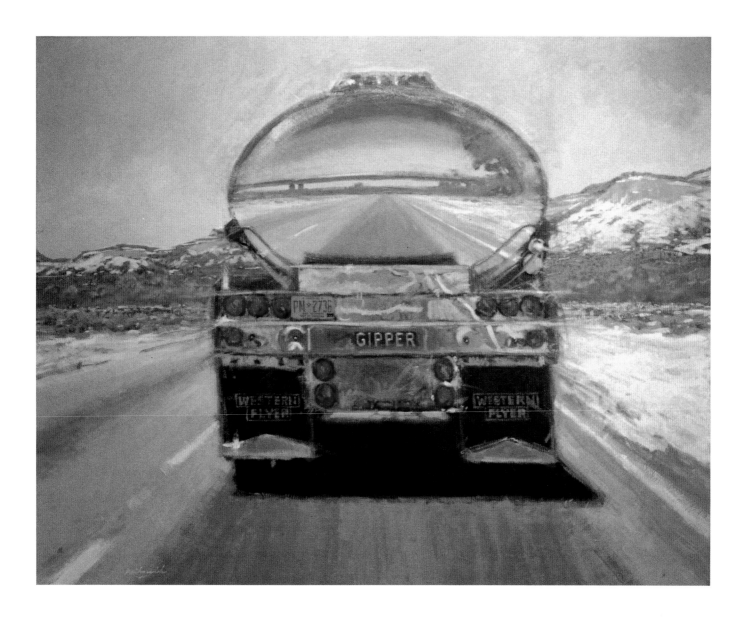

Milk Truck (rear)

Long before *True Stories* was filmed, Paul Milosevich captured the essence of the endless road on a billboard that didn't advertise a product. The idea suggested itself on a trip north from Austin in 1984. In the middle of the bleak landscape, he stopped, got out and stood in the middle of the road, and took several photographs. He enlarged these into the two-by-eight-foot painting *Crossover*. The Lubbock Poster Company decided to blow up the painting to billboard proportions. It was displayed at the corner of Broadway and Avenue Q in Lubbock without a syllable of sales pitch. Back at the office, the telephones were kept busy with people asking, "What's the deal?" Other callers were eager to identify the exact spot where the painting was made. The site identifications covered the country from Missouri to Melrose, New Mexico. Thus, Roscoe, Texas, was transformed inadvertently into a universal point in space.

The car as subject was not ignored by Milosevich. He painted a shiny red camper in Santa Rosa, the rear end of a milk truck speeding down the highway, and two front seat interiors reflecting the honky tonk

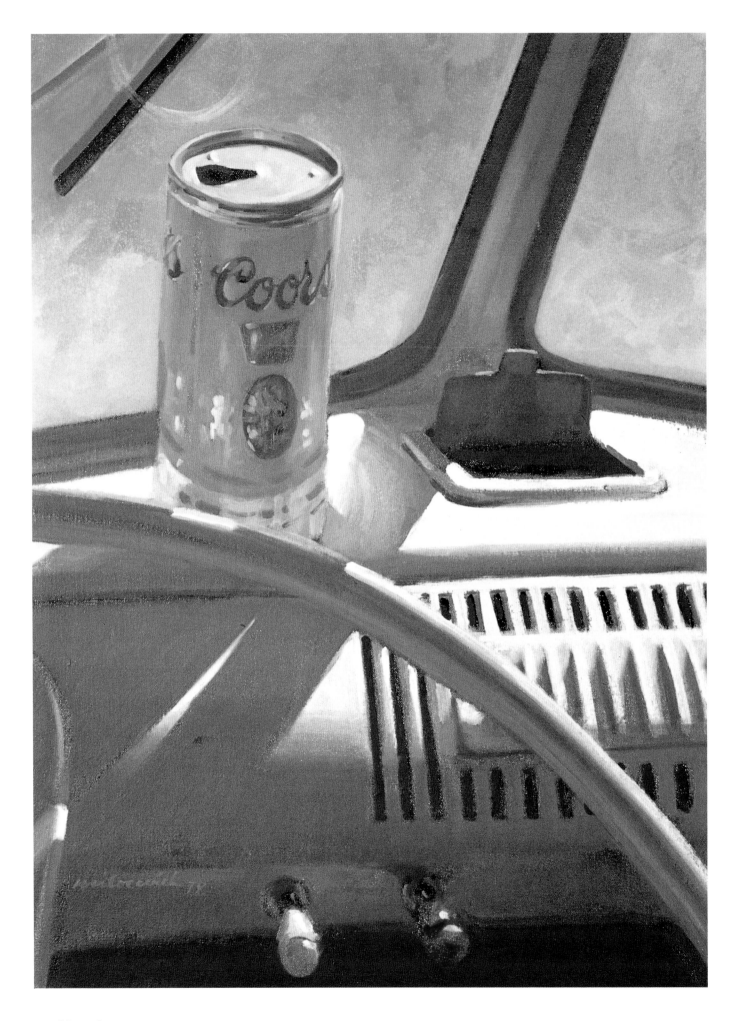

Dashboard

Drinkin' & Drivin'

life style. *Dashboard* has a strong pictorial design constructed around a Coors can on the dash, repetitive patterns of grillwork, the arc of the steering wheel, and the straight angle of the windshield wiper. The strong red accent on the beer can is balanced by the red knob of the cigarette lighter. Sunshine and reflected light are offset by the facelessness revealed through the windshield glass. The illusion is of an invisible driver piloting the car through the air.

The second car interior is called *Drinkin' and Drivin'*. In the catalogue for The Santa Fe Change, Michael Ventura calls the painting "one of the most powerful modern 'interiors' I know."[25] It is portrait of a woman's hands and jade-colored sleeves. One hand manipulates the steering wheel while holding a cigarette; the other hand holds a can of beer. Countering the green-blue

sleeves and the cool gray-greens of the upholstery, a path of red is traced from the grayed values of the sticker on the windshield to the red spot on the can, the glowing tip of the cigarette and the muted red of the lighter. The mind conjures up pop art images: the bronzed beer cans of Jasper Johns and the red lips of James Rosenquist's *Woman I*. The terse unconventionality of Milosevich's painting has a literary partner in Bill Porterfield's description of Aunt Arbie, a liberated woman. He sizes her up with the words: "[Arbie] was the only woman in our family to smoke a cigarette and cuss in public. . . . She even drank beer. . .while sitting in her car at drive-ins. *In broad daylight*. That's how bold she was."[26]

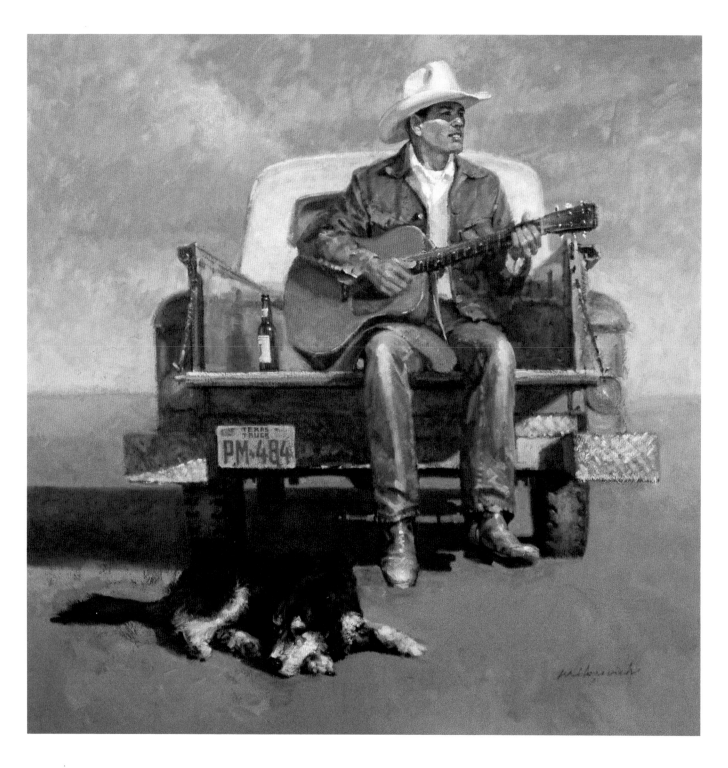

Nothin' Else to Do

Another Milosevich painting, this time of a truck, was a pivotal point of an exhibition hosted in the fall of 1984 by The Museum, Texas Tech University. Future Akins, interim curator of art, was one of the forces behind the idea of bringing together artists and musicians in an unexpected three-dimensional, multimedia, footstompin' tribute to West Texas music. The Museum took another innovative step; two art pieces were commissioned for the exhibition and then were to be installed in the permanent collection. Tony and Jennifer Greer produced a neon design of dancers from the "white sports coat and pink carnation" era, called *Barefoot Boogie and Blue Suede Shoes*. The second commission went to Paul Milosevich. He painted a West Texas

ranch hand sitting in the back of a pickup and strumming a guitar. Its title, *Nothin' Else to Do*, became the name given to the exhibition. During the fifties and sixties in Lubbock, "nothin' else to do" meant hangin' out at the Hi-de-Ho Drive-in, listenin' to the radio, or gettin' together with like-minded friends to do some pickin' on the guitar or banjo, playin' the harmonica or maybe the saw or washboard, perhaps formin' a jug band. An eloquent tribute to Milosevich's painting was written by Mikal Gilmore:

For me, one of the more memorable depictions of [the] push-pull between freedom and flight (the tension at the heart of so much West Texas music) was . . . a painting by Paul Milosevich of a young cowhand sitting on the rear end of a pickup . . . a look of intense yearning on his face as he stares over the illimitable Texas flatlands . . . dreaming a way out of his fateful indolence. Stationed just in front of the painting was an honest-to-goodness 1957 salmon pink Cadillac with charcoal blue upholstery. . . Taken together, the painting and the car told a timeless, virtually mythic story of longing and attainment. . .[27]

The Cadillac's pink fins pointed towards the heart of the exhibition, a tribute to C.B. Stubblefield of the famous Stubb's BBQ, and another of Milosevich's friends. From 1969, when the small place on East Broadway was opened, it was a haven to almost every musician worth his beer, whether from Lubbock or just passing through. Stubb's Sunday Night Jam Sessions offered a platform, a bit cramped in size but big in soul, to those on their way up and those on their way down. A musician could always count on Stubb's words of encouragement offered with humor and hot ribs and cold beer. A few years ago, when

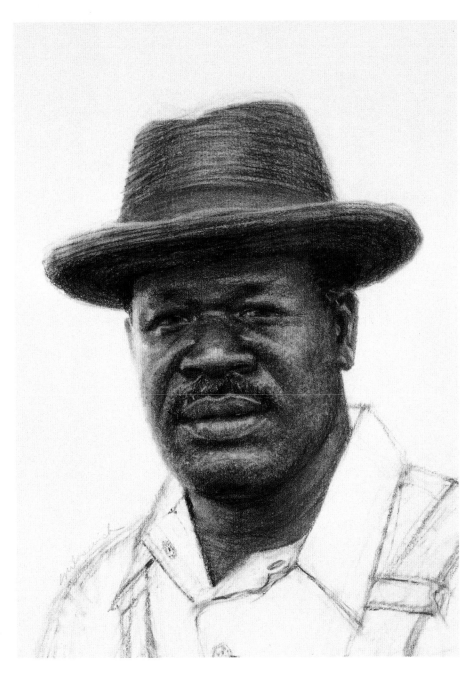

Stubb

Stubblefield was approached by the Internal Revenue Service, rumor has it, he responded to their charges of failure to file income tax returns with the severe logic, "I never made any money, why should I pay taxes?"

One of the legendary events that took place at Stubb's will challenge generations of folklorists. This is The Great East Broadway Onion Championship of 1978. It inspired a Tom T. Hall song by the same name which appeared in the album, *Places Where I've Done Time*. It was also the subject of a black-and-white painting by Milosevich and Jim Eppler. According to the painter, it all began one evening when Hall, Paul, Jim Eppler, and "a guy named Al" were sitting around drinking beer and talking. Hall had never met Stubb; to remedy this they drove out to East Broadway. When they got there, Joe Ely was shooting pool in the back room, and before anyone could say "eight ball," Tom T. was in the game. "Smoke was hangin' low and thick"; as play accelerated, it got hotter and hotter, and later and later. Joe's girl friend Sharon, who is now his wife, was tired and disgusted, so she pounced on the cue ball and carried it off. Refusing to be discouraged, Ely reached into a bag of Stubb's onions, took out a big one, and put it down on the felt to the disbelief of the kibitzers standing around roaring with laughter. He announced that he was going to play with a broom handle, which he did. Milosevich explains that this "cue stick" really sliced up and punctured an onion pretty badly, which meant that the onion had to be replaced from time to time. When the game ended, the table looked like a green hamburger covered with chopped onions before the catsup is added. Tears were streaming from the competitors' eyes as they battled on, until finally Tom T. was declared the winner of the championship title. Magnanimously, Joe Ely offered a rematch the following year, but Hall said, "No. There are a lot of good onion players out there, and they deserve a shot at the title, too." In Milosevich's and Eppler's painting, Tom is grinning on the left. Ely is easily identifiable by the broomstick he holds. In the background, Jim Eppler and the painter, drinking beer, are back to back with profiles facing in opposite directions like the Roman god Janus.

In 1984, when Stubblefield locked the door of his barbeque parlor for the last time before moving to Austin, Future Akins and Clyde Jones, the University Museum director, were on hand to salvage as much of the history-making memorabilia as possible and to organize the mementoes into a three-dimensional display for the Nothin' Else to Do exhibition. The tribute to Stubb occupied a display area where the booths and posters were arranged. Gazing down upon the old piano was a deer's head, glass eyes staring through dark glasses. Hanging on a wall, the famous sign announced "There will be no BAD talk or LOUD talk in this PLACE," and another placard carried the instructions "Equal time for all musicians. No more than 2 guitars at a time. Thank You."

Milosevich says, "Now on East Broadway, where Stubb's little joint was, there's just a bare concrete slab with a lot of good vibes still hovering above it. Recently, Stubb stood on that slab, looking around East Broadway, and then returned his gaze to the bare concrete. He laughed, 'It's like looking at the bottom of a good cup of coffee!'"

Nothin' Else to Do helped pave the way for the Texas Tech Museum's response to the state's sesquicentennial anniversary in 1986. Gary Edson, Museum director, and Future Akins, at that time curator of art, planned an unusual recognition of the musicians and artists who had tapped the vital forces of the South Plains. A review of the exhibition in *Artspace Magazine* describes that background:

In the last decade, chunks of Texas have been seized by metroplexamania and stamped by the boots of office cowboys working-out on mechanical bulls. Driving along West Texas roads, however, a nostalgia for simpler times is still stirred by songs drifting from jukeboxes in cafes and truck stops. The songs wail with memories of warm hearts, cold lips, 90 proof whiskey, and unrequited love. The neon glowing in the blackness, the music, and rubbin' elbows inspired Honky Tonk Visions.[28]

Honky Tonk Visions invited live performances by musicians and art inspired by the honky-tonk theme. Among those participating, Terry Allen built a three-dimensional environment that was a tribute to old friends and memories.

A white wooden bed was the focal point. All over the amorous piece of furniture there were words from favorite love songs inscribed in multicolored paints and markers by Lubbock musicians and high school buddies. The museum staff gasped one afternoon to see members of the Maines Brothers Band piling from their bus and running into the gallery so each could write a few lines. . . .On the night that Honky Tonk Visions opened, the bed was suspended within a room enclosed by solid walls on two sides and a screen mesh defining the remaining side. Pierced by emotions, the bed was penetrated by knives, swords, hatchets, and machetes. . . .Every ill-fated lover suffering from love, deserted by love, abandoned in the mournful words of country and western music, once slept here.[29]

The Great East Broadway Onion Championship, 1978

Honky Tonk Vision

Milosevich's painting *Honky Tonk Vision* represented the opposite side of the coin—Sunday morning at Katie's Lounge, in Odessa, after the patrons have danced the last dance and slipped slowly off into the night. Only two cars are left soaking in the warm sun, which shines with the clarity of the light that sifts over the architecture in Edward Hopper's paintings. Katie's is the center of a triptych with a cowboy fiddler on one side and a girl playing a guitar on the opposite panel. They express a healthy exuberance that seems to

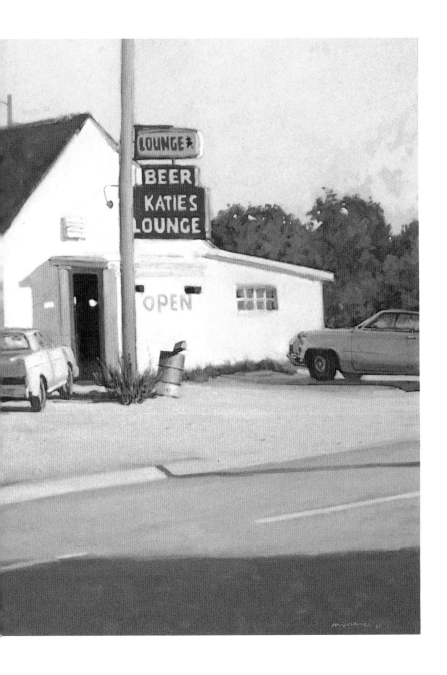

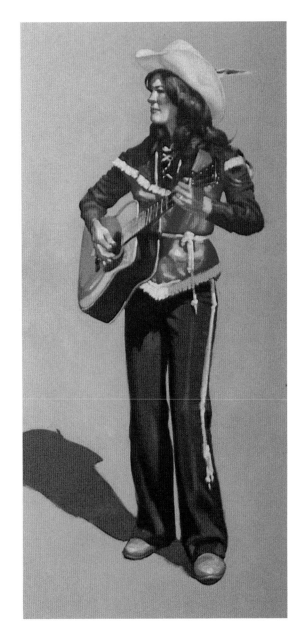

illustrate Gilmore's proposition: "In West Texas, musicians are free to play what they like. . . . After all, in a territory so vast and unpopulated, freedom is a fact of the air and the land; nobody can tell you what to play or dream on your square acre, because the land is big enough for you to dream as you please, unconfined."[30]

Santa Fe, New Mexico

ilosevich has called Santa Fe "a great escape place." In 1981, he and Deborah decided to try living there. The basic facts were condensed by the artist into a paragraph. It begins:

There's a lot of ways "to do" Santa Fe. The best way is if an artist already has an established reputation and steady income. Otherwise, one must be prepared for a struggle, which Deborah and I did for about three years. (Our son Vincent was born there in 1982.) We bought an old adobe garage in the "ghetto" on Agua Fria Street and set about remodeling it. Dope dealers and neighbors who played loud disco music nonstop, loud traffic, a sky full of power lines, leaky roof and primitive plumbing is how we "did" Santa Fe. We each worked a half day and baby-sat Vincent a half day. . . . In March 1985, Deborah and Vincent moved to Lubbock. I stayed in Santa Fe another year, sold the place, and returned to Lubbock to be near Vincent (p. 105). Deborah and I divorced in 1986. "Down the Road," a song recorded by Bill and Bonnie Hearne, helped me through some rough times.

Nonetheless, the painter acknowledges his love for Santa Fe:

Geographically, it reminds me of Trinidad. The cosmopolitan mix— Indian, Hispanic, Anglo, plus visitors from all over the U.S. and Europe—is unique. So are the adobe-style buildings, wonderful restaurants (Josie's), and dozens of art galleries. It's possible to see live Indian dances and live opera on the same day. . . . As always, my work was a steadying influence.

The development of Milosevich's painting during the Santa Fe years was the remarkable part of the experience. In discussing Santa Fe with Michael Ventura, Milosevich divides his paintings into three phases.[31] A period of introspection was brought about by the death of his parents in the early 1980s. The result was the family portraits painted with great sensitivity and tenderness, and the views of the Trinidad farm.

The time for remembering was followed by a second phase, whose beginning the painter describes as the moment when "I started feeling like I belonged in Santa Fe, instead of just being a trespasser." This period is marked by portraits of local characters and is associated with a charcoal drawing of Pat Barela (p. 104), a Taos woodcarver. Barela was a

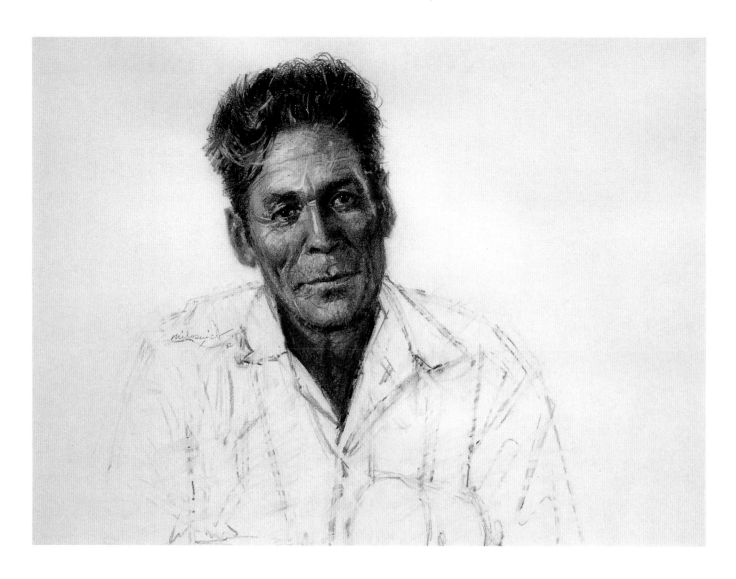

Pat Barela

friend of Frank Waters, who regards the thoughtful likeness as one of Milosevich's best accomplishments.

Another fine portrait, belonging to this same period, is the painting of Josie (p. 105), famous for her home-style Santa Fe restaurant. She is painted behind the cash register; her rosy, sympathetic face radiates warmth, as well as pride in her kitchen, which is in the background. The textures of plaid cloth, pottery cups, transparent glassware, bowls, a jar of mayonnaise are painted with a keen eye for detail. In the foreground, the composition includes the repeated circles of crusty pies and the tilted circular units for holding knives, forks, and spoons. Josie's portrait accomplishes for a family restaurant something of what Manet achieved for the Folies-Bergère with its buxom barmaid. Here, however, instead of dazzling reflections in a mirror, there is an invitation to look into the comfortable homeliness of the kitchen with its fragrant odors

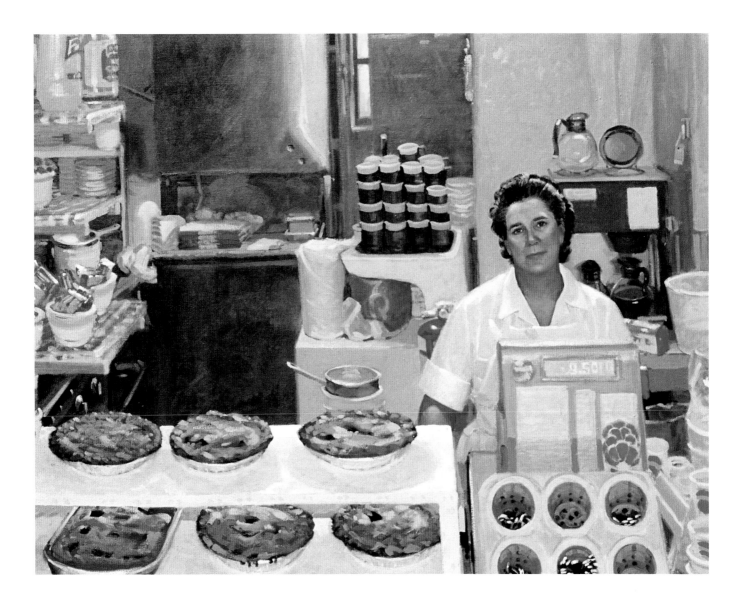

Josie

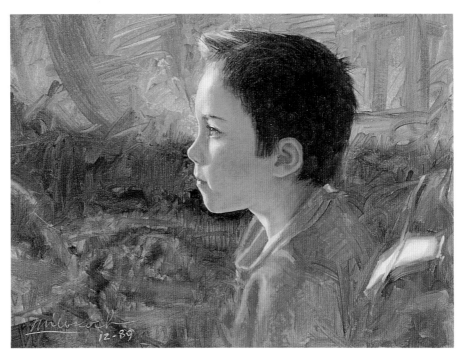

Vincent

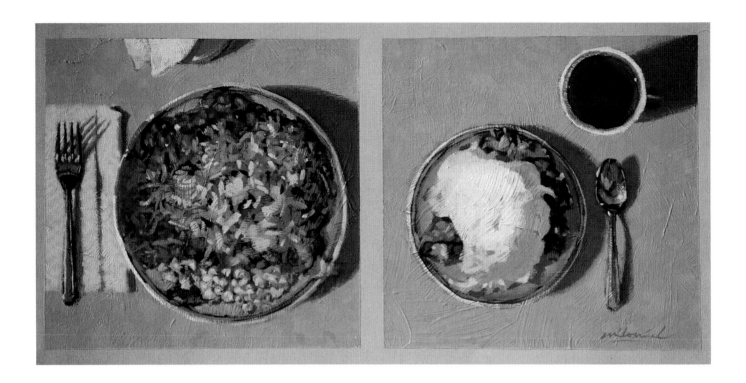

Josie's Combo

and satisfying food. Food as a subject was painted in *Josie's Combo*, a delicious order with a slight tang of pop art and a nod to Wayne Thiebaud's recipe for similar themes.

Antonio Fernandez, a Santa Fe newspaper seller, appealed instantly to the artist. Milosevich says, "When I first saw him standing in the middle of the street with his papers, I said, 'There's my Dad in Santa Fe!'" Fernandez had no objection to being painted. When the canvas was finished, it was hung in Josie's restaurant. The artist sat down to wait for the paper seller's reaction when he came in with his stack of daily papers. As the story goes, Fernandez walked in without looking around. When he came to the artist's booth, Milosevich asked him what he thought of his portrait. Fernandez looked at it and responded, "That's pretty nice. Want to buy a paper?"

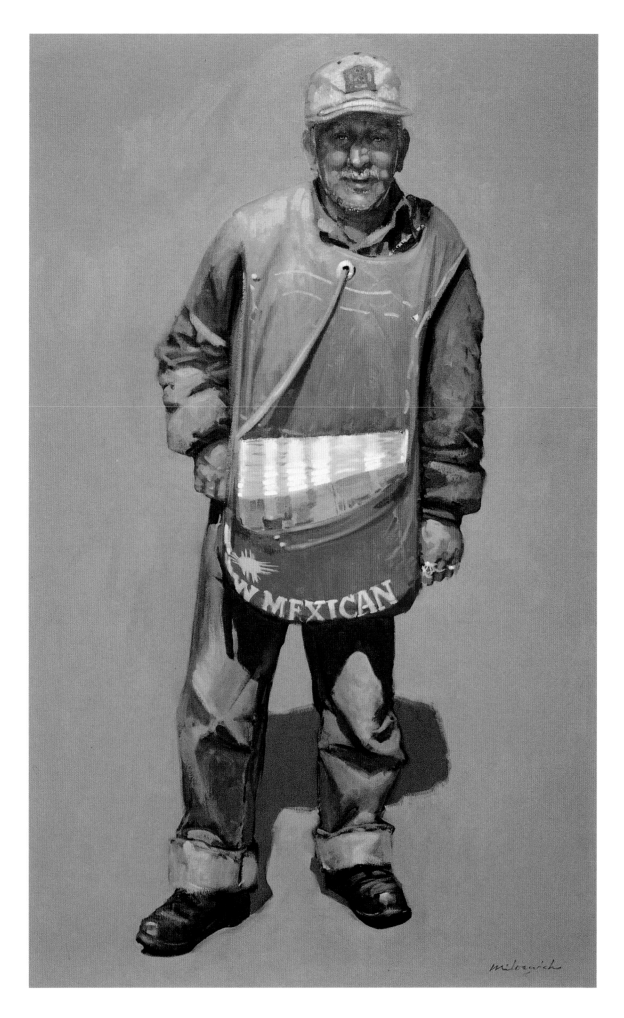

Antonio Fernandez

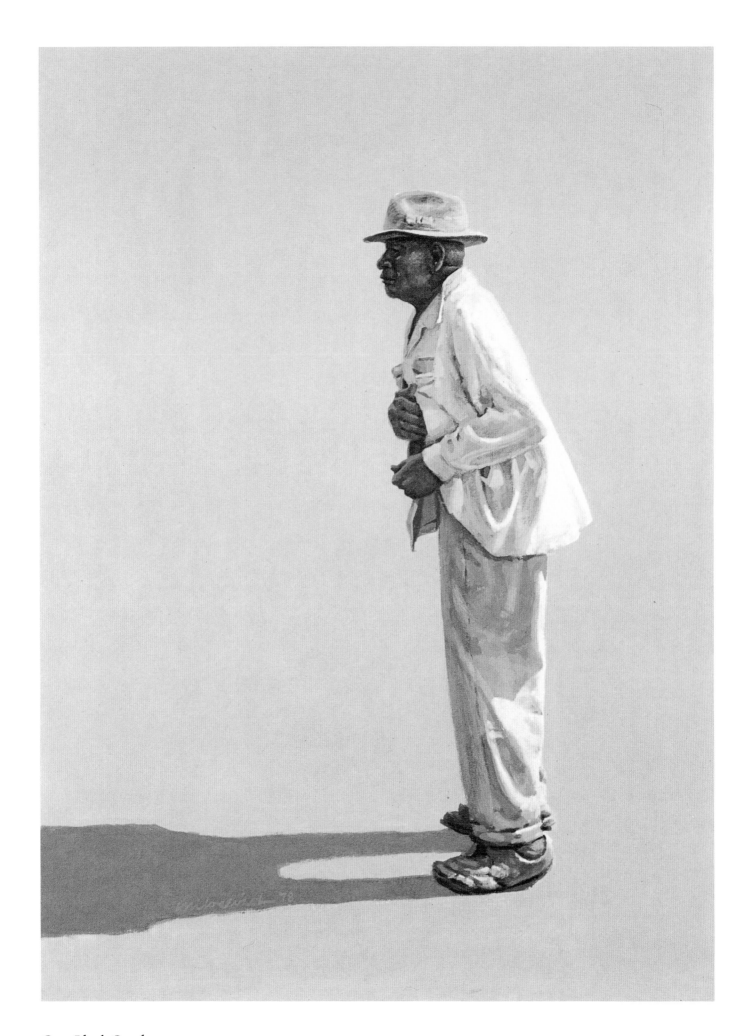

Gray Black Gentleman

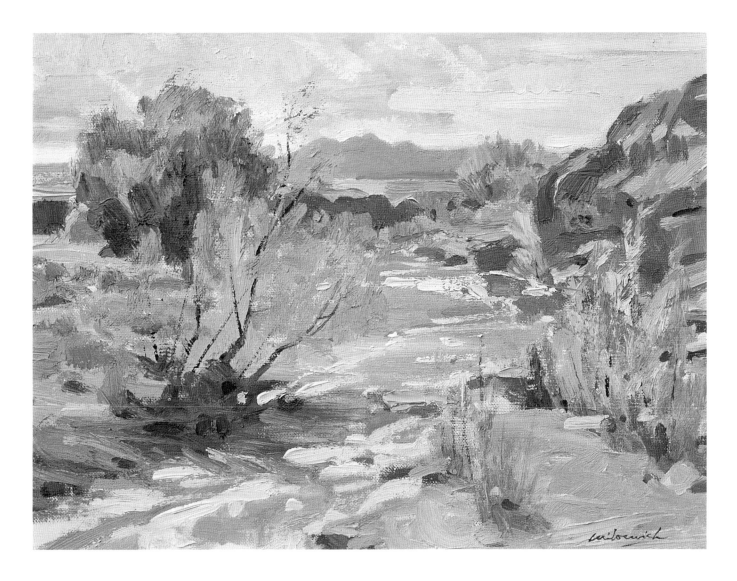

Cerrillos Creek

Another subject linked to the painter's father was that of *Gray Black Gentleman*. It was the way the black gentleman stood, with his too-large clothing hanging limply on his small body, that awakened memories. Asked what for him was an effective subject, Milosevich answered, "Wherever I go, I see really interesting people. Something clicks, and I know that person reminds me of something from my past."[32]

The third period in the Santa Fe years explored new avenues of style and technique. Having been a studio painter for most of his career, Milosevich was accustomed to using photographs and sketches of subjects; suddenly, in New Mexico, he began to go out-of-doors to paint, working rapidly and directly in the changing light, making on-the-spot observations. He tells about the changes:

[In Santa Fe] other artists like Woody Gwyn, Ray Vinella, and Elias Rivera would encourage me to go out and paint with them, and we'd paint together. It was one of the most satisfying, honest things that I've ever felt. I'd pack a lunch, go out, do a painting in the morning, take a lunch break, then do another painting in the afternoon, and come home at night with two paintings! It just felt so honest. My direct response to nature.

I remember once being in an arroyo shielded from the wind. The sun was beating down in this arroyo, and it was really quiet. You'd hear a bird once in a while, or occasionally you'd hear a car in the far distance—but it was just me and the sun in this arroyo. It's kind of like an active meditation. Like I was meditating on the rocks and clouds and the mountains, and how the sunshine was striking these objects, but instead of just sitting there and looking at it, I was painting it. I can't describe it, except that it felt like damned near the most meaningful way that I could spend a day.

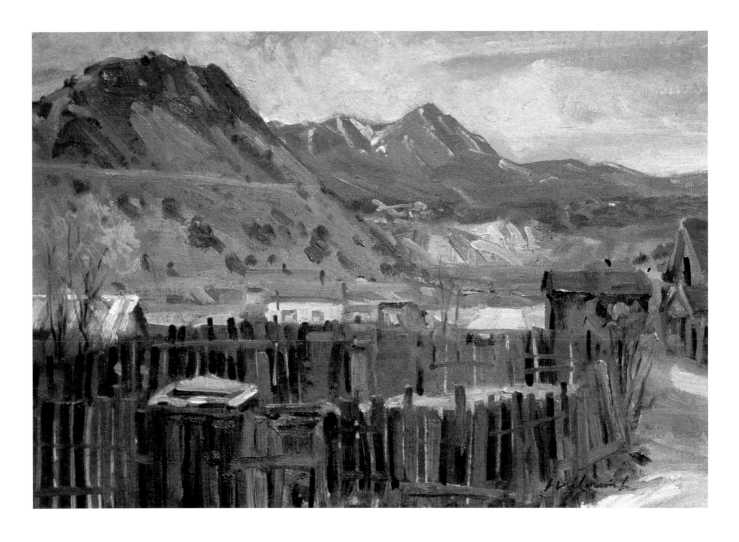

Madrid

There's this little town of Madrid.
. . . I remember one day Elias Rivera
and I were painting there, and I
painted some old buildings that had
kind of a coyote fence around them,
or a goat fence. It was in the spring-
time, pretty cold and windy, and I
almost got the painting done when
the wind blew my easel over. Right
behind me was an abandoned barn
that was made out of corrugated tin,
so I moved my stuff into the barn.
There was a window without glass
looking out over the scene I was
painting, so I thought I could finish
the picture in there. One whole side
of this barn was gone, missing. It
happened to be the north side, so
north light was coming in this
whole open side of the barn. The
other three sides protected me from
the wind. So I was painting inside,

but I was actually outside . . . I fin-
ished the painting, and then Elias
and I went to this little restaurant in
Madrid, run by a guy from
Switzerland—a fantastic cook,
makes pastries and all that—and
Elias had done a nice painting, and I
had done a nice painting, and we're
sitting there having lunch and
laughing and saying, "Hell, it can't
get any better than this! I mean, this
is the best it can be!" It's like keep-
ing the best kind of diary you could
possibly keep—your immediate
response to having lived this day
at this time.[33]

Painting outdoors, Milosevich's
palette didn't change, but he says
that he painted in higher values.
Working in sunlight "pitched values
up to a higher key." When he began to
do landscapes on the spot, he found
that his sky was usually too dark.
Painting in the morning, Milosevich
found that the light was always com-
pletely different from the light and
its effects on colors in the afternoon.
In this context, Robert Henri
observed of his own paintings in
New Mexico:

Especially in painting brilliant sun-
light, working outdoors is difficult,
for it takes a long time to get your
eyes accustomed to the difference
between light and pigment so that
anything like a translation can be
made. In fact I think most pictures
in the Southwest are to a great

Charlie Stewart's Place

extent false because the painters get blinded into whiteness, make pale pictures where the real color of New Mexico is deep and strong.[34]

"Painting in the middle of nature, you have to think on your feet," Milosevich acknowledges:

You can look around and add details from out of the scene you've decided to paint, or you can eliminate a detail that doesn't work properly. A photograph is much more restrictive in this sense. Painting from life has helped in using photos. It has helped me see into shadows. In photographs, the shadows have uninteresting values. In nature, shadows are filled with reflected colors. Paint outdoors for a year, you'll become a

different painter. It's a communication with nature. You feel the sunlight hitting you on the back, hear the crows. You think you must have died and gone to heaven.

These points are excellently illustrated by *Charlie Stewart's Place*. A backdrop of distant blue peaks rises above a meadow painted in rich colors laid on quickly with brush loads of thick pigments, each stroke defining a rock surface or a swath of grasses. The shadows cast by the stones are touched with pure blue, while warm siennas and ochres

John's Place

enliven the rock formations. *John's Place* is equally spirited, recording the first touches of spring greens and the pale yellow froth of budding leaves.

A warm adobe wall stands on ground sun streaked with light beige and darker reddish tan suggesting the gentle peace of *Dasburg's, Taos. Taos Afternoon* (p. 114) has as its subject an earthen wall against which a figure wrapped in a white blanket sits. The hypnotic blue of the door and window frame introduce a meditative magic that exerts a strong fascination. Painted in more direct

Dasburg's, Taos

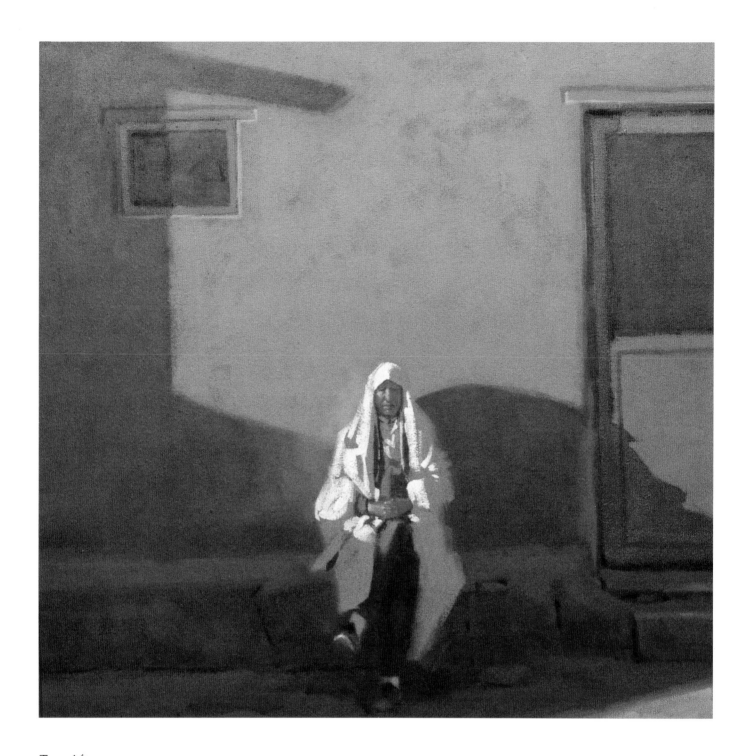

Taos Afternoon

sunlight, the beige adobe of *Warm Place, Taos* sends out heat waves engulfing the men basking in their places in the sun. The foreground shadow is painted with impressionistic touches of the brush weaving together tan and rose with the blue-gray and soft green strokes. The reflected heat from the old wall has sent a small dog into a sheltering shadow cast by a neighbor's quarters.

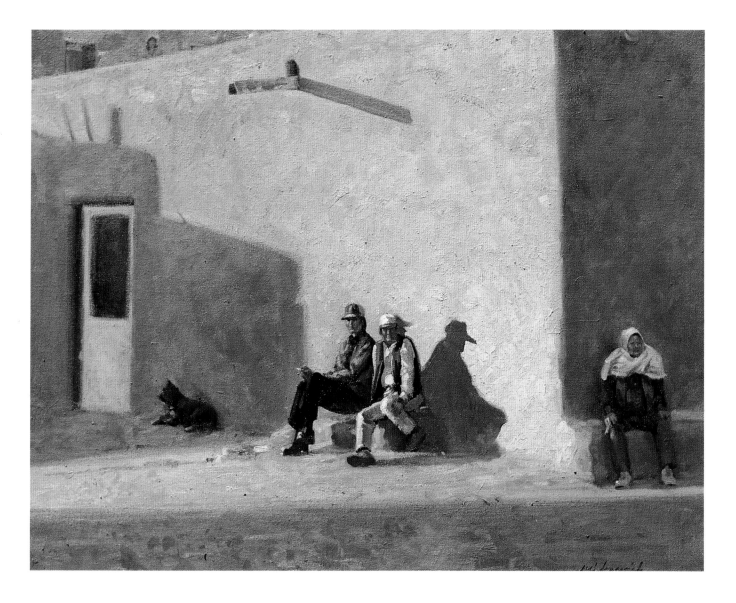

Warm Place, Taos

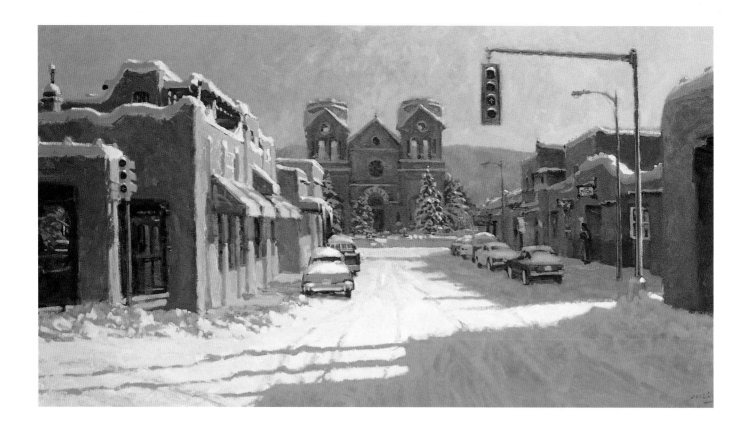

Sunday Morning in Santa Fe

There are two winter landscapes that have something new and personal to say about Santa Fe, at a time when nothing seems to have been left untouched by generations of artists. (Even collectors and critics moan, "Not again!") *Sunday Morning in Santa Fe* reveals a snowcovered street looking toward the cathedral. La Fonda stands on one corner and the row of shops opposite are shadowed by snowy awnings and icicles. The painting is so unpretentious, wiped clean of tourists and inhabitants alike, that the pristine vision expresses pure joy. The shadows on the snow and the sunlight on adobe carry on a badinage of blue and yellow-orange. The winter chill is moderated by the sun and clear air. For a moment, time stops.

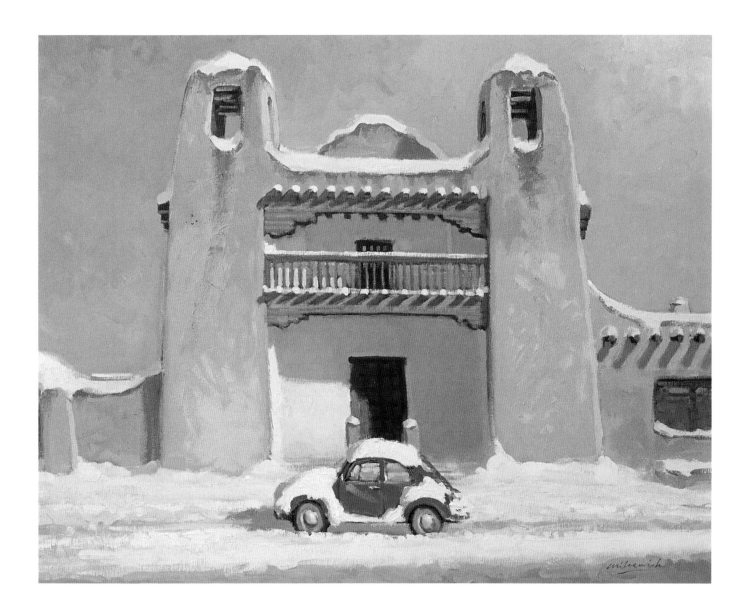

Santa Fe Museum

A second painting of winter in Santa Fe has as its vantage point a head-on view of the Art Museum. The immovable buttresses are forced to endure the impertinence of a snow-covered red Volkswagon parked on the street, symmetrically aligned with the recessed entry porch.

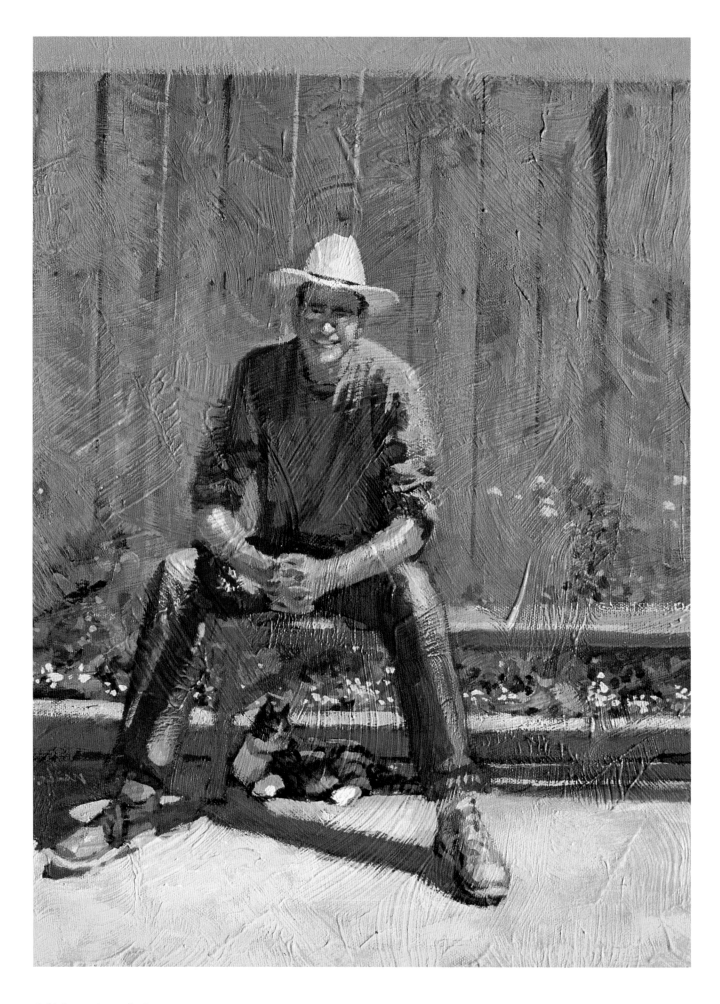

Self-Portrait with Cat

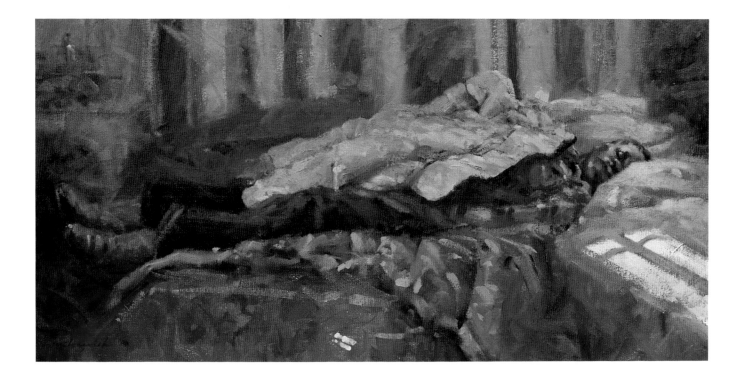

Stubb Napping

The same brilliant colors charac-
terize a self-portrait painted in sum-
mer from a photo of the artist sitting
in front of the boards of the garden
fence. Aunt Sister is lying content-
edly in the shadows of her owner's
legs.

Colors heat into a glowing array in
a painting of Stubb napping in a dis-
array of blankets and quilts. This
stirs visions of Delacroix's voluptu-
ous harem paintings in North Africa,
or it could pass for a tongue-in-cheek
parody of Matisse's *Odalisques*.

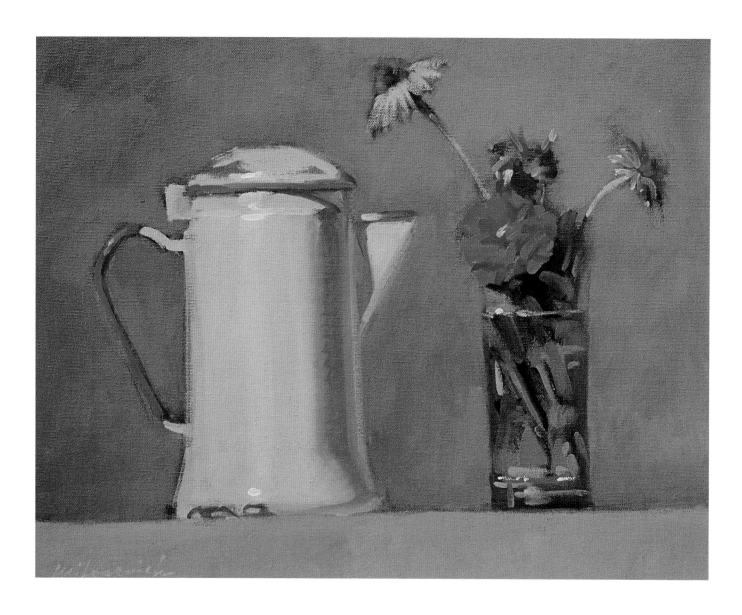

Enamel Pot and Flowers

The hours spent painting at the site in the changing light that changes with each hour—catching illusive impressions with rapid brushwork, seeing color in a different way—brought about remarkable developments in the paintings that the artist continued to do in his studio. The change in studio work is illustrated by *Enamel Pot and Flowers*, painted in Lubbock, and *Kitchen Still Life*, from the time spent in Santa Fe. The painting of

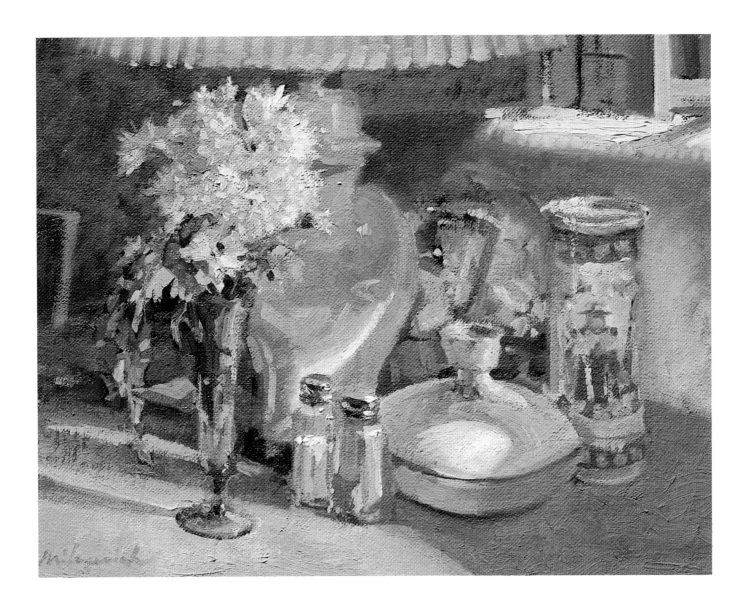

Kitchen Still Life

the coffee pot and the transparent glass with flowers reveals a delight in the array of contrasting surface reflections and in the solidity of inanimate objects contrasting with the impermanence of the flowers. The brushstrokes in the kitchen canvas seem to perform a dance, with dabs of thicker pigment forming a counterpoint to the washes of thinly applied color. Once the artist touched brush to canvas, there was no turning back.

Painted in a similar vein, Aunt Sister sits outside on a window ledge staring at the snow banks. The sun peering through the glass warms the red geraniums inside and sends elongated shadows across the table. The colors are subtle and sun washed. Light is the subject.

A comparison of a painting of a hammer (p. 124) and one of a carburetor (p. 125) provides a strong contrast. Milosevich's "portrait" of his father's hammer shares a kinship with pop art in the exaggerated size used to represent a simple tool. But more important to the essence of the painting is its commemoration of Matt Milosevich's everyday labors and skills, and of his hands, which left their imprint on the wooden handle. There is a monolithic endurance about the subject with its contrast of cold steel and the friendlier wood. *Carburetor* is rooted in modern inventiveness. In its abstraction, it is close to Picasso's analytical cubism. The delicacy of overlapping planes and tonal gradations produces a shimmering, almost-human mechanism. Moreover, the circle with its curving projection resembles the mask of a one-horned kachina dancer. *Carburetor* possesses a bond with the mysterious transformations that seem to exist for those living in the shadows of the Indians' sacred mountains.

Milosevich has summarized the effect that Santa Fe has had on him as an artist: "Artistically and spiritually, Santa Fe was a very meaningful experience. Artistically because of the art and artists. . . and seeing the light and beauty of the place. And spiritually because for the first time in my life I experienced a 'oneness' with the universe. Not as a matter of faith, but as a matter of fact."

Milosevich remembers an afternoon drive to Galisteo:

Noticing the highway, chamisa, clouds, cars, fences. . . the thought occurred to me that if, for some reason, the sun didn't come up tomorrow, all of this would disappear. . . . that means that everything and everyone is totally dependent upon the sun. Further, we are all manifestations of the sun. The sun is in us and we are in the sun. For the first time, I felt "tied" and interwoven into the cosmic scheme of things. As a matter of fact, not belief. It was quite a revelation. Of course, the sun is totally dependent on a still larger system, and so on, until one arrives at the Source. . . . It seemed logical to me that whether we realize it or not, or acknowledge it or not, everything and everyone is part of that Source and that Source is part of us.

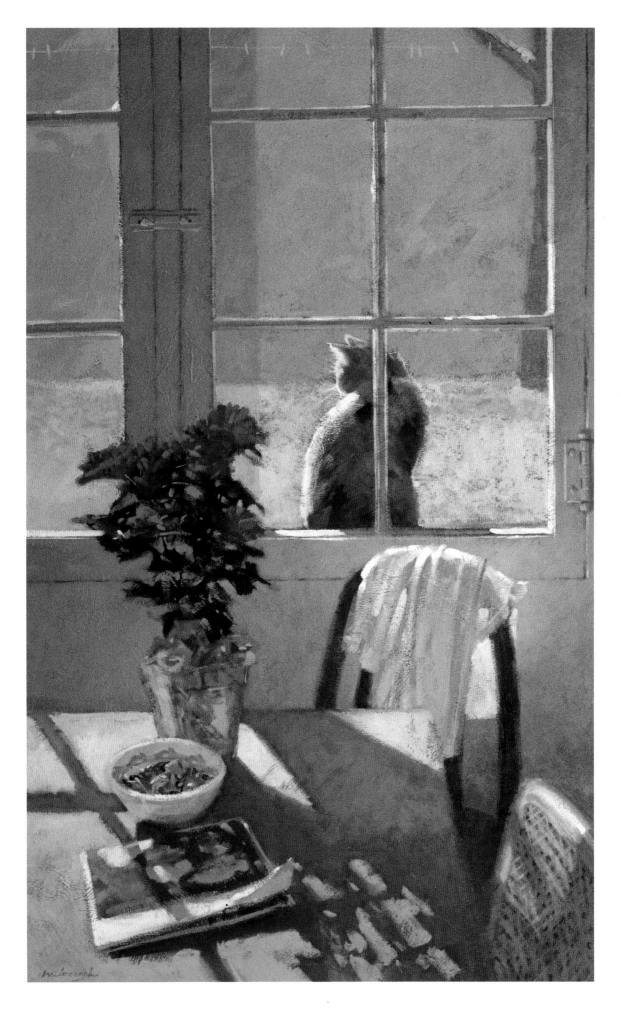

Aunt Sister

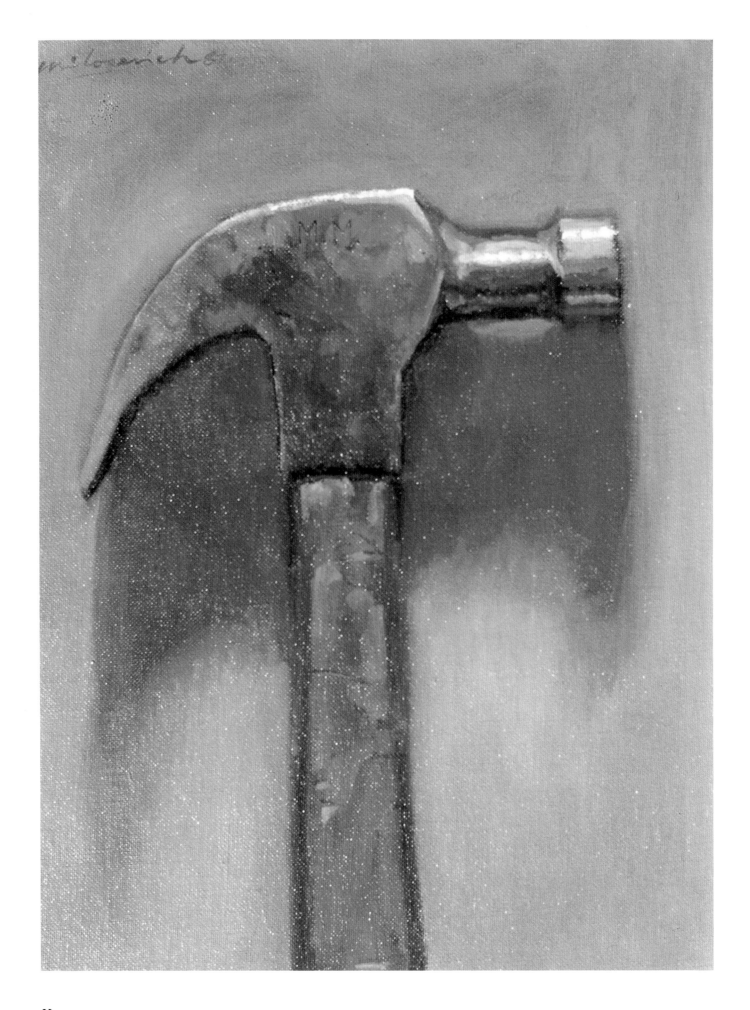

Hammer

Carburetor

My search for other horizons has led
me around again to my first one
Paul Milosevich

Golf

I began sketching golf subjects as a teenager in the 1940s," Milosevich says. Growing up on a farm next to a golf course offered the natural incentive for a boy to caddy as a way of earning pocket money. Learning the game by watching the local stars and practicing when time permitted followed in a logical sequence. If the caddy had a talent for drawing, also, what better subjects could be asked for than golfers with their active poses and, for still life, golf gear. A memento from his youth that the artist has kept with him always is a notebook whose title page introduces his comic-book style version of Ben Hogan's "life story." It is dated June 7, 1950, the year that Milosevich won a caddy tournament prize in Denver. Ben Hogan's autograph was inscribed years later on May 12, 1987.

It was not until the 1980s that the idea of becoming a "golf artist" struck Milosevich as an interesting possibility. "Maybe," he speculates, "it takes me a while to catch on. Slow learner. But I never knew anyone who was making a living [in this field of specialization]." The triggering device was a "senior" golf tournament, the Liberty Mutual Legends of Golf, held in Austin. There were, the artist says, "many wonderful professionals over the age of fifty. Since that was about my age, it gave me the idea to focus on golf as a subject and . . . become an active player again, which I did."

The growing popularity and prestige of the senior tour gave impact to the notion of doing a series of golf portraits like those of the country and western musicians and songwriters. There is a fine charcoal drawing of Ben Hogan, and a painting of *"The Hawk"* (p. 129), a painting of Hogan seated on the ground. Portraits of other golf legends include the drawing of Byron Nelson (p. 130) and *"The Slammer"* (Sam Snead) (p. 130), a composition in sepia tones, in which the gallery of watchers is painted in a lower key to intensify the concentration on Snead in his snowy white shirt and white hat. A former member of the Texas Tech faculty, Don Flynn (p. 131), is painted in a more vivid palette.

Contrary to what might be imagined, golf has occupied a place in the history of art at least since Rembrandt, who was not oblivious to an early Dutch version of the game known as *kolven*. There is an etching, dated 1654, commonly

Ben Hogan—Life Story (1950)

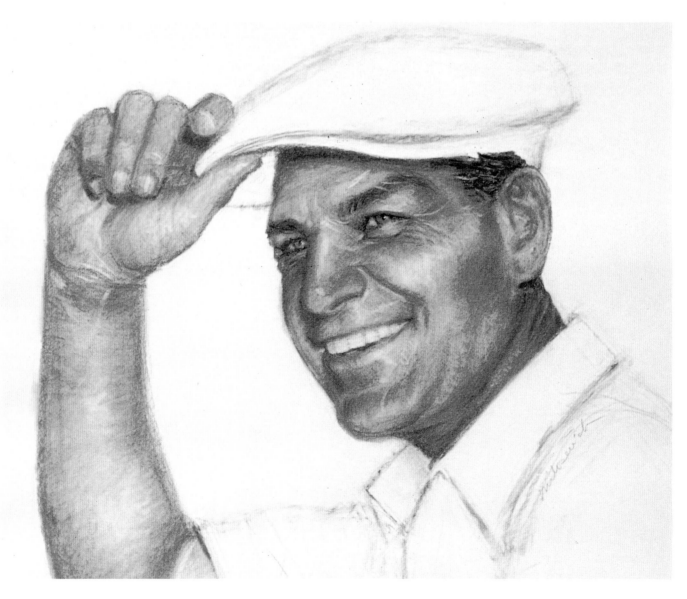

Ben Hogan

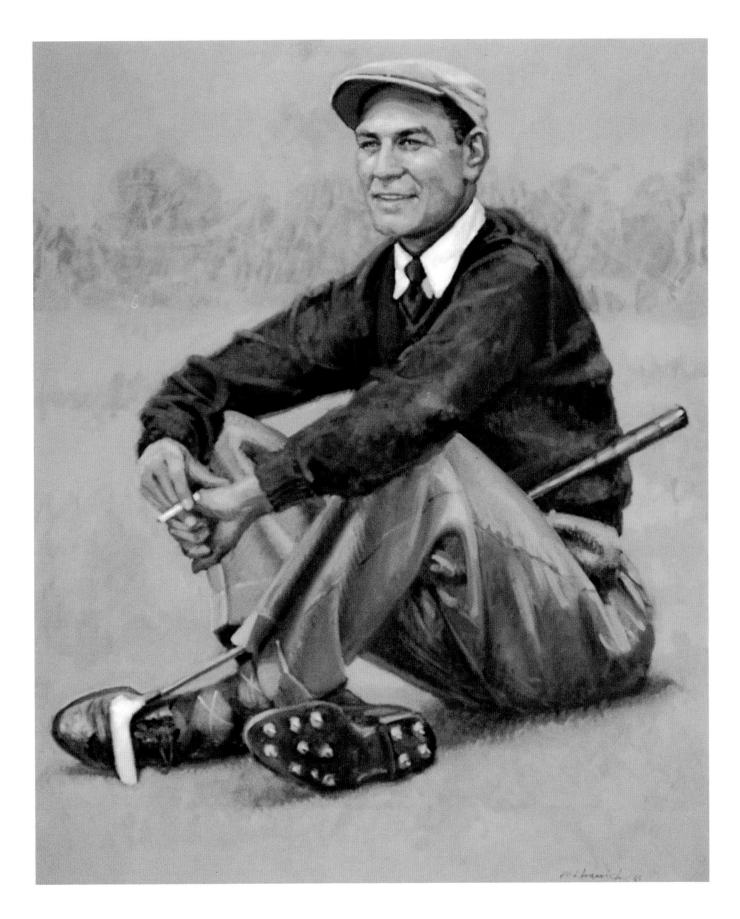

"The Hawk" (Ben Hogan)

Byron Nelson

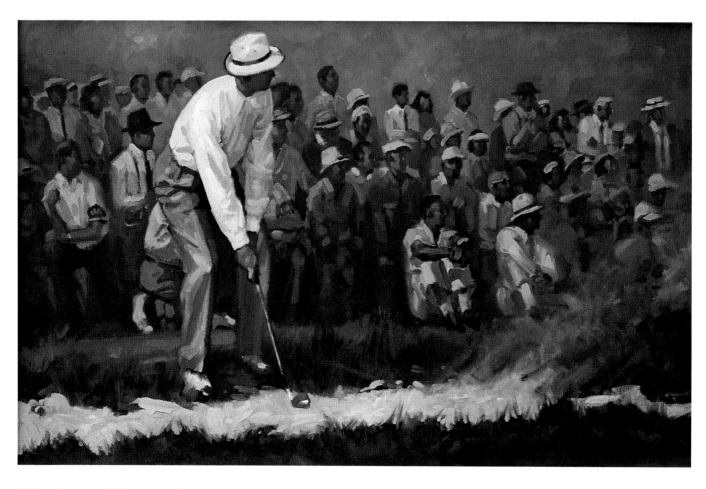

"The Slammer" (Sam Snead)

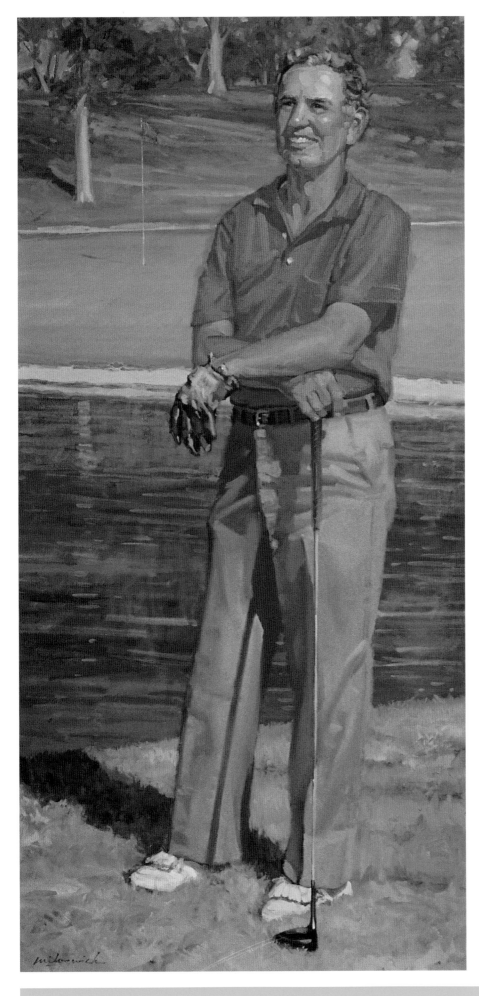

Don Flynn

called *The Golfer*. Through the open door of an inn, a fellow is seen striking a croquet-sized ball with a "club" that resembles a small spade or garden hoe. Another seventeenth-century Fleming, Paul Bril, was responsible for a landscape in which a group of golfers apparently are discussing the loss of a ball.[35] In 1917, George Bellows's *Golf Course—California* was placed in the midst of a landscape of mountains and valleys[36]; six years later, Childe Hassam captured the "gentle joy" of playing in a mixed foursome at Maidstone Golf Club.[37]

As a result of the growing interest in Milosevich's paintings and drawings devoted to golf, he was invited in May 1988 to exhibit twenty pieces at The Sporting Scene, a Dallas gallery specializing in art related to sports and sporting events. A reviewer called attention to the painter's "thorough knowledge of the golf swing, his love for the total golf course atmosphere, plus his technical mastery of [the] figure, still life, and landscape painting, [which] make him extremely qualified to capture the look and feel of the golf scene. . . . He prepares for his golf portraits by playing golf with his subjects, snapping action photos and sometimes even conducting a painting session at the fairway's edge."[38]

The exhibition in Dallas brought about an important commission. The United States Golf Association wanted a portrait of Patty Berg. This was unveiled in August 1988 at the National Women's Amateur Golf Tournament in Minneapolis; from there the portrait was sent to New Jersey to be housed permanently at the Far Hills USGA Golf House Museum. Milosevich remembers seeing Berg in old news reels. She won thirty-three pro tournaments after 1940, and helped to establish the Ladies Professional Golf Association in 1948. To meet Ms. Berg, the artist flew to Fort Myers, Florida, where she lives. They spent time talking and looking at scrapbooks. With an extra hour to spare before the return flight to Texas, the famous lady gave her guest a short putting lesson. The painting represents Patty Berg in her golfing prime with the sun in her face and her golf club lifted over her shoulder.

In addition to the portraits, there are several paintings of golf equipment. *My Sticks (I)* has as its subject a golf bag leaning on a leather chair with two favorite pieces of head wear, a light-gray soft-brimmed hat and, in the foreground, a white cap with a visor. The artist calls this "my most traveled painting." Owned by Tom T. Hall, the oil painting hangs in his tour bus. *Golf Glove* (p. 135) appears to have earned a life of its own free from the human hand. It palpitates with brilliant yellows and touches of red and emerald green applied with brushstrokes that give the effect of the tesserae of a Byzantine mosaic.

Milosevich observes contentedly that after working at painting and drawing for thirty years, "it's great to get a Mulligan [a second chance] to combine two of my loves—golf and art." He muses, "One of the nice things about being an adult is the chance to realize the dreams of childhood."

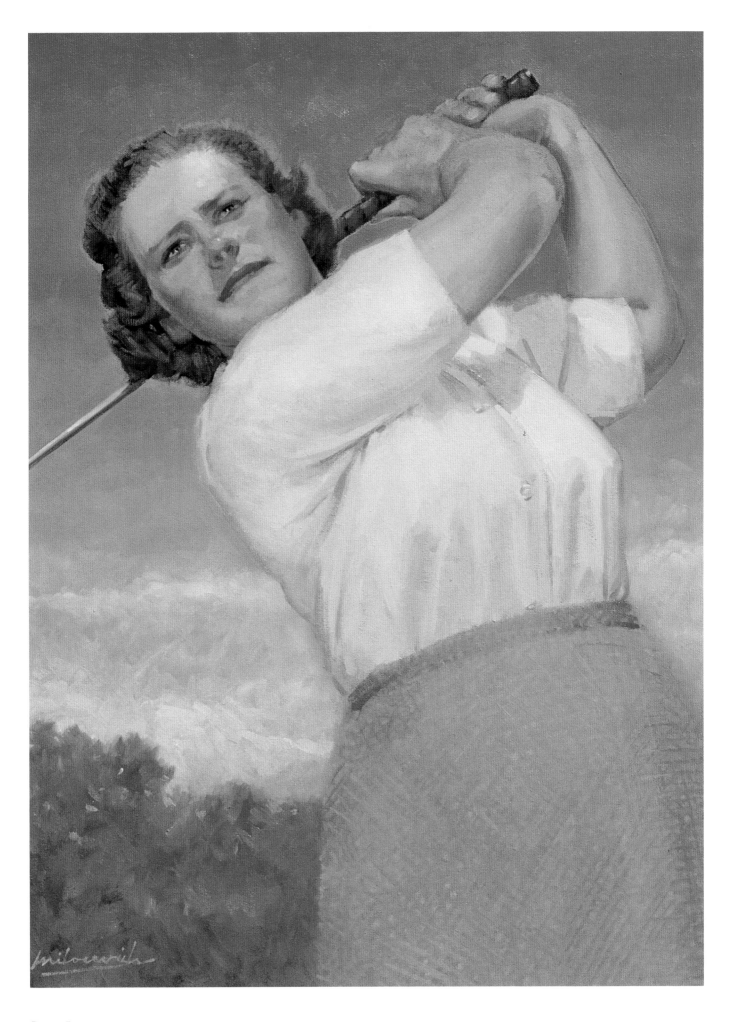

Patty Berg

My Sticks (I)

Golf Glove

Putting It All Together

ne of Paul Milosevich's strengths has always been the desire to learn. "Since I graduated from college in 1965," he has written, "I have continued my 'art training,' studying with professional artists from whom I've learned a great deal." His appreciation and remembrance of the teachers he has met along the way does not diminish with time. A discussion of memorable teachers always begins with Arthur Mitchell (p. 138), the painter with whom he worked at Trinidad Junior College. Not only was Mitchell a fine instructor; he introduced the young student to his collection of paintings by some of the best illustrators of the first half of the twentieth century. After Mitchell's death, Milosevich helped to establish the Mitchell Memorial Museum in Trinidad to house his teacher's collection of paintings as well as Mitchell's own work.

Mitchell and Frank Waters were close friends. The New Mexico writer is another person deeply admired by Milosevich. They met during the Christmas holidays in 1969. The artist recalls sitting with Waters in front of a small fire and talking well into the night while a snow storm swirled outside.

Milosevich refers to Waters as "a wise friend with so much knowledge of archaeology and science." He says that by reading books written by Waters, such as *The Man Who Killed the Deer*, he has gained insight into the philosophy and life-style of the Pueblo Indians.

Others from whom the artist has received valuable instruction are Wayne Thiebaud and Mark Daily. Daily's remark, "If you painted the right color, you would get the right value," is often quoted by Milosevich, whereas Ray Vinella's comment, "Growth in painting comes in large part from painting from life," reinforced the Santa Fe experience of painting on the site.

But of all those with whom he has worked, Milosevich acknowledges, "It was Ramon Froman (p. 139) who helped me the most in terms of color, value, the handling of paint, how to lose an edge [how to accentuate a line or an area]. He was the first artist I ever saw actually paint." On June 6, 1980, Milosevich interviewed Froman for an article which was published in *Southwest Art*. Froman died on June 23. The profile of the painter contains comments made during classes. Many of these remarks are interesting in relation

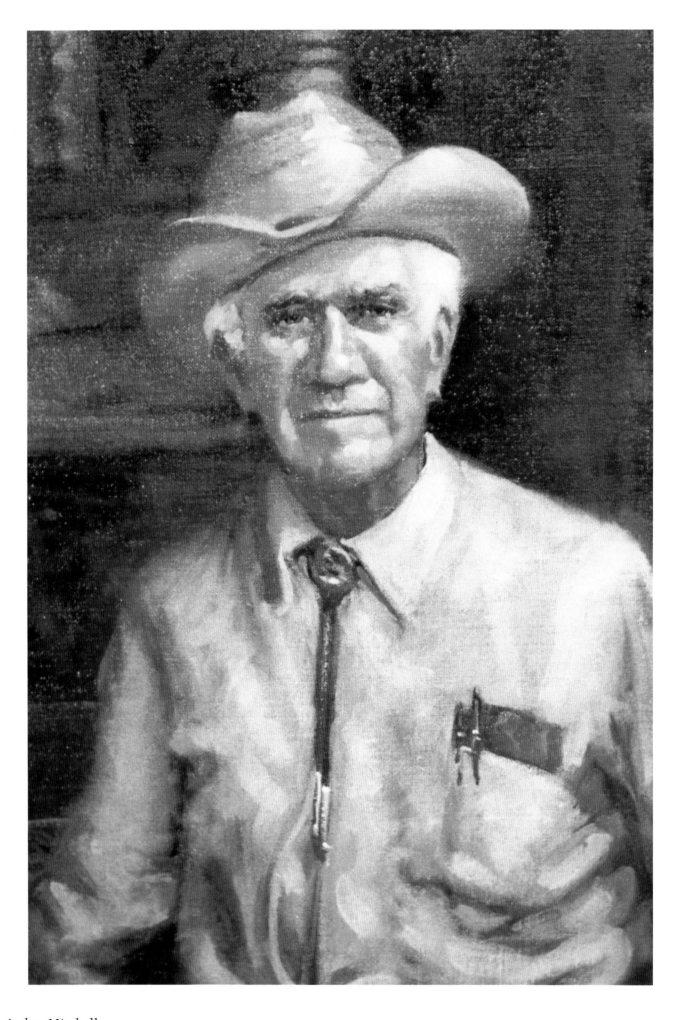

Arthur Mitchell

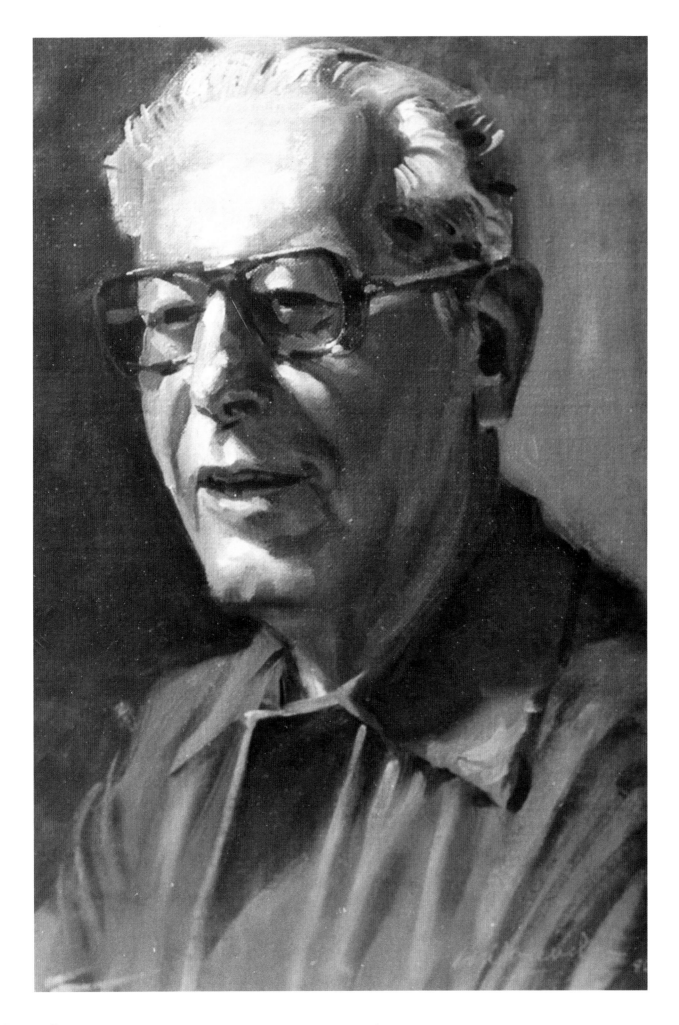

Ramon Froman

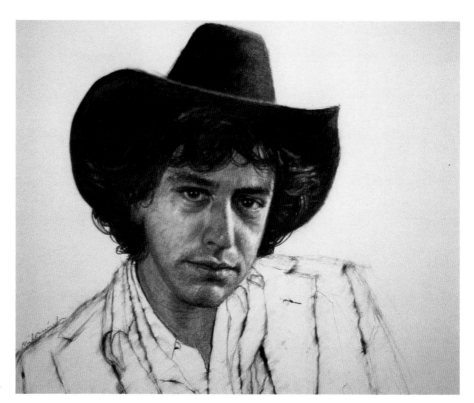

Joe Ely

to Milosevich's development as an artist.

Draw. Correct. Draw again. We have one strike against us before we start. We're trying to do something in the round on a flat surface. So we use certain devices, like lost and found edges, value and color contrasts, to create the illusion of depth.

All shadows are reflected light. Yellow ochre is a good old standby. It ties in light and shadow. Work mainly in about four values. Your palette is your laboratory, where you experiment with color and value. Simplify. Make up your mind. Paint a short concise telegram of how that subject affects you.

. . .you must be a craftsman first. [But] if you remain a craftsman, you're a mere technician. . . . After you have the craft down, then a painting is like a poem or a song. It's a simple expression. It's a comment on something. It's telling your own feeling about something.[39]

Robert Henri went a step farther and suggested that what the painter feels, or thinks, is a part of every brushstroke. He said, "Whatever you feel or think, your exact state at the exact moment of your brush touching the canvas is in some way registered in that stroke . . . and nothing in the world can help it from showing."[40]

Many people believe that the artist discloses more in sketches than in his, or her, formal pieces. Milosevich has always sketched prolifically. The media differ—pencil, pen, brush, charcoal; the communications differ, also. The lively drawings throughout this book give validity to Henri's observations on the subject:

People say, "It's only a sketch." It takes the genius of a real artist to make a good sketch. . .one must have real wit to make a sketch. Pictures that have had months of labor expended on them may be more incomplete than a sketch.[41]

It is always interesting to watch an artist at work and see how a drawing or a painting proceeds from the beginning to the finished form. Milosevich has offered comments on the stages of a drawing of Joe Ely, which was started at eight o'clock in the morning and finished by noon. The artist used charcoal pencils and worked on two-ply Bristol paper, which he says has a slight tooth and is rather like cold-press illustration board. Milosevich keeps the following items at hand: a blob of cotton, a "stump" for blending tones, a kneaded eraser, cotton swabs for taking out highlights, a single-edged razor blade for lifting out the lightest values, fixative for spraying on the finished drawing to keep the charcoal from smearing. The work was begun with a line drawing to establish the pose and likeness, as well as the relationship to the background; at this stage, the sensitive line drawing recalls the portraits done by Holbein for the court of Henry VIII. Darker values are then added to create the modeling of the face and head. There is always the opportunity to darken the tones, and to lighten or remove other values with cotton, tissue, or a kneaded eraser. At this point, the artist says, he may take off his glasses and squint at the sheet to concentrate on the effect of the general relationship of light and dark passages. Erasing parts of the

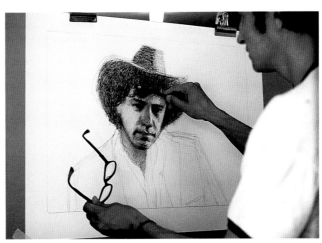

Joe Ely

lines and sharpening some contours causes some forms to recede and others to come forward in space. The light areas are easily created with cotton swabs or the eraser; the charcoal pencil intensifies the definition of the drawing and increases the crispness of the lines. One of the final steps in the process is the use of the razor blade to lift out the highest lights and to roughen the paper slightly. Roughing the paper, Milosevich explains, helps to catch the light. As the drawing proceeds the artist steps back from his work to study it from different vantage points. Finally, Milosevich looks at the drawing in a mirror to detect any flaws or irregularities. The finished portrait of Joe Ely is that reproduced on one of the musicians's album covers (see p. 88).

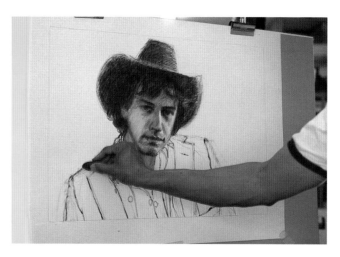

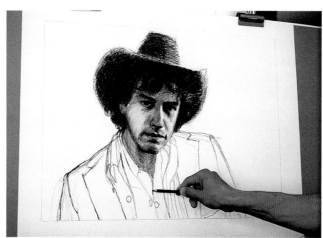

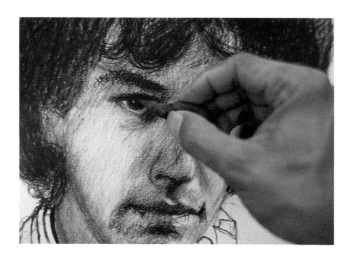

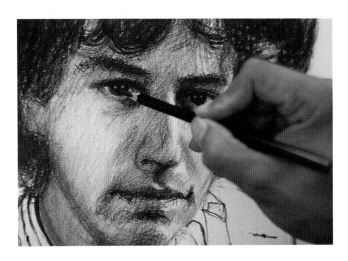

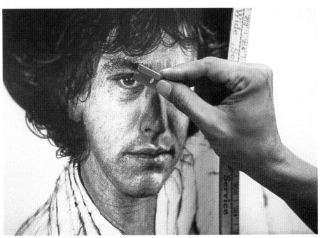

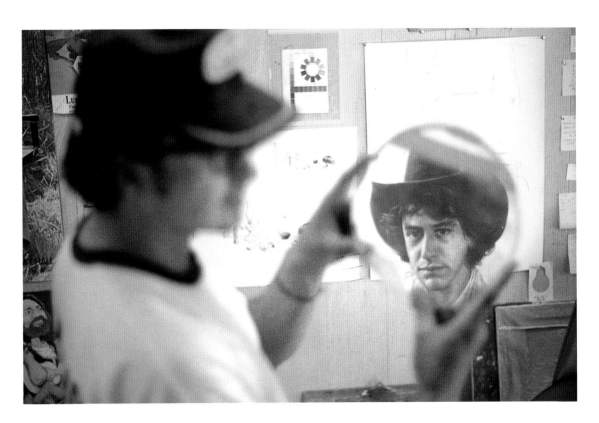

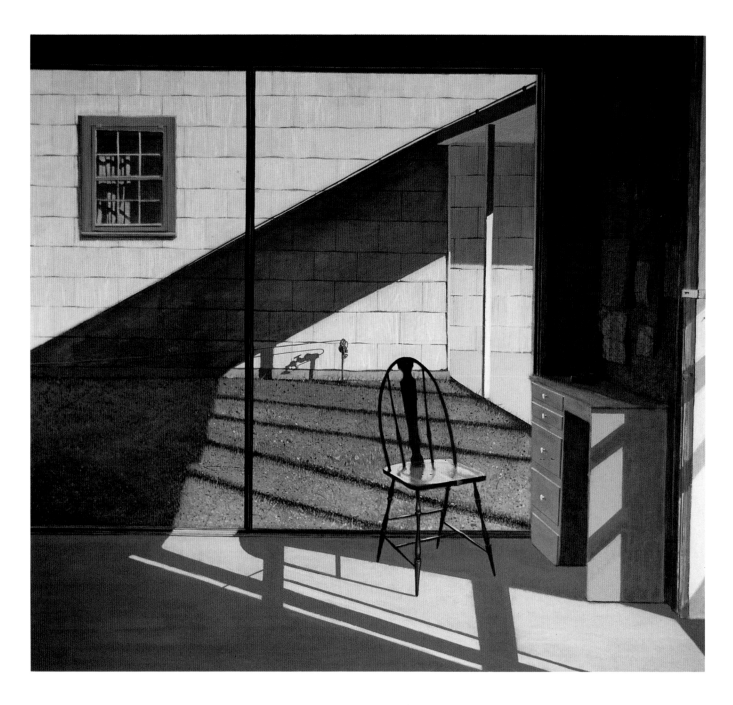

Backyard Studio

Sketching and drawing are usually integral steps in the planning of a painting. Measuring forty-eight-by-forty-eight inches, *Backyard Studio* is a painting in acrylic. A preliminary pencil sketch was made in "a get-acquainted-with-the-subject" session. The pencil drawing, which was fourteen-by-eighteen inches, aided in the decision-making process. Should the composition be designed in a vertical or horizontal manner? In this case, a square

format was chosen. The drawing becomes a study for the layout, the elements of the design to be stressed, and an experiment in values. While considering the composition as a whole, the artist was attracted to the pattern of the spigot to which the hose was attached. A handsome sketch was made of this small part of the whole. To give consideration to the colors, the artist painted a watercolor—a step that he is likely to bypass unless the painting under consideration is very complex. The next stage is the blocking-in of the composition using acrylic washes of chrome oxide green and, in the background, yellow and white. White canvas is left in the foreground; if a light value is needed, the bare canvas works very well. At this juncture, a wash of cadmium yellow light is added, and the drawing is redefined with burnt sienna. The painter says that he begins a painting with light washes, correcting the drawing with a dark hue, and, if necessary, correcting again with a still darker value. Because acrylics dry rapidly, it is possible to correct a drawing with different colors without worrying about picking up the underpaint. Milosevich adds that Wayne Thiebaud often outlines objects with brilliant colors. When he continues the painting, the outline is allowed to remain. This produces a "neon effect," or a slight aura around the subject. Next in *Backyard Studio*, an opaque

Backyard Studio (above, top)

Backyard Spigot (above, middle)

Backyard Studio (right)

surface is built up. The artist then begins with the darkest values, adding the middle values, then the light values, and last of all, the highlights. Rarely does Milosevich feel a need to use black; ultramarine blue and burnt sienna will produce tones as dark as necessary. Milosevich makes the general observation that artists who use vigorous contrasts in light and dark have a tendency not to emphasize color; those who use brilliant colors seem to place less stress on contrasts in value.

Different effects are achieved with acrylic in contrast to those produced by the use of oil paint. Two paintings illustrate this in an amusing way: *Time Out to Roll His Own*, a full-length figure of a cowboy whose back is turned to the viewer as he concentrates on his tobacco and cigarette paper, and *Ponytail*, the rear view of a horse trailer with a black horse tail hanging over the tailgate (p. 148). The cowboy is painted in oil and the horse trailer is painted in acrylic. The compositions have an unexpected similarity. The bow-legged ranch hand wears flaring chaps that rise in a pyramidal shape to his outspread elbows. The composition then follows the arms and shoulders to the apex of a well-rolled hat. The same pyramidal mass is apparent in the back of the trailer. The triangular reinforcements on either side of the tailgate parody the cowboy's chaps. In the painting of the trailer, the symmetry is thrown off-balance by the horse's black tail on the left. An inverted triangular band in dark ochre decorating the back of the trailer forms a reversal of the triangular motif. The differences provided by oil paint and acrylics are easy to discover. In the oil painting, the cowboy faces a sunny landscape

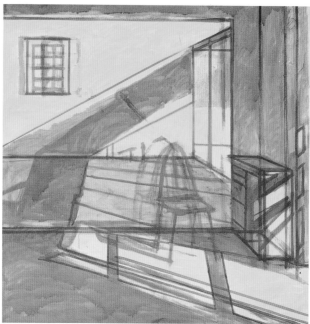

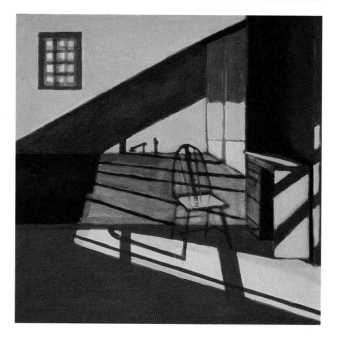

Backyard Studio

Time Out to Roll His Own

Ponytail

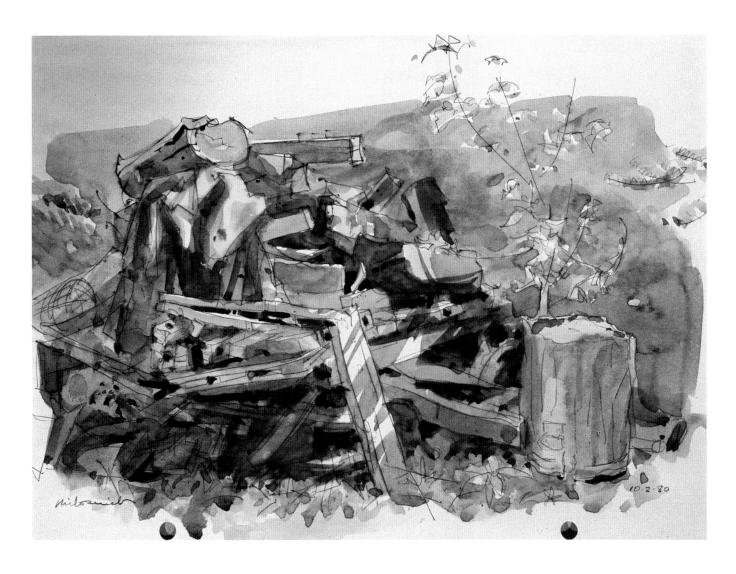

Trash Heap

with receding distances. The brush-work and rich application of pigment help in the creation of light and dark passages that build round, solid forms enlivened by textural interest. The background of *Pony-tail*, painted in acrylic, is a flat blue; the base line is implied rather than delineated. The painted areas are flat and decorative with pop art overtones. The style is hard-edged. According to Milosevich, the distinction between the two media in his

paintings is that the result is more contemporary when acrylic is used; paintings in oil give the impression of a greater traditionalism.

Milosevich works less frequently in watercolor, but when he does use the medium, his sketches are filled with animation and rapid-fire sensations conveyed without a second's hesitation. An example is a trash heap of discarded bits and pieces. In contrast, there is the watercolor

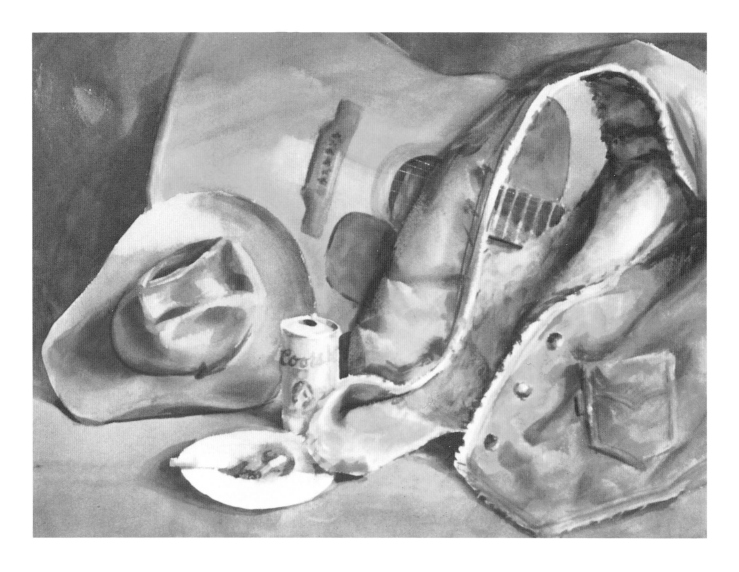

Picker's Stuff

Picker's Stuff, which is carried to a greater degree of finish, but without losing freshness.

Of his paintings, Milosevich writes: "There are as many ways to paint as there are painters. I am most familiar with the 'painterly realism' style. This style is characterized by recognizable subjects done in a loose, direct way with fairly thick paint applied with large brushes. Artists such as Rembrandt, Hals, Velasquez, Manet, Henri, and Fechin worked in this way." Another painter admired by Milosevich is Andrew Wyeth for his love of minutiae and fastidiously painted textures.

Milosevich's search for his own personal ways of representation over the last three decades has focused upon a preoccupation with light and the effects of light. There is the sparkling clarity of light that transformed mops and brooms, painted in California, into a complexity of textures and colors (see pp.14-15). The same quality permeates a watercolor of a wooden cross leaning against a wall. Light is also used by the artist to construct a clean geometry of solid forms in the manner of the American landscape painter Edward

Cross in Backyard

Gas Station at White Lake, NM

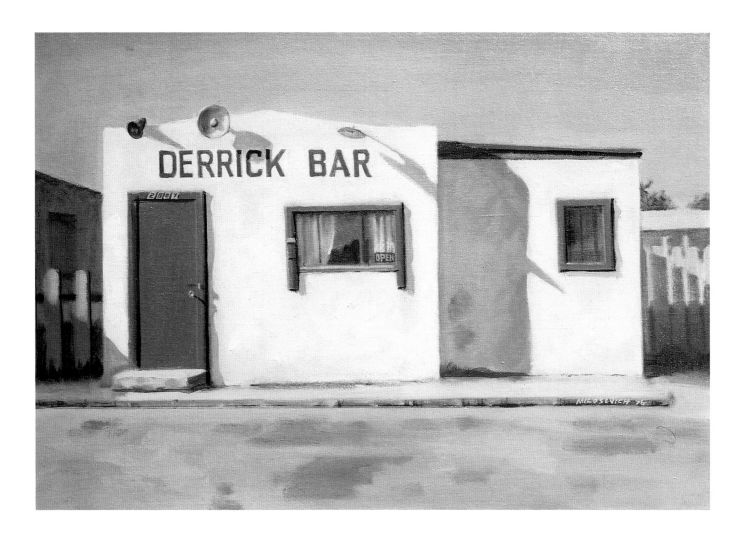

Derrick Bar

Hopper. *Gas Station at White Lake*, painted in a blaze of sunlight illuminating the white wall, illustrates the Hopperesque treatment. *Derrick Bar* is a visual statement drawing upon the deceptive simplicity of Georgia O'Keeffe.

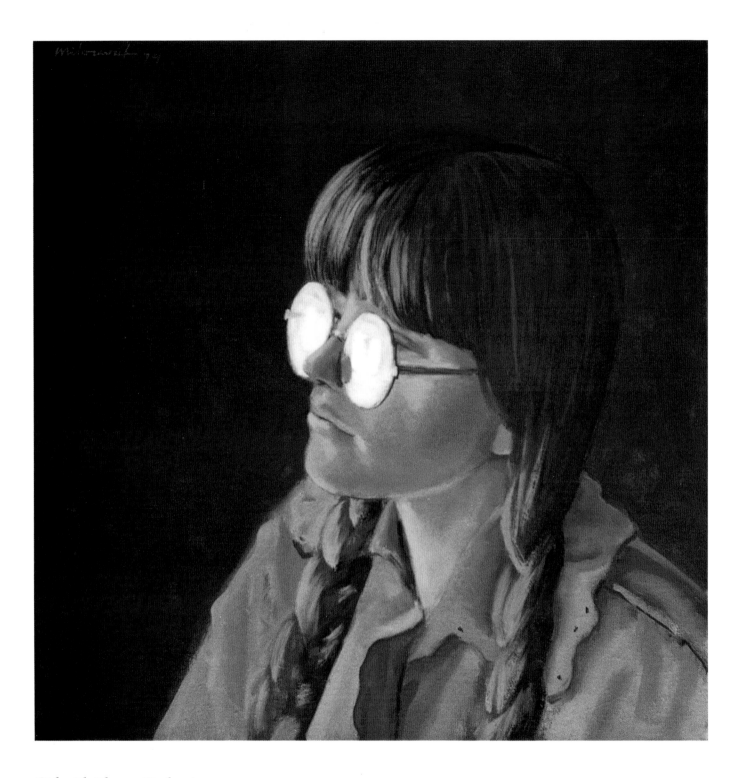

Girl with Glasses (Carlton)

Reflections on mirrored surfaces are another aspect of light challenging the painter. Dark glasses shading a young girl's eyes turn white in the glare of an unknown light source, thus providing a double shield to hide the thoughts and emotions that the eyes might reveal. A similarly enigmatic and concealing device is at play in a portrait of a Navajo man whose strong face is shadowed by the brim of his hat and whose eyes are hidden by the reflected light on a pair of sunglasses.

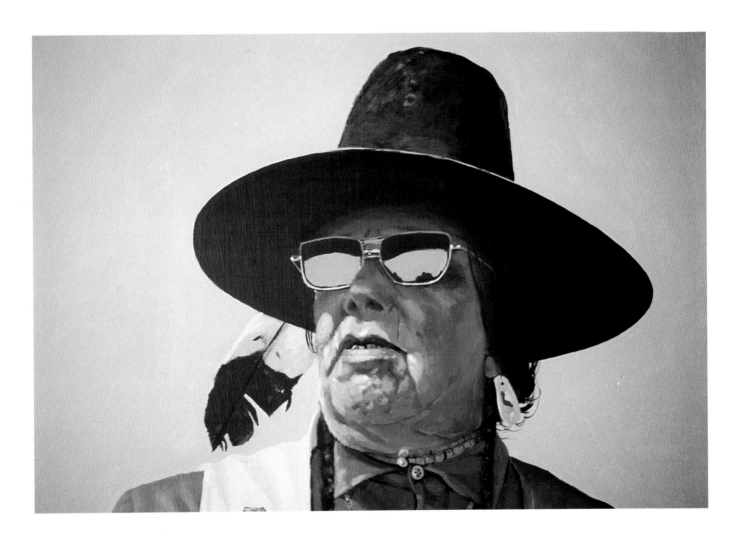

Navajo Man

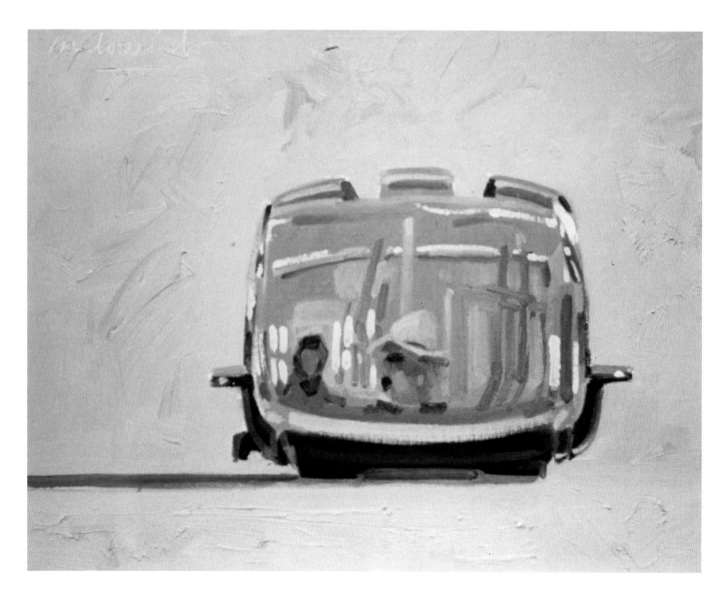

Toaster

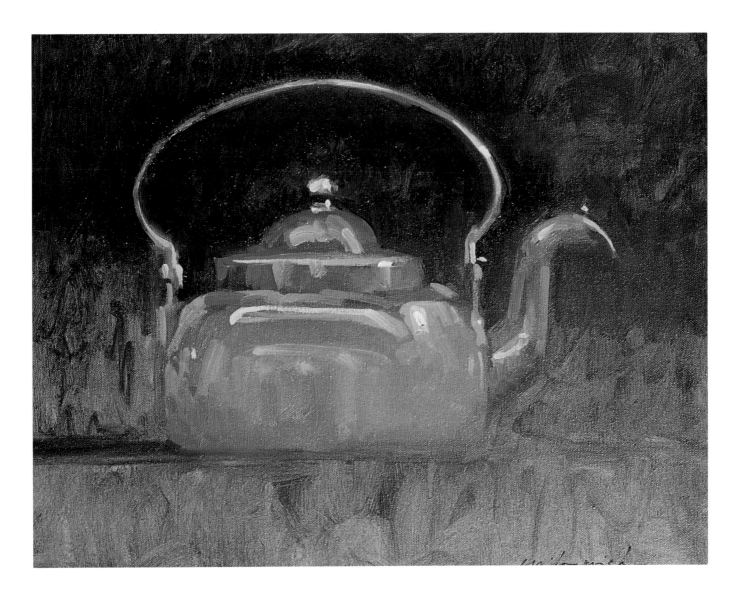

Copper Teakettle

Shiny objects that reveal their environment are often selected as subjects by Milosevich. There is a technically awesome painting of the reflections on the curving sides of a chromium toaster. The highlights on a copper teakettle are multiplied to macrocosmic proportions on the rear end of a Western Flyer (see p. 93) speeding along a flat highway toward the foothills of the Rockies. The reflections on the back of the truck seem to open up a tunnel through the moving vehicle to the road that lies ahead.

The painter says that it is the bright light of West Texas and the Southwest that he finds most challenging in his work. Light and shadow have been called a

Milosevich trademark. He said a few years ago, "I have been fascinated with light and shadow patterns since I was a kid. Light can create a mood in a painting just like it can on the stage. . . .Without light, we're out of business as artists. . . .Whatever I get into will be something from my own personal experience, and it will be done using strong light and shadow."

Objects with which the artist can associate have always been his favorite subjects—mops, an old glove, a golf cap, a worn jacket on a hanger, faded denims, guitars, wine jugs, pieces from everyday life that have acquired a patina with age and use. Milosevich's advice to students is "Paint simply and paint the obvious, not the impossible"; so much the better for the mature talent if the "obvious" has taken on a heady mix of the "impossible"; for example, such an object as the toaster with its mirrored imagery.

Landscape is another subject painted by Milosevich, and his landscapes are transformed by light. The artist expresses an empathy with nature and a sensitivity to the differing moods of the seasons. In a canvas such as *Backyard Studio*, shadows are an important element in the design. Light and dark contrasts are often the result of working from snapshots.

In the last few years, however, color has become more and more important as the painter has taken his canvases out-of-doors to carry on a direct dialogue with nature. The result has been brighter colors, freer brushwork, and the development of the speed necessary to put down on canvas the light that changes throughout each hour of the day. Milosevich says he may mix a color and suddenly say to himself, "Man, I've never mixed that color before!"

In addition to the easel paintings of landscapes, there are several large-scale compositions that have been blown-up to billboard proportions and installed at busy Lubbock intersections. The Lubbock Poster Company decided it would be an unexpected novelty to put up a billboard with a painting unencumbered by advertising. This has led passersby to comment, "Someone's doing something right."

Compositions with large numbers of people are also painted by Milosevich. There are scenes of Indians dancing in pueblo plazas and cowboys riding herd on cattle or enjoying a picnic.

But it is portraiture that, over the years, has occupied a great deal of the painter's time and attention. Milosevich has a rare gift for capturing a likeness of the person who is posing for him. The portraits are not always of humans. There is a fine portrait sketch of a dog, "a rare, sagacious cur," like Gainsborough's oil painting of Bumper owned by Mrs. Henry Hill. Portraits are done in all sizes, shapes, and media. About the art of portrait painting, Milosevich writes:

Faces have always fascinated me. Tom T. Hall wrote a song called "The Story of Your Life Is in Your Face," and that is often the case. People of all ages and nationalities have so much in common and yet each is a unique individual. Capturing someone's personality in a portrait is a never-ending challenge. . . .

Besides the psychological interest, the human face and figure are wonderful artistic motifs. Each curve is balanced by a straight line, fascinating color changes occur, subtle value changes create form (cones, cylinders, spheres, cubes), and so on. Rembrandt, with his great skill and poetic soul, is probably my all-time favorite artist.

As interesting as human subjects are, we must detach ourselves and look at the subject as a "still life," or get overpowered in the process. Each form has light, shadow, color, texture, value, and shape which must be analyzed, interpreted, and re-created with a dash of "soul" blended in to have a presence. The human head and figure will always be a fascinating, never-ending challenge to draw and paint.

Portrait of a Dog

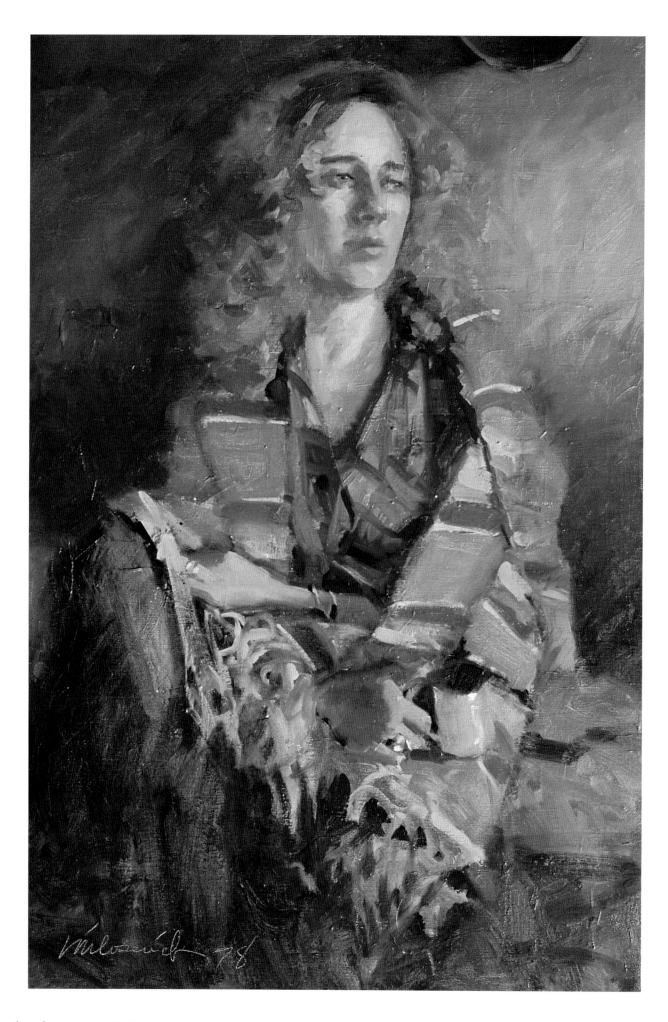

Deborah (Morning Coffee)

One of the memorable portraits in oil is *Deborah*. It is a poignant and lovely painting in which each brush load of paint delineates an essential feature—the cloud of sunlit hair, the hands, the coffee cup, the folds of the striped shawl. The painting expresses the delicacy and elegance of a Renaissance portrait, but with the eccentric orange and mauve tones, the grayed blue associated with mannerism. Technically, it shares a kinship with the work of Robert Henri and Ramon Froman. It is proof of Henri's remark, " 'Pretty faces' are often dull and empty. Beauty is never dull and it fills all spaces."[43]

Detail from *Deborah*

Detail from *Deborah*

A double portrait by Milosevich, dated 1988, is given the title *Conversation*. Although it differs from the impressionistic charm of *Deborah*, it is another of the painter's finest achievements. It marks growth and a maturing talent. The painting is a rigorously composed study of two women. One looks toward the viewer, while the woman on the right directs her attention towards her companion. Bridging the distance between the women is a typical New Mexican motif, a skull with curving horns. Warm colors are dominant. The rich red of a skirt is balanced by red embroidery on a black blouse. The whole is brought into a carefully planned harmony by the warm pink adobe wall. Through a window, a deep blue mountain looms. This follows Henri's dictum: "The effect of brilliancy is to be obtained principally from the opposition of cool colors with warm colors and the opposition of grave colors with bright colors. If all colors are bright, there is no brightness."[44]

The painting is accomplished with what gives the appearance of perfect ease. There is no evidence of struggle, nor is there a false stroke. Textures are a handsome embellishment, but they are handled without succumbing to the sheen of turquoise or the glitter of silver braid. The canvas is filled with quiet grace. The key is *order* in the relation of parts to the whole.

The pattern of change and development over three decades in the art of Paul Milosevich is noteworthy; but the message is, of course, most eloquent in the paintings and drawings themselves. Despite the artist's involvement with particular subjects, he has never been satisfied to repeat the same concepts or techniques again and again; he has studied and learned and experimented and thought deeply. At every period there have been changes, but the artist has retained those elements that have contributed to expressive power and has discarded those things that have been less useful. Milosevich has always stretched towards the future. He has not been caught up in a flood of contemporary *isms*, swinging from this year's popular mode to the next short-lived movement. Restlessness is not a fault in Milosevich's art; he has maintained a desire for excellence in spite of personal ups and downs. He

illustrates in his work the paragraph with which he closed the profile of Ramon Froman:

I met a man and talked to him seriously. . . He said, "Things change in the world. Fads come and go. . . Learn the technique. Learn the craft. Do the thing you're best suited for. Whether it's in favor or not, do it, and maybe someday before you die, or maybe after you die, you might be recognized. Maybe you'll never be recognized. That's immaterial. The thing is, do yourself."[45]

Conversation

Notes

1. Translated from Frank Waters, *People of the Valley.*

2. *Art Since 1945* (New York: Harry N. Abrams, n.d.), 309.

3. Larry Chittenden, "Hell in Texas," in *Songs of the Cowboys*, ed., N. Howard Thorp (Lincoln: University of Nebraska Press, 1984), 79.

4. David Byrne, *True Stories* (New York: Viking Penguin, Inc., 1986), 158.

5. Michael Ventura, *Paul Milosevich: The Santa Fe Change* (Lubbock: The Museum, Texas Tech University, 1985).

6. George Hancock, *Go-Devils, Flies and Blackeyed Peas* (Corsicana, Texas: privately printed, 1985), 38.

7. Hancock, *Go-Devils*, 39.

8. Clara Hieronymous, "Western Artist Finds Fans in Music City," *Nashville Tennessean*, 19 March 1978.

9. Marsha Gustafson, "Portrait of a Songpainter," *The Texas Techsan*, June 1979, 4.

10. Gustafson, "Songpainter."

11. Ronald G. Pisano, *William Merritt Chase* (New York: Watson-Guptill Publications, 1982), 22.

12. George Wildenstein, *Chardin* (Zurich: Manesse Verlag Conzett & Huber, n.d.) plate 34, 149.

13. Robert Henderson, *The Dictionary of Eponyms* (New York: Stein & Day, 1985), 182.

14. Alison Lurie, *The Language of Clothes* (New York: Vintage Books, 1983), 176.

15. Lurie, *Language*, 180.

16. Lurie, *Language*, 180.

17. Larry McMurtry, *Texasville* (New York: Simon & Schuster, 1987), 209.

18. Russ Parsons, "Beyond a Doubt," in the catalog for Honky Tonk Visions (Lubbock: The Museum, Texas Tech University, 1986), 17.

19. Parsons, "Beyond a Doubt," 19.

20. Parsons, "Beyond a Doubt," 19.

21. Parsons, "Beyond a Doubt," 19.

22. Parsons, "Beyond a Doubt," 19.

23. Butch Hancock, "The Dirt Road Song," in G. Hancock, *Go-Devils*, 81.

24. Alexandra Jacopetti and Jerry Wainwright, *Native Funk and Flash* (San Francisco: Scrimshaw Press, 1974), 30.

25. Ventura, *Santa Fe Change*, 4.

26. Bill Porterfield, *Texas Rhapsody* (New York: Holt, Rinehart & Winston, 1981), 19.

27. Mikal Gilmore, "West Texas Music from the Outside," in the catalog for Honky Tonk Visions, 8.

28. Elizabeth S. Sasser, "Honky Tonk Vision," a review in *Artspace Magazine*, Fall 1986, XX4.

29. Sasser, "Hony Tonk Vision," 43.

30. Gilmore, *West Texas Music*, 12.

31. Ventura, *Santa Fe Change*, 4.

32. Marsha Gustafson, *Texas Techsan*, 4.

33. Ventura, *Santa Fe Change*, 3.

34. Robert Henri, *The Art Spirit* (New York: Harper & Row, 1984), 170-71.

35. Peter Andrews, "The Fine Art of Golf," *Golf Digest*, May 1988, 86-87.

36. Andrews, "The Fine Art of Golf," 88.

37. Andrews, "The Fine Art of Golf," 89.

38. *Chronicle-News*, Trinidad, Colorado, May 4, 1988, 4.

39. Paul Milosevich, "Ramon Froman: the Only Sin is to Refuse to Grow," *Southwest Art*, March 1982, 194.

40. Henri, *The Art Spirit*, 57.

41. Henri, *The Art Spirit*, 96.

42. John Hayes, *Gainsborough*, (London: Phaidon Press, 1975), 201, n. 1.

43. Henri, *The Art Spirit*, 124.

44. Henri, *The Art Spirit*, 57.

45. Milosevich, "Ramon Froman," 106.

The Paintings

Putting It All Together

Chronology of the Artist's Life

1936 Born 27 February in Trinidad, Colorado, to Yugoslav immigrant parents, Zora Padjen and Matt Milosevich. Youngest of eight children. Father a coal miner, tradesman, farmer.

1941-1953 Attends public schools in Trinidad. Develops interest in drawing, but no art classes available. Basketball, golf, and farm life are main interests.

1954 After high school graduation, works at various jobs in the Los Angeles area.

1955 Enrolls at El Camino Junior College, majoring in pre-dentistry. Competes on the golf team. Works full-time as clerk-typist/stenographer.

1957 Transfers to Trinidad Junior College. Meets western artist Arthur Roy Mitchell, who becomes influential artistic catalyst. Works part-time as sales clerk.

1958 Marries Wanda Myers in Torrance, California. Returns to Trinidad Junior College. Works at gas station. Continues art classes with Arthur Mitchell.

1959 Completes A.S. degree at Trinidad Junior College. Works on wheat harvest in Texas. Deferred from military service. Daughter Jena born.

1960 Moves family to Torrance, California. Enrolls at Long Beach State College, majoring in art education. Works full-time as janitor for five years.

1963 Completes bachelor's degree in art. Daughter Tanya born.

1965 Completes master of arts degree in drawing and painting at Long Beach State. Thesis on the portrait painting of Andrew Wyeth and Nicolai Fechin. Receives appointment as instructor of art at Odessa College (Texas). One-man exhibitions at Long Beach State and Odessa College. Daughter Karla born.

1967-1970 Serves as chairman of art department at Odessa College. Receives several regional and national awards. Portrait commissions include Jack Rogers, President of Odessa College.

1968 Visits parents' homeland in Yugoslavia, and has exhibition of work done there.

1969 Marriage ends in divorce. Meets author Frank Waters in Taos, New Mexico.

1970 Paints in the summer at Taos. Experiments with nonobjective art. Receives appointment as instructor of art at Texas Tech University, Lubbock. Visits major art museums and galleries during

two-week trip to New York and other major eastern cities.

1971 Exhibits watercolors and drawings in Holland. Visits and works in Yugoslavia.

1972 Participates in regional and national competitive shows, earning several awards.

1973 Executes first record album cover for western singer Tom T. Hall. Subsequently does four more album covers and several paintings for Hall's home in Nashville, Tennessee.

1975 Resigns associate professor position at Texas Tech University to devote full-time to personal artwork and private workshops. Begins portrait assignment for annual inductees into the Nashville Songwriters' Hall of Fame. Subsequently does portraits of Kris Kristofferson, Willie Nelson, Waylon Jennings, Tex Ritter, Hank Williams, Chuck Berry, and numerous other honorees.

1976 Marries Deborah Thompson. Writes and illustrates for *Country Rambler* magazine.

1977 Enrolls in first of several workshops with Ramon Froman, inspirational artist and teacher.

1978 Participates in West Texas Realism exhibit in Lubbock and Nashville. Involved in "East Broadway Onion Championship" with Tom T. Hall, Joe Ely, and C.B. Stubblefield.

1979 Has one-man show, *Cowboys and Indians*, at Lubbock Lights Gallery. Work appears on NBC "Today" show.

1980 Last workshop with Ramon Froman, who dies in June. Writes story on Froman for *Southwest Art* magazine. Works to establish Mitchell Museum in Trinidad. Father dies.

1981 Moves to Santa Fe, New Mexico. Exhibits at Streets of Taos Gallery and Mitchell Museum, Trinidad. Mother dies.

1982 Son Vincent born. Does on-site painting with Woody Gwyn, Ray Vinella, Elias Rivera, and Albert Handell.

1983 Exhibits at Smith-Stewart Gallery, Santa Fe. Exhibits at Lubbock Arts Festival.

1984 Exhibits at Santa Fe Festival of the Arts. Paints the poster *Nothin' Else to Do* for Texas Tech Museum tribute to West Texas music.

1985 Has one-man show, The Santa Fe Change, at The Museum, of Texas Tech University. Exhibits at C.G. Rein Gallery, Santa Fe.

1986 Marriage ends in divorce. Moves to Lubbock, Texas. Begins series of golf subjects. Teaches workshops in Tulsa, Cloudcroft, and Santa Fe.

1987 Portrait subjects include Dolly Parton, Texas Governor Mark White, Federal Judge H.O. Woodward. Becomes involved in "billboard art." Studies with Donald "Putt" Putman; studies with Ted Seth Jacobs. Teaches workshops in Santa Fe, Abilene, and Cloudcroft.

1988 One-man show of golf art at Sporting Scene Gallery in Dallas. Portrait subjects include Ben Crenshaw, Patty Berg, and Phil Speegle, President of Odessa College. (Patty Berg portrait commissioned by the United States Golf Association, Far Hills, New Jersey.) Begins work on illustrated books, *Grassroots Golf and Texas Golf Legends*, to be published by Texas Tech University Press. Teaches workshops in Lubbock, Santa Fe, and Levelland. Studies with Mark Daily in Taos; studies with Wayne Thiebaud in Santa Fe. Executes mural for Mira Vista Golf Club in Fort Worth.

1989 Portraits include Federal Judge Eldon Mahon for Federal Court House, Fort Worth; golfer Lee Trevino for USGA Golf House, Far Hills, New Jersey. Executes two mural-size paintings for Mission Hills Country Club, Indianapolis, Indiana. Commissioned by the Hickey-Freeman Company to do on-site art work at the U.S. Open golf tournament, Rochester, New York.

Index